목탑과 한옥

목탑과 한옥

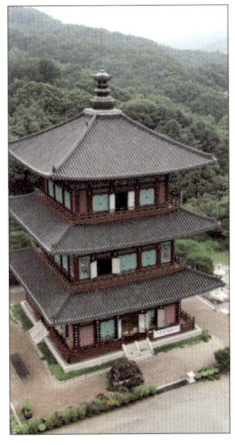

자연을 품은 사찰 보탑사와
한옥 건축 이야기

김영일 지음

청아출판사

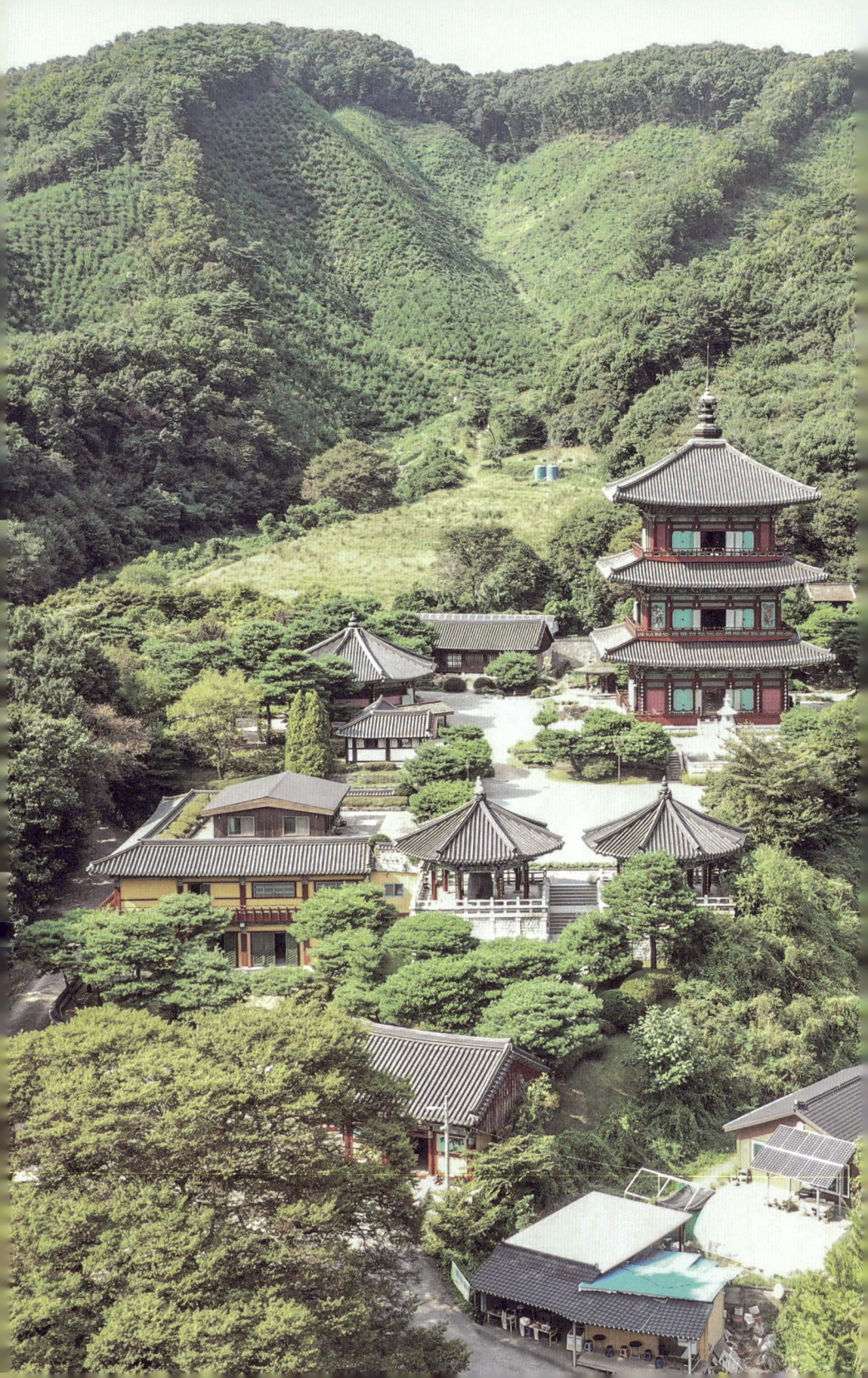

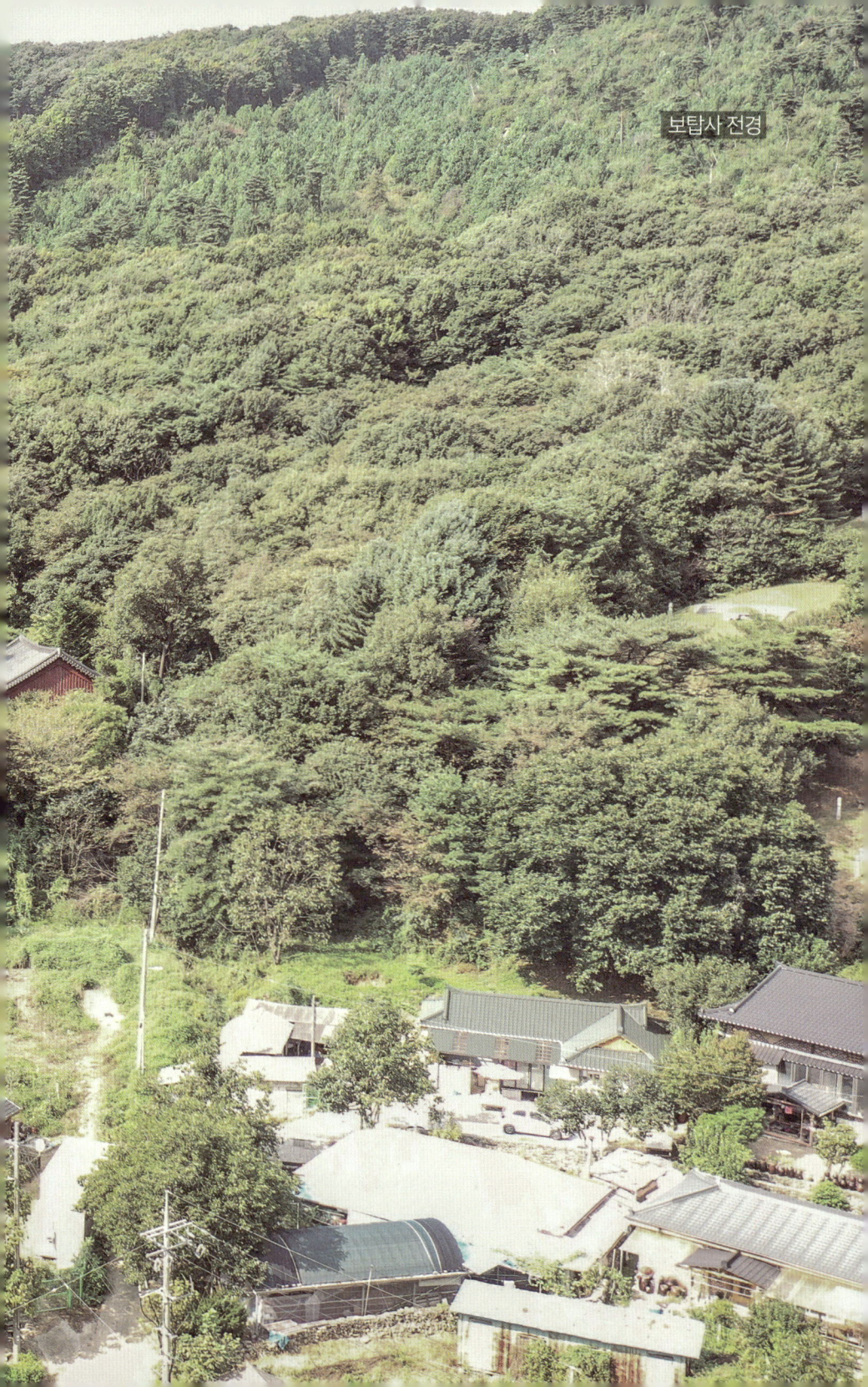

보탑사 전경

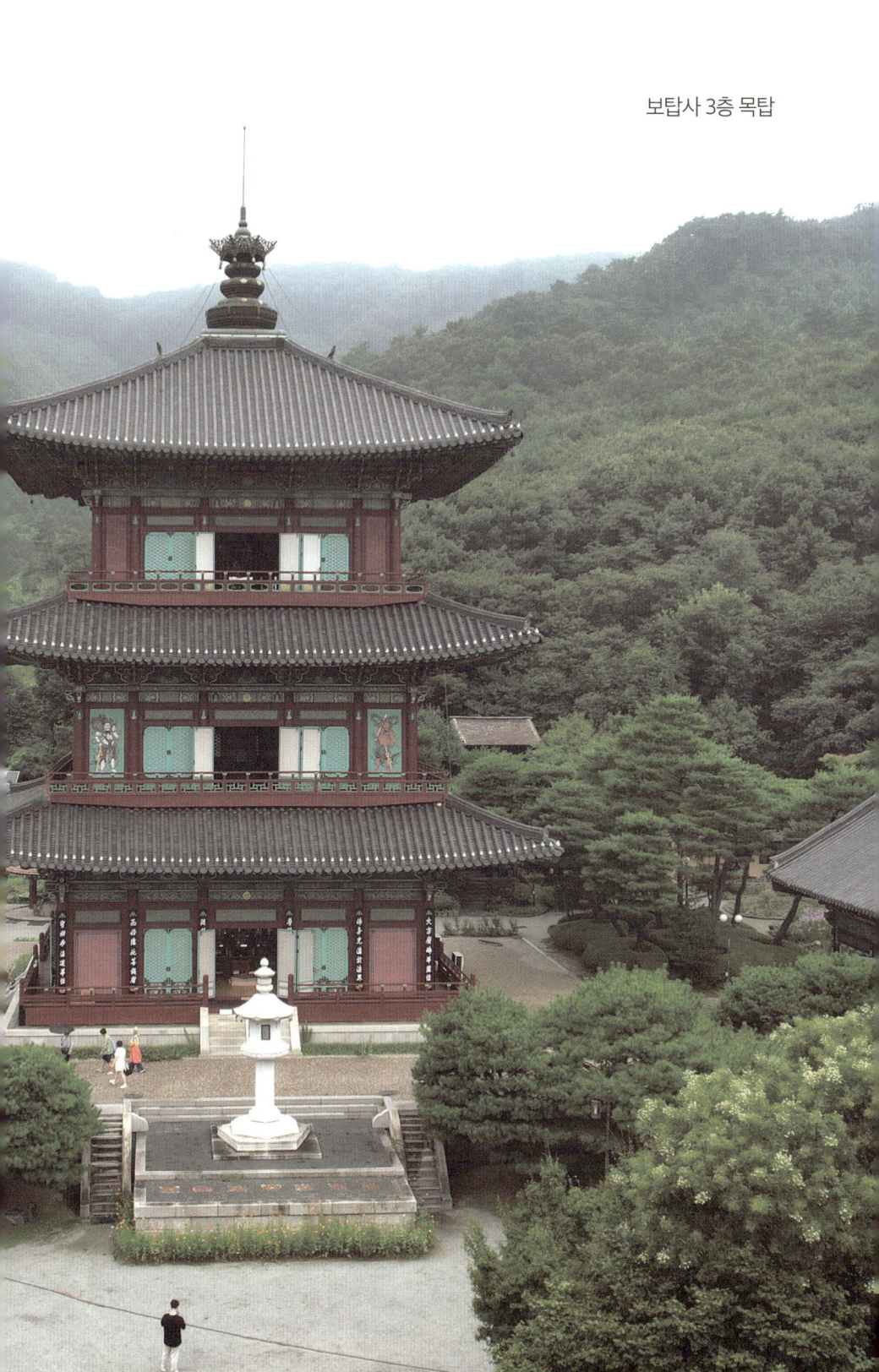

보탑사 3층 목탑

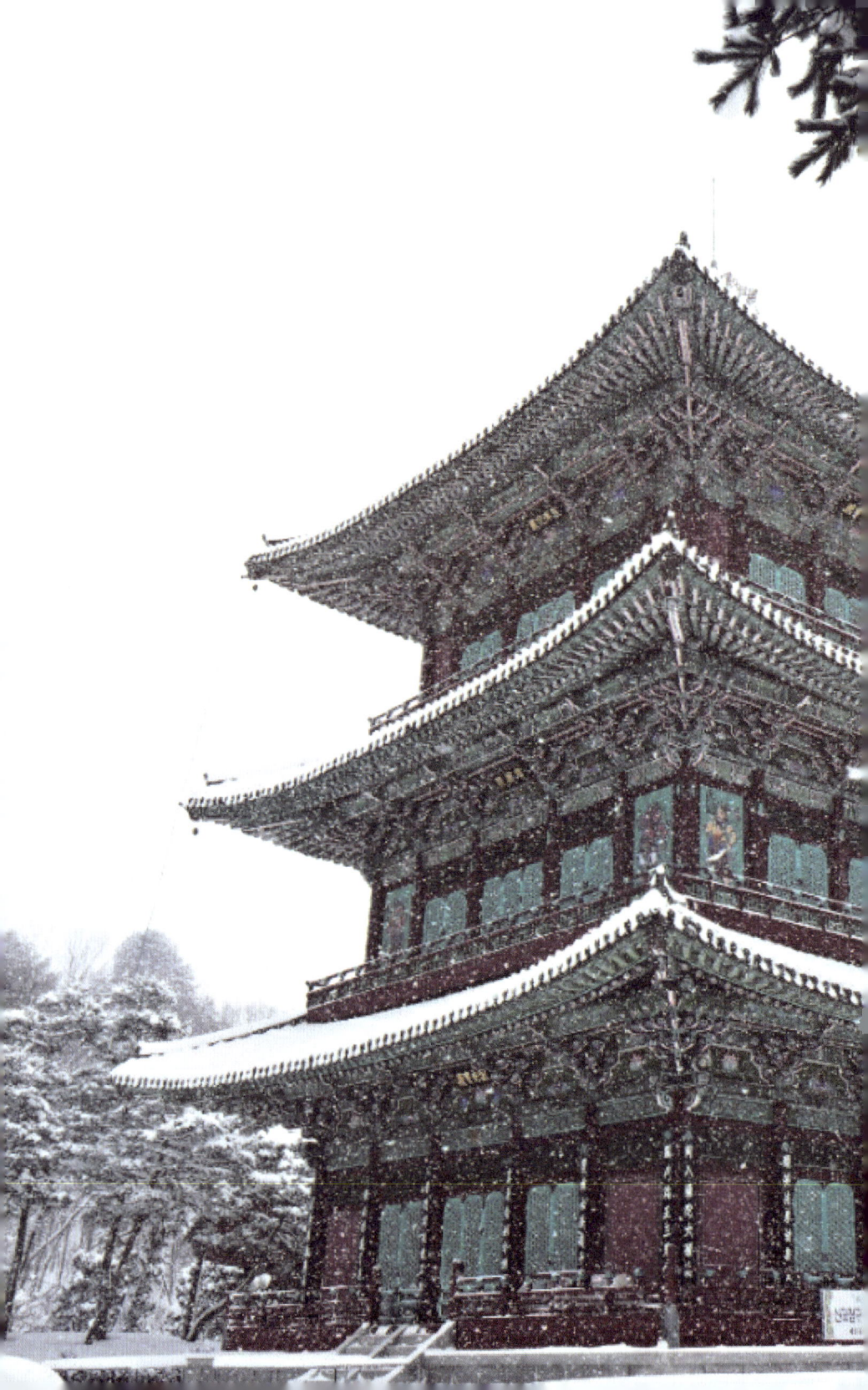

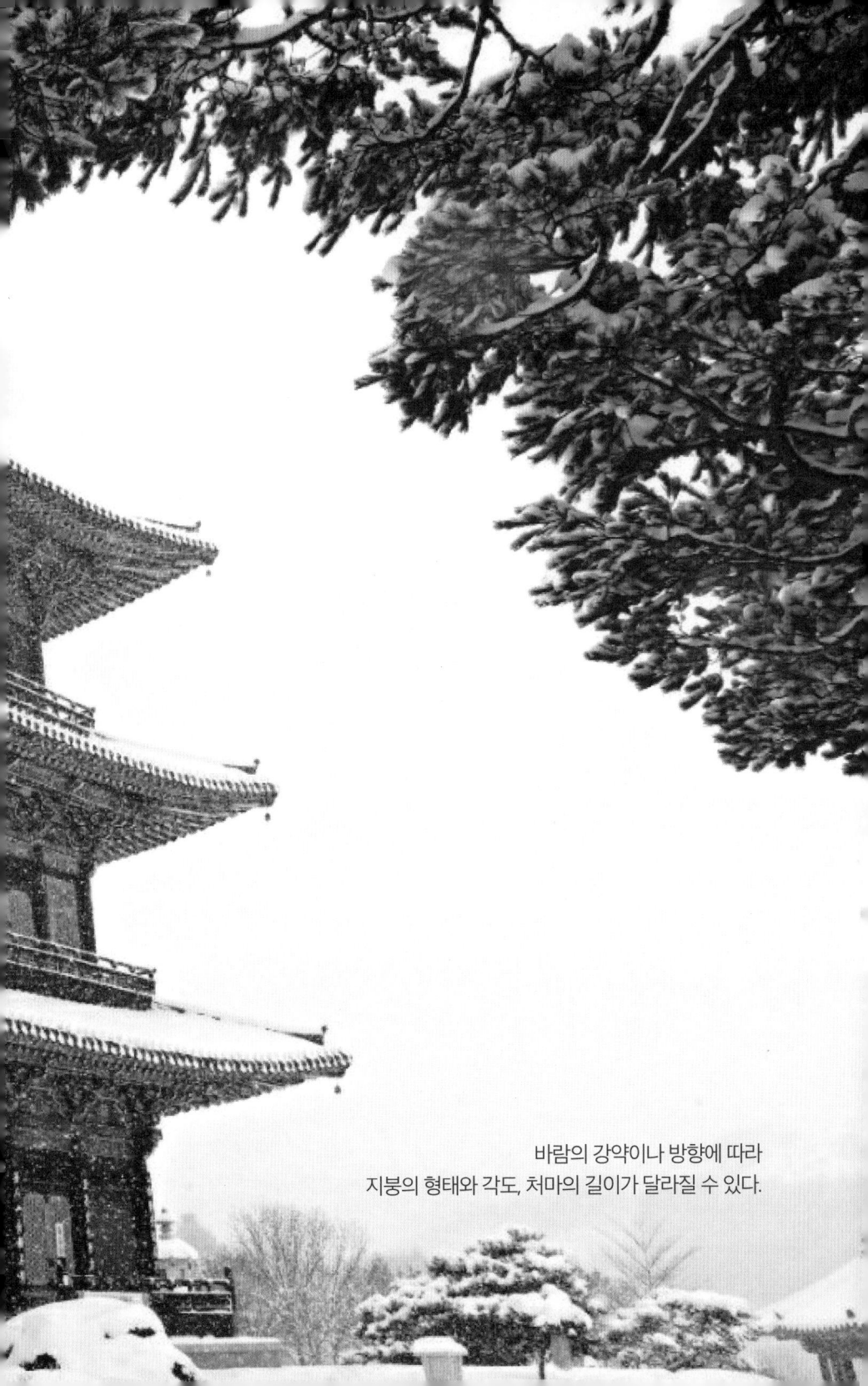
바람의 강약이나 방향에 따라
지붕의 형태와 각도, 처마의 길이가 달라질 수 있다.

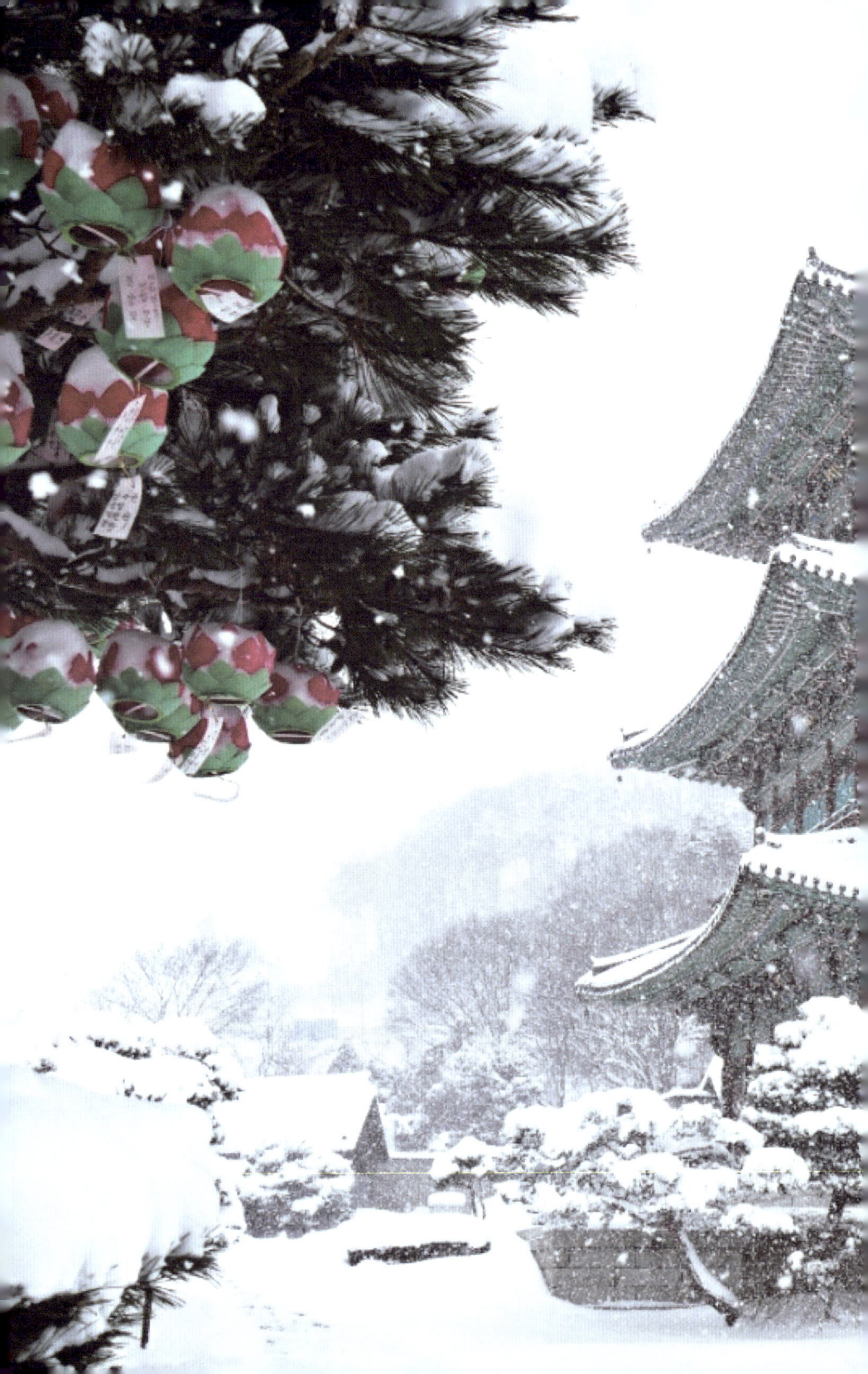

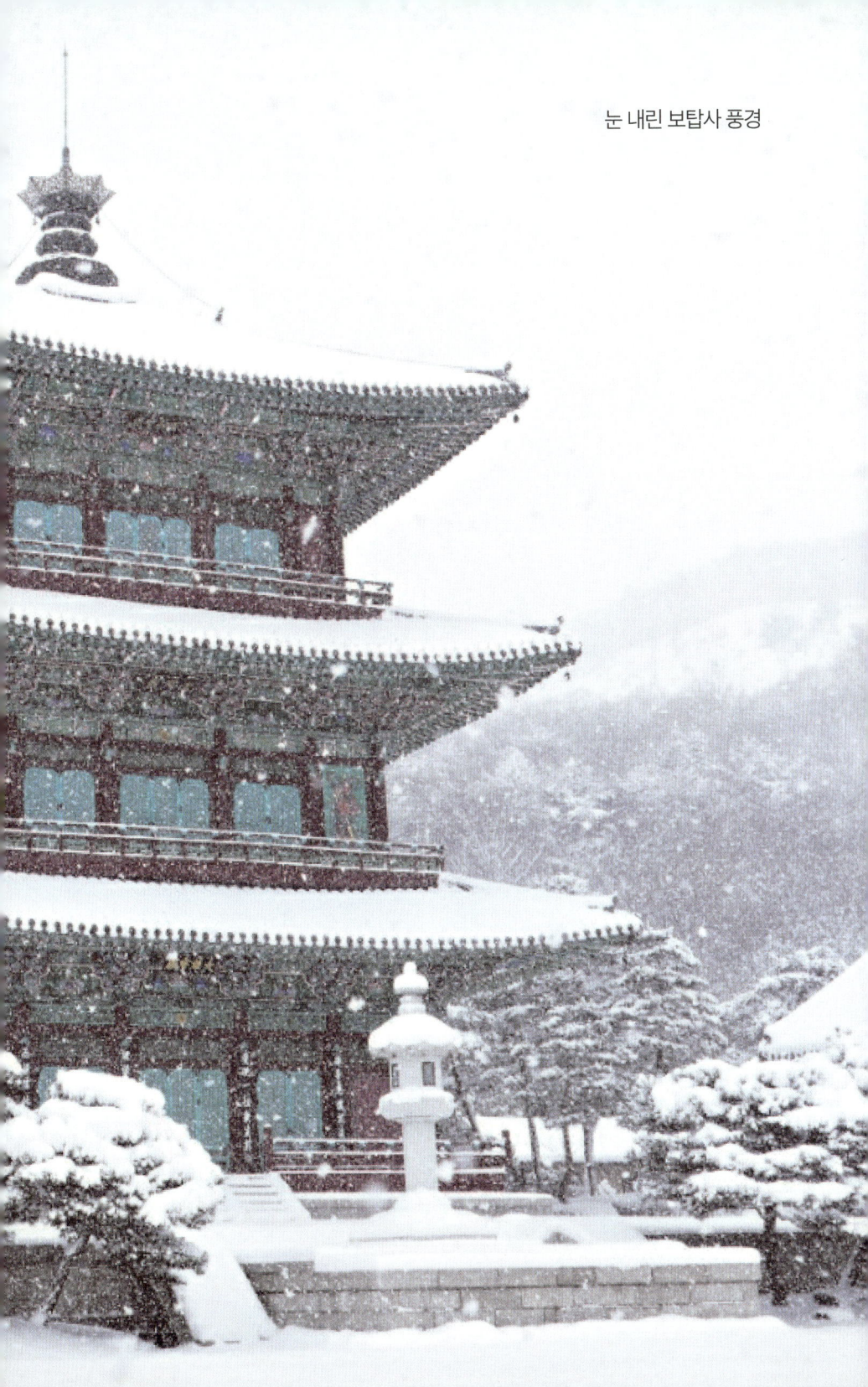

눈 내린 보탑사 풍경

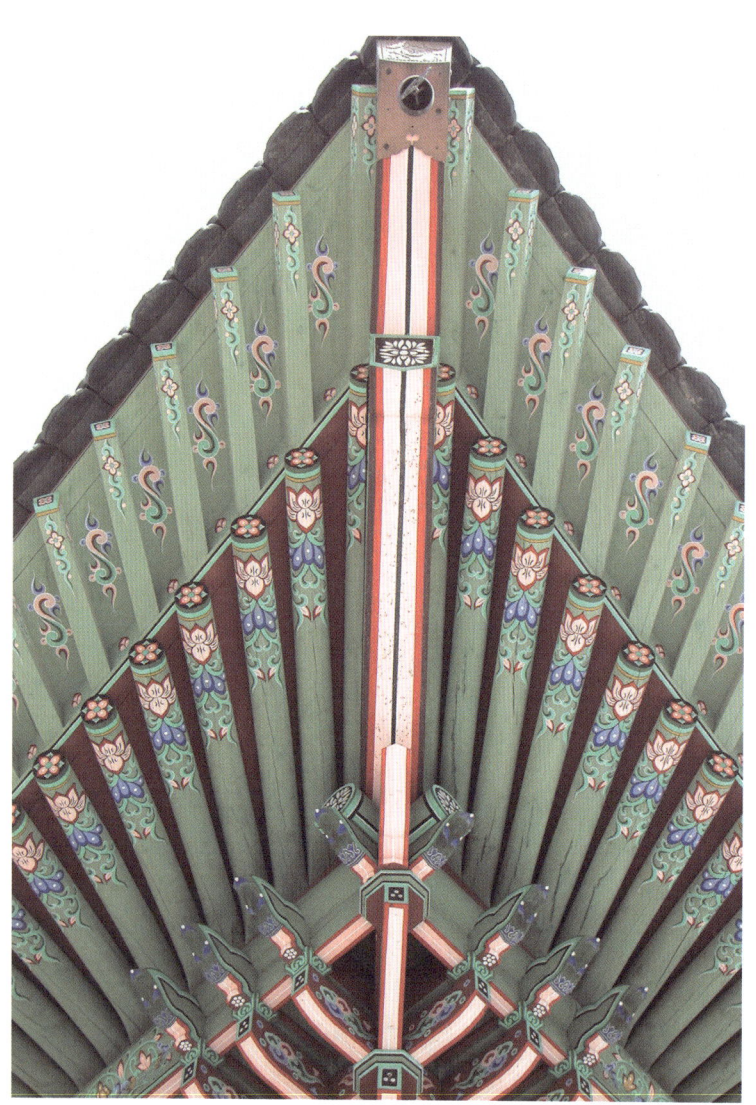

서 문

보탑사가 지어진 지도 30년이 훌쩍 넘었다.

지금껏 60년 가까운 세월 동안 한옥을 지으며 살아온 내가 가장 심혈을 기울인 작품을 꼽으라면 단연 보탑사를 택할 것이다. 그만큼 보탑사는 한옥 짓는 전통 방식을 고스란히 따랐다.

한옥이 우수하다는 사실은 이미 여러 방면에서 증명되었다. 무엇보다 한옥은 자연 친화적인 자재를 사용하기에 그 안에서 살아가는 사람이 건강한 생활을 영위할 수 있게 한다. 그럼에도 현대 사회에서 한옥은 크게 활용되지 못하고 있다. 그러다 보니 한옥을 짓는 소중한 전통 기술이 차츰 잊히고 있는 게 현실이다.

나는 내가 알고 있는 한옥에 대한 모든 지식과 경험이 남겨져 후손들에게 조금이나마 도움이 되길 바라는 마음이 간절하다. 이 책은 그런 마음에서 시작되었다.

한옥은 자연에 순응하고 화합한 집이다. 나는 아름다운 한옥이 더 많이 지어지길 원한다. 그리고 이 책이 한옥을 짓는 이들에게 보탬이 될 수 있기를 소망한다.

끝으로 보탑사를 지을 때부터 이 책이 나오기까지 많은 도움을 주신 보탑사 주지 능현 스님과 가산종합건설(주) 윤철중 님, 이상해 명예교수님, 정연상 교수님, 박무룡 소장님, 보수 기술자 김종남 님께 감사의 마음을 전한다.

추 천 사

무슨 세월이 이리도 빠를까? 내가 민학회民學會 답사 모임에서 행수 김영일을 처음 만난 지 어느덧 50년이라는 세월이 흘렀다. 민학회는 한국의 전통 풀뿌리 문화를 공부하는 모임이다. 문화재위원을 비롯해 전통문화계 인사들의 연구회지만, 나 같은 문외한도 함께하는 모임이다. 워낙 아는 게 많고 다변이자 달변이었던 그는 답사 때마다 구수한 경상도 사투리로 재미나게 설명해 주곤 했다.

그 후 나는 그와 오랜 우정을 쌓아 왔고, 그가 보탑사를 어떻게 지을지 고심하던 모습도 곁에서 지켜보았다. 인생 중반을 고스란히 보탑사에 바친 그는 목탑 건축에 완전히 미쳐 있었다. 공사를 하다 말고 연구해야 할 것이 생기면 일본이든 중국이든 어느 오지든 훌쩍 떠났다. 옆에서 지켜본 나로선 솔직히 그의 학구열에 기가 질렸다. 광적인 열정이었다. 그는 아름다운 광인이었다.

그렇게 완성된 역작, 보탑사의 준공식에 참석해 축사를 하게 된 나 역시 감격스러워 말이 나오지 않을 정도였다. 그간 그가 얼마나 수고하고 애썼는지 잘 알았기 때문이다. 보탑사 곳곳에는 그의 피와 땀, 혼이 스며 있다.

내가 이 글을 쓰는 건 우정에서만은 아니다. 그와 같은 열정을 지닌 장인들에게 경의를 표하기 위함이다. 그는 이 책에 자신이 경험하며 체득한 지혜를 담아 모든 사람과 공유하고자 하였다. 이 책이 빛나는 우리 전통문화의 맥이 계속해서 이어져 나가는 데 보탬이 되기를 기원한다.

2025년 3월
사단법인 세로토닌문화 원장 이시형

차 례

서문 13

추천사 14

들어가기 전에 18

1부

운명처럼 목탑을 세우다

목탑이 들어서면 안성맞춤인 자리 23

본격적인 목탑 연구 28

연꽃의 중심부에 심초석 놓기 39

전통 방식에 따라 땅 고르기 44

기능을 더해 기단 쌓기 50

통돌로 계단 놓기 54

나무 기둥 다듬기와 세우기 60

이음과 맞춤으로만 기둥과 보, 창방을 짜 올리기 68

하중을 견뎌 내는 공포 짜기 74

깊고 아름다우면서도 안정적인 처마 87

보첨 100

숨겨진 공간, 암층 103

연봉으로 장식한 기와 잇기 106

꼭대기를 장식하는 상륜 올리기 110

오래도록 빛나는 단청 118

층마다 개성이 넘치는 내부 모습 124

보탑사를 구성하고 있는 건물들 133

2부

한옥을 짓다

터 잡기 167

석재 선택하기 169

목재 제대로 고르기 176

기와 구입하기 181

기단과 주초석 단단하게 놓기 184

나무 기둥을 다룰 때 중요한 것 188

기둥에 벽선을 붙이는 세 가지 방법 193

창방과 보 올리고 걸기 196

공간을 지탱하는 공포 짜기 198

높이 쳐든 처마와 서까래 205

꼼꼼하게 기와 잇기 209

바닥이 따뜻한 구들 놓기 216

집의 중심, 마루 설치하기 220

몸을 건강하게 해 주는 토벽 미장하기 225

내부와 외부를 잇는 창호 달기 231

완성된 집에 색 입히기 235

한옥, 마무리 작업하기 237

글을 마무리하며 244

들어가기 전에

보탑사는 충청북도 진천군 진천읍 연곡리에 있는 보련산 자락에 자리 잡은 조계종 소속 사찰로, 서울 성북구 미아리 동선동에 위치한 삼선포교원 주관으로 창건되었다. 1991년 5월 12일에 시작된 공사는 목탑 건축에만 5년이라는 시간이 걸려 1996년 6월 9일에 완공되었고, 그 주변 건물의 완성까지는 총 23년이 걸린 대장정이었다.

서울이 끝나는 경계에서 보탑사까지의 거리는 약 108㎞이다. 보탑사를 감싸고 있는 보련산의 보련寶蓮은 '보련화', 즉 연꽃을 아름답게 이르는 말이고, 동네 이름인 연곡리蓮谷里 역시 '연꽃 골짜기'를 뜻해 연꽃처럼 감싸고 있다는 의미다. 풍수지리적으로 연꽃형인 이곳에 보탑사 목탑은 꽃술에 해당하는 위치에 세워졌다. 즉, 연꽃에 꽃술을 달아 준 셈이 되었다.

목조 건물에서 가장 큰 걱정거리는 벼락 문제이다. 불에 타기 쉬운 목재의 특성상 아쉽게도 오늘날까지 완벽하게 남아 있는 목탑 유적이 별로 없다. 지금으로부터 1,400여 년 전 신라의 수도 경주에 세워졌던 황룡사 9층 목탑 역시 591년 동안 서 있으면서 몇 차례 벼락을 맞아 중수되었다가 고려 고종 때인 1238년 몽골의 침략으로 불에 타

없어지고 지금은 터만 남아 있어 후손들은 그 모양을 추측해 볼 뿐이다. 따라서 충분한 기술이 계승되지 못한 지금에 와서 층고를 높인 목탑을 재현하기란 쉽지 않은 일이다. 그럼에도 보탑사 3층 목탑을 실현해 낸 것을 실로 다행스럽게 생각한다.

전통 시대에 만들어진 목조 다층 건물 중 현존하는 것은 조선 시대에 중건된 보은의 법주사 팔상전과 화순의 쌍봉사 대웅전 단 2개뿐이다. 팔상전은 5층이고 대웅전은 3층인데, 둘 다 내부에서 위층으로 올라갈 수는 없다. 황룡사 9층 목탑의 양식을 빌려 온 보탑사 3층 목탑은 유일하게 2층과 3층까지 사람이 오르내릴 수 있는 구조로 되어 있다. 보탑사 목탑은 기단基壇 9자, 탑신塔身 99자, 상륜相輪 33자로, 그 합이 141자에 이른다. 황룡사 9층 목탑이 225자이니, 그 절반을 훌쩍 넘는 높이다. 보탑사의 부지 규모는 약 1만 3,223㎡(4천여 평)이고, 연면적은 511.4㎡(155평)이며, 탑의 높이는 42.73m에 달한다.

보탑사 목탑은 삼국 통일의 대업을 이룬 신라의 황룡사 9층 목탑 이후 우리 땅에 다시 세워진 목탑으로, 한민족의 역량이 집약된 결정체라고 할 수 있다.

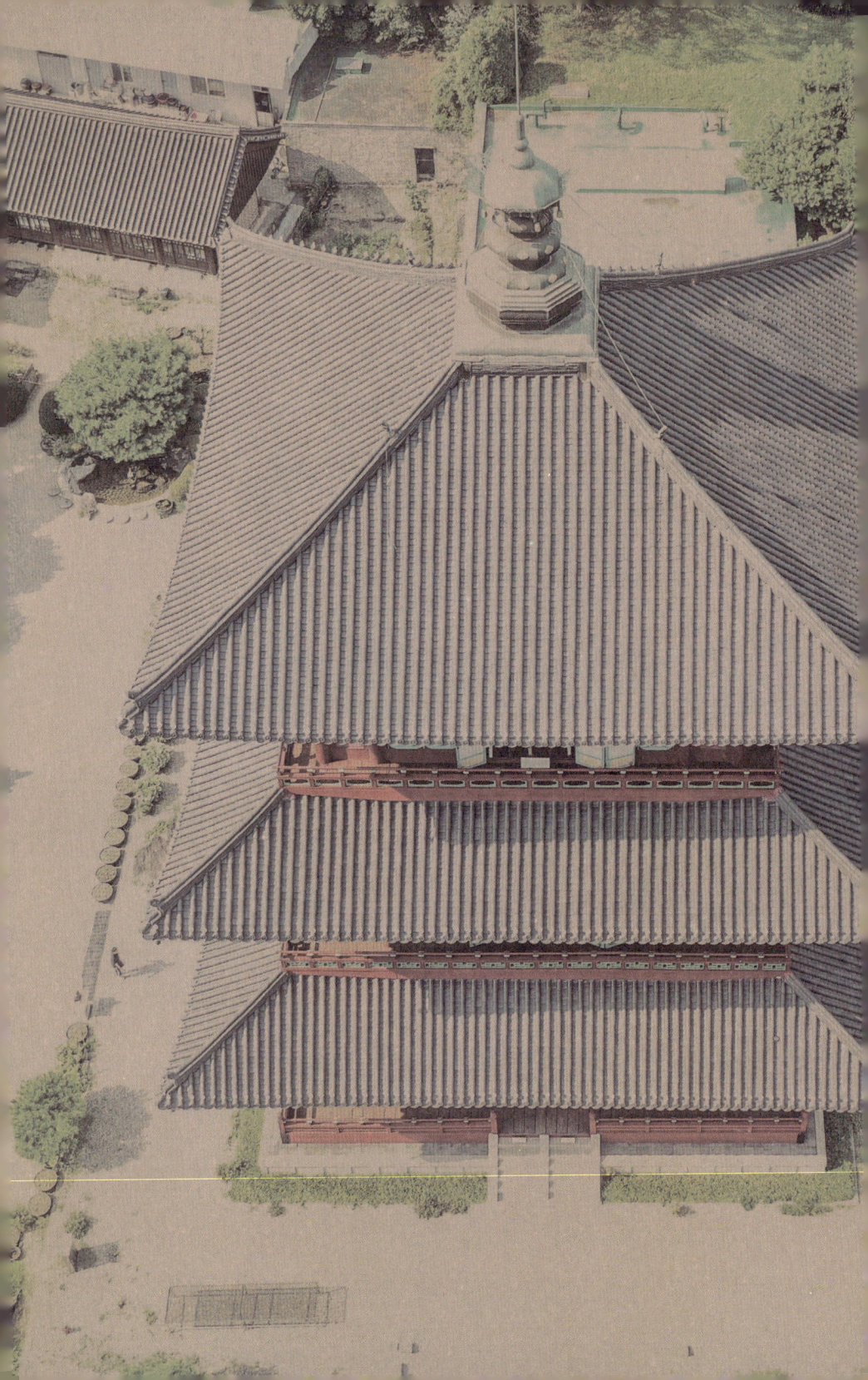

1부

운명처럼 목탑을 세우다

목탑이 들어서면 안성맞춤인 자리

보탑사와의 인연은 삼선포교원 시절로 거슬러 올라간다. 도시 포교당을 짓고 싶어 했던 지광 원장스님, 묘순 스님(현 삼선포교원 강사), 능현 스님(현 보탑사 주지스님)이 미아리에 포교원 건물을 새로 지으면서 문화재위원이었던 신영훈(1935~2020) 선생에게 이 일을 자문하셨다. 그때 나와도 인연이 닿아, 법당 앞마당에 검은색 벽돌로 전탑을 세우는 일을 내가 맡아서 했다. 전탑을 완성하고 난 뒤 공사비를 받았는데, 포교원 마당이 좁아 보였던 나는 남은 돈으로 마당을 넓혀 주었다. 그 뒤로 스님들은 삼선포교원에서 무슨 일이 생기면 무조건 나와 먼저 의논하셨다.

그러던 어느 날, 삼선포교원 주지이신 지광 원장스님이 나를 부

르셨다. 시골에 절을 하나 지어야겠으니 절터를 함께 보러 가자고 하셨다. 나는 지광 원장스님, 묘순 스님, 능현 스님을 모시고 진천으로 향했다. 그런데 막상 절이 들어설 터를 보니 나 혼자 섣불리 결정할 일이 아니다 싶었다. 그래서 스님들께 여러 전문가의 의견을 들어 보고 결정하는 것이 좋겠다고 말씀드렸다. 그렇게 당시 문화재관리국의 전문위원이며 충청북도 문화재위원이던 신영훈 선생, 태창건축설계사무소의 박태수(1935~2019) 소장과 함께 다시 진천을 찾아가게 되었다.

중부고속도로를 달리던 차는 진천으로 들어서서 내가 1975년에 현장 소장으로 일했던 김유신 태대각간의 사당인 길상사 앞을 지나갔다. 마침내 절터에 도착해 건물이 들어설 곳을 다시 찬찬히 둘러보니, 보련산 줄기에 둘러싸인 지형이 영락없는 연꽃 모양이었다. 절을 창건하기에 더없이 좋은 지형이었다. 잘생긴 산이 기름져 보였다.

터를 둘러보면서 절을 어떻게 지을지 서로 이런저런 의견을 나누었다. 그러다 문득 신영훈 선생이 여기다 목탑을 하나 세우면 좋겠다고 했다. 그것도 그저 목탑이 아니라 3층짜리 목탑으로 지으면 좋겠다고 말이다. 목탑은 전혀 생각지도 않았던 나는 깜짝 놀라 말했다.

"선생님, 3층으로 지으려면 단층짜리 세 채를 짓는 것보다 공사비가 몇 배는 더 들어갑니다. 더군다나 아직까지 아무도 해 보지 않은 일인 건 아시지요?"

보련산은 산줄기가 연꽃 모양의 형국을 이루는, 잘생기고 기름진 산이다.

"그렇긴 하지만 그렇다고 못할 건 없지요."

순간 나는 한 대 얻어맞은 사람처럼 멍해졌다. 서둘러 정신을 차리고는, 즉시 스님의 의중을 여쭈었다. 엄청난 일이라 스님의 동의가 없으면 그야말로 헛꿈에 불과한 일이었다.

"스님, 들으셨죠? 여기에 3층짜리 목탑을 지으려면 공사비가 수십억은 들 겁니다. 그만한 돈이 있으십니까?"

그러자 스님은 심상한 표정으로 말씀하셨다.

"5천만 원 있습니다."
"5천만 원이요? 아니 스님, 그 돈으로는 어림도 없습니다."
"목탑을 짓는 게 좋다면 목탑을 지어야죠. 5천만 원 가지고 시작하면 되지 않겠습니까?"

그렇게 말씀하시는 스님의 표정은 단호했다. 스님이 목탑을 지을 생각이 있으시구나 싶었다. 하지만 나로서는 선뜻 하자고 나설 수가 없었다. 그래서 다시 말씀드렸다.

"이건 돈이 많이 들어가니까 큰 회사와 하는 것이 좋겠어요. 저는 돈이 없습니다."

그랬더니 스님이 웃으며 말씀하셨다.

"그것 참 잘됐네요. 돈 없는 건축주와 돈 없는 시공자가 같이 하니 얼마나 좋습니까. 재미있겠네요."

돈 없는 건축주와 돈 없는 시공자가 의기투합하여 작업 한번 해보자는 스님의 말씀에 나는 큰 감동을 받았다. 사실 감히 엄두를 내지는 못했지만, 언젠가 한번은 목탑을 짓고 싶다는 생각은 전통 건축가라면 평생의 염원이 아닐 수 없었기 때문이다.

본격적인 목탑 연구

　3층 목탑이라는 엄청난 공사를 맡고 나서 부담이 없었다면 거짓일 것이다. 그렇게 목탑을 짓기로 한 후 우리는 본격적으로 연구를 시작했다. 목탑에 관한 각종 문헌 자료를 찾아 공부하면서 어떤 목탑을 세울지 밤낮없이 구상하였다. 그리고 목탑이 있는 곳이라면 국내는 물론이고 일본, 중국 등 어디든 돌아다니면서 내 눈으로 직접 보고 익혔다.

　내가 본 일본의 목탑들은 1층만 개방되고 위층으로는 사람이 올라갈 수 없는 구조였다. 일본 목탑이 층수만 높고 위로 올라갈 수 없는 이유는 목탑 내부에 부재들이 무수하게 얽혀 있어서 불상을 모시거나 사람이 들어갈 공간이 없기 때문이다. 그러니 암층暗層의 존재

가 있었는지도 알 수 없다. 일본에 현존하는 220여 개의 목탑 중에 1층이 아닌 위층에 공간이 구성되어 있는 사례는 없다고 한다.

중국 산시성 응현應縣에 있는 불궁사 석가탑(응현 목탑)은 5층까지 올라갈 수 있게 되어 있다. 그 역사만 거의 천 년에 이르러 현존하는 목탑 중에서 가장 오래되었고, 규모도 크며, 층마다 불상이 봉안되어 있는 팔각 목탑이다. 겉으로 보기에는 5층 목탑이지만, 내부의 층과 층 사이에 밖에서는 보이지 않는 암층이 있어 실제로는 9층이다. 암층이 존재한다는 것은 내부 계단을 통해 위로 올라갈 수 있는 목탑이라는 의미다. 그러나 아쉽게도 2층 암층은 최근 십여 년 전에 보수하는 과정에서 목재를 볼트로 지나치게 단단히 조여 오히려 더 불안정하게 보인다.

현재 국내에 남아 있는 다층 목구조 계열에 속하는 한옥으로는 조선 시대에 세워진 법주사 팔상전(5층)과 쌍봉사 대웅전(3층)이 있다. 이들 건물은 1층만 개방되어 있고, 위층으로는 사람이 올라갈 수 없다. 우리가 재현하고자 하는 목탑은 황룡사 9층 목탑처럼 내부 계단을 통해 위층으로 올라갈 수 있는 구조의 건물이었다. 하지만 백제의 장인 아비지가 지었다는 황룡사 목탑을 우리는 눈으로 직접 확인할 수 없다. 안타깝게도 고려 고종 때 몽골의 침략으로 불에 타서 없어지고 터만 남아 있기 때문이다.

절터의 규모와 문헌에 남아 있는 기록들로 볼 때 황룡사 9층 목탑

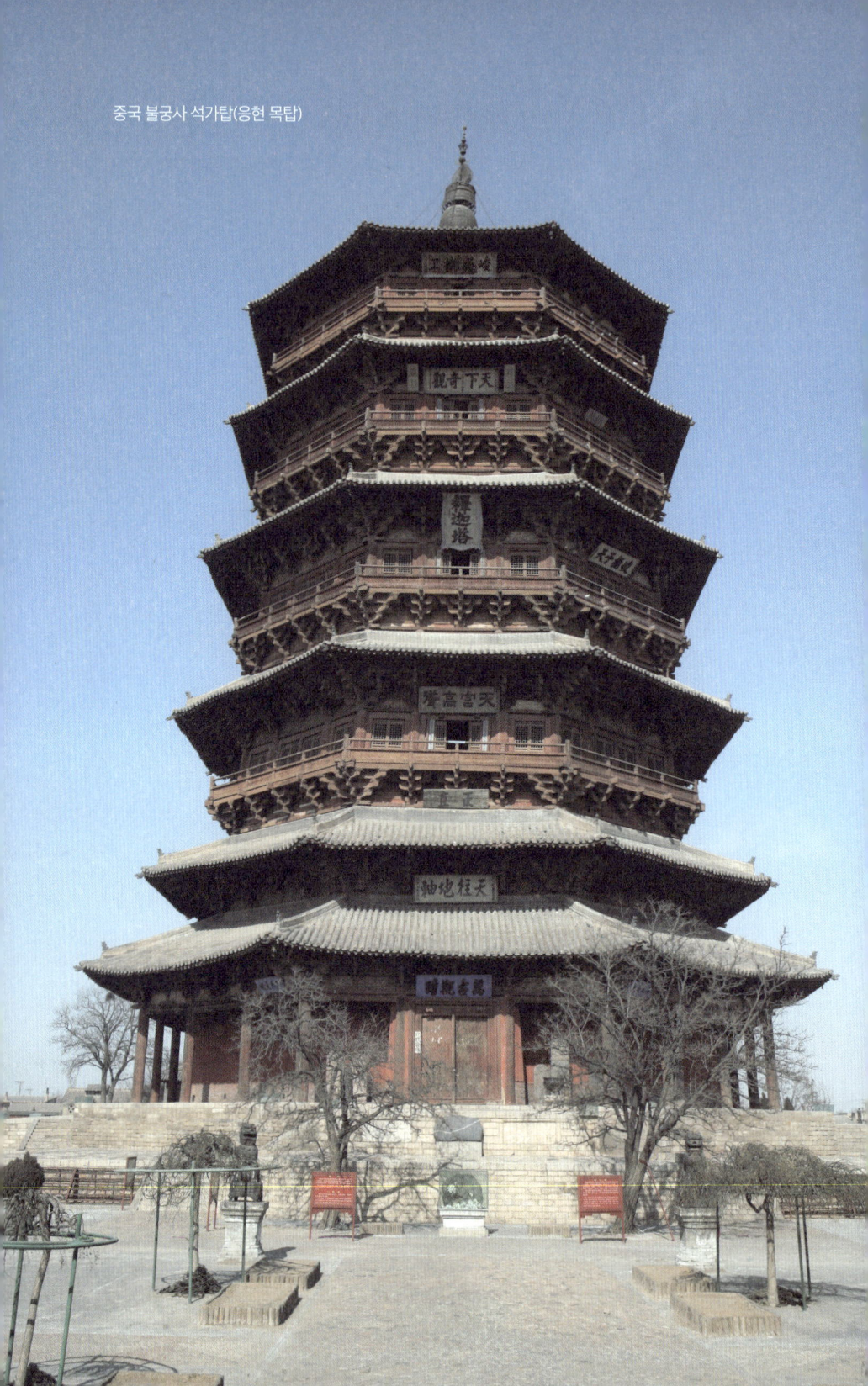

중국 불궁사 석가탑(응현 목탑)

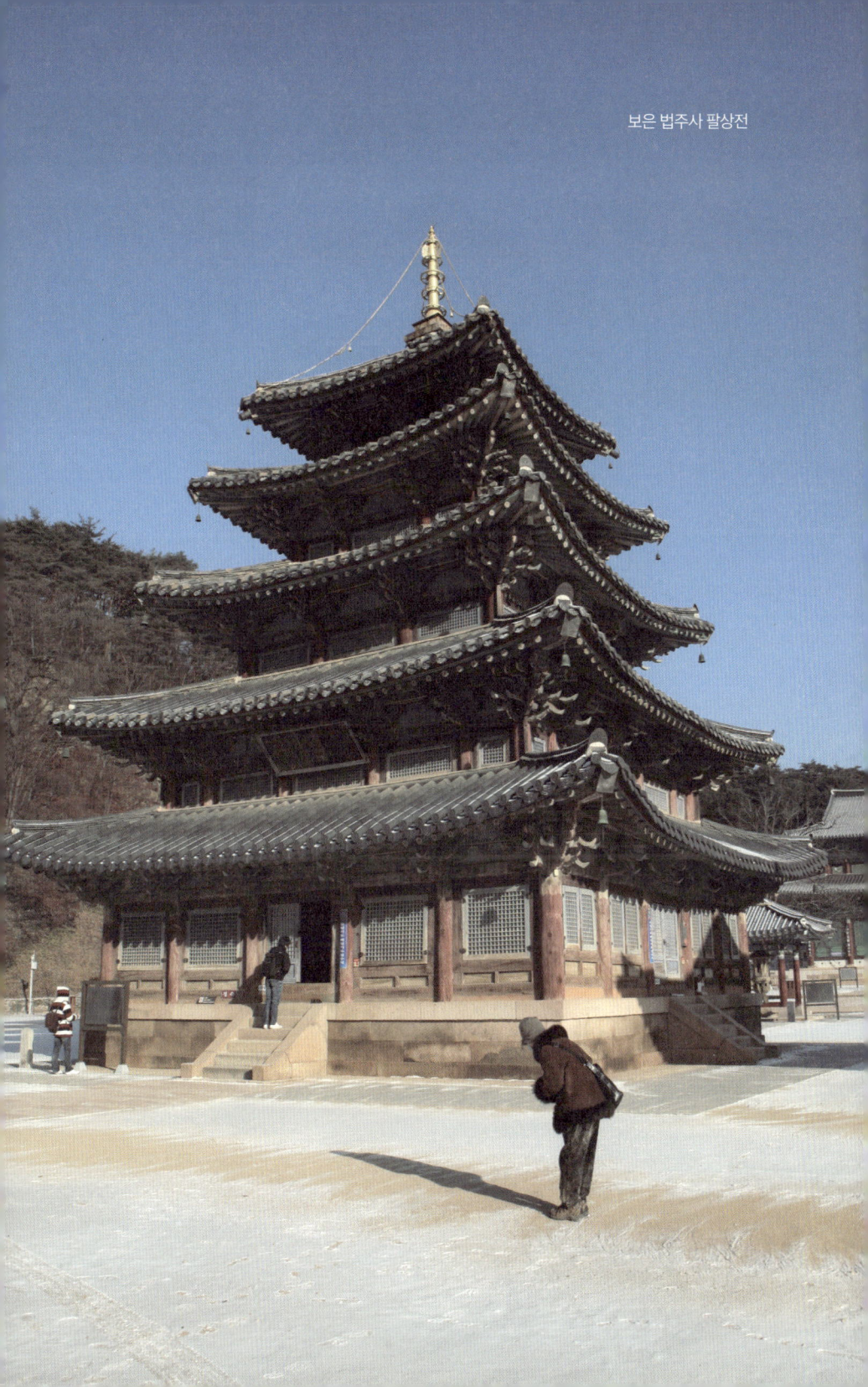

보은 법주사 팔상전

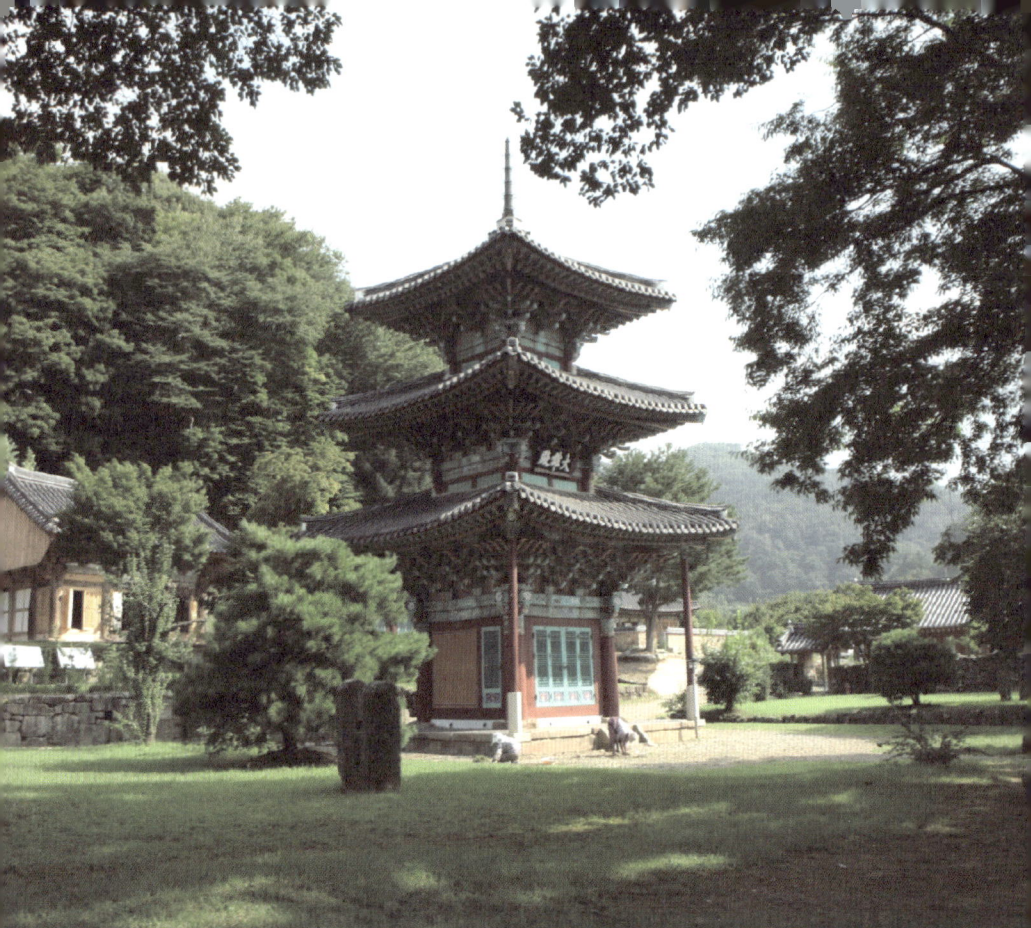

화순 쌍봉사 대웅전

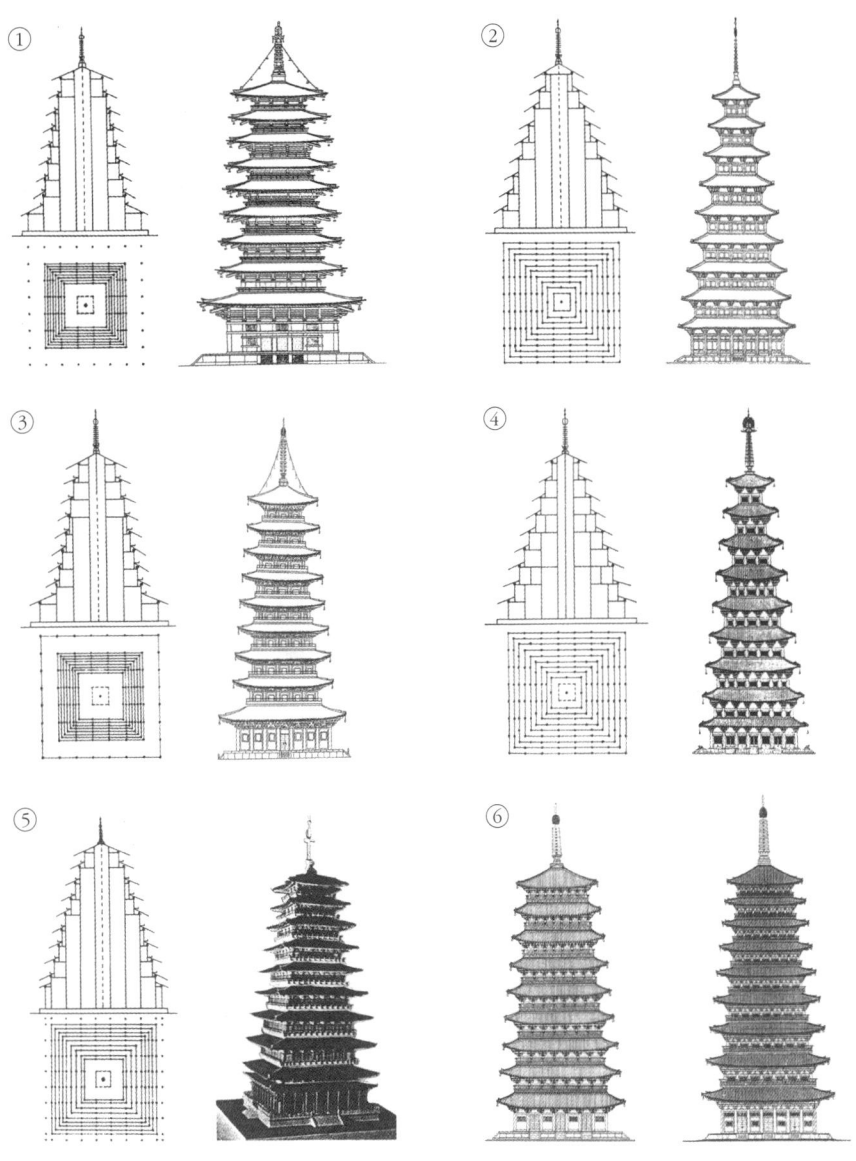

황룡사 9층 목탑 추정 복원도 및 구조 개념도 ① 후지시마 가이지로 ② 김인호 ③ 장기인 ④ 김정수, 박일남 ⑤ 북한 ⑥ 김동현의 복원도 (출처: 권종남, 《황룡사 구층탑》, 2006)

산치 대탑(위), 내부 모형(아래)

은 높이 183자, 상륜 42자로 전체 225자에 달한다. 이는 높이만 80m 가까이 되는 것으로 추산되는데, 아파트 27층 높이 정도가 된다. 그 시절에 이런 대단한 건축 기술을 가지고 있었다는 사실이 놀라울 따름이다.

목탑의 흔적은 고구려, 백제, 신라 삼국 모두에서 발견된다. 목탑에 관한 최초의 기록은 《삼국유사》에 나타난다. 고구려 성왕(동명성왕)이 요동성 밖에서 가마솥을 덮은 것 같은 모양의 아육왕탑을 발견하였는데, 나중에 그 자리에 7층 목탑을 세웠다는 기록이다. 여기서 고구려 성왕이 발견했다는 아육왕탑은 인도 스투파의 영향을 받은 초기 형태의 3단 토탑이었을 것으로 추정된다. 인도 스투파는 탑의 원형으로, 기단 위에 봉분이 올려진 형태다. 산치 대탑이 바로 인도 스투파의 대표적 형태다. 산치 대탑은 기원전 250년경에 인도 아소카왕이 사랑하는 연인을 위해 세웠다고 알려져 있다.

이처럼 여러 유형의 고대 탑의 흔적을 찾아 국내외 곳곳을 돌아다니고, 각종 문헌 자료를 살피면서 많은 공부를 하고 영감을 받았지만, 우리가 짓고자 하는 목탑에 딱 들어맞는 모델을 찾을 수는 없었다. 하는 수 없이 눈에도 보이지 않는 황룡사 9층 목탑의 건축 기법을 머릿속으로 상상하여 실현시킬 수밖에 없었다. 하지만 상상을 실현해 내는 일은 결코 쉽지 않다. 더군다나 확실한 모델이 없는 경우에는 더욱 그렇다. 자료를 찾아볼수록 답이 보이기는커녕 사람이 오르

경주 남산 탑골 바위에 새겨진 탑의 형상. 기둥이 있는 1층의 높이와 지붕이 있는 부분의 높이가 거의 같다.

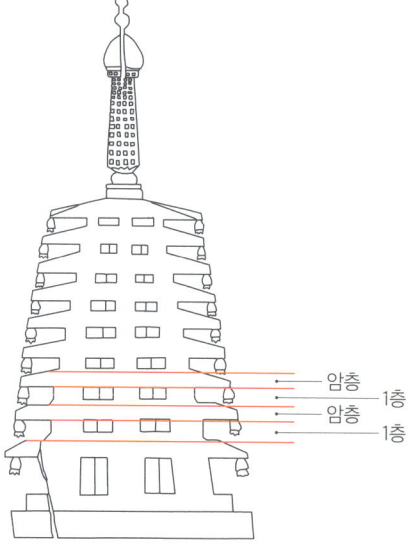

내릴 수 있는 3층 목탑의 실현이 미궁으로 빠지는 기분이었다.

그렇게 걱정하던 차에 경주 남산 탑골에 가게 되었다. 그곳에 있는 커다란 바위에는 부처님과 탑의 형상이 조각되어 있다. 그동안 열 번도 넘게 갔던 탑골이었는데, 그날따라 왠지 남다른 느낌이 들었다. 3층이라는 목표를 두고 고민하던 차라 조금 높은 곳에서 바위를 보면 어떻게 보일까 하는 생각에 사다리를 놓고 위에서 내려다보았다. 그랬더니 이제까지 보이지 않았던 그림이 눈앞에 펼쳐졌다. 기둥이 있는 1층의 높이와 지붕이 있는 부분의 높이가 거의 같았던 것이다. 그때까지 마음에 품고 있던 수수께끼의 정답을 알아낸 듯한 기분이 들었다. 바로 암층의 존재였다.

그렇게 1991년 5월 12일, 운명과도 같은 보탑사 공사의 첫 삽을 뜨게 되었다.

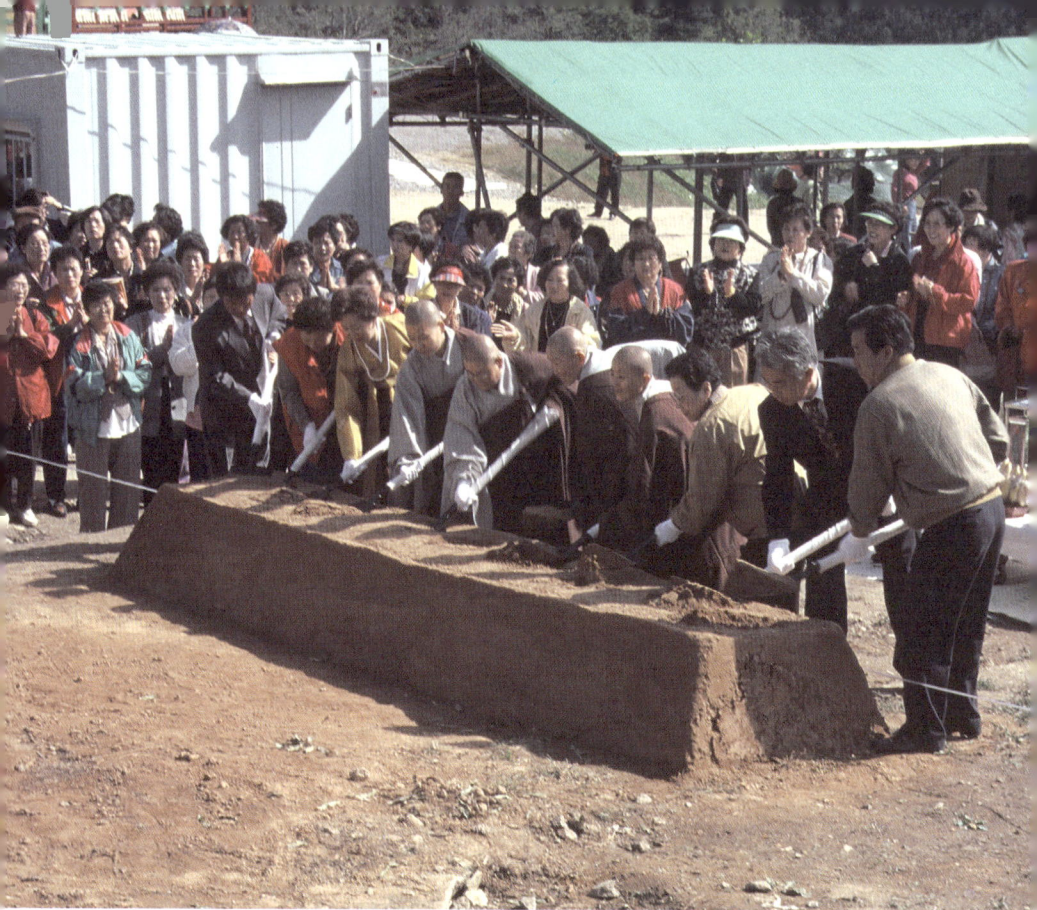

1991년 보탑사 공사의 첫 삽을 뜨다.

연꽃의 중심부에 심초석 놓기

보탑사를 지을 때 될 수 있으면 모든 단계에서 전통 법식에 기초하여 지으려고 노력했다. 그러다 보니 어찌 보면 사소할 수 있는 일에도 심혈을 기울이게 되고는 했다.

탑 중심부에 놓을 심초석心礎石 자리를 잡을 때도 그랬다. 중심부라 생각한 곳에 내가 장대를 수직으로 들고 서 있고, 신영훈 선생이 이 산 저 산으로 다니며 적확한 중심부를 찾으려 손짓하면 그에 따라 조금씩 움직였다. 하지만 시간이 길어지면서 장대를 쥔 팔은 아파 오는데, 주변 산을 온통 뛰어다니는 그의 손짓은 도무지 끝나질 않았다. 그렇게 긴 시간 애쓰며 중심을 잡기 위해 서로 고생을 했다. 그러다 마침내 말뚝을 박아도 좋다는 신호가 떨어졌다.

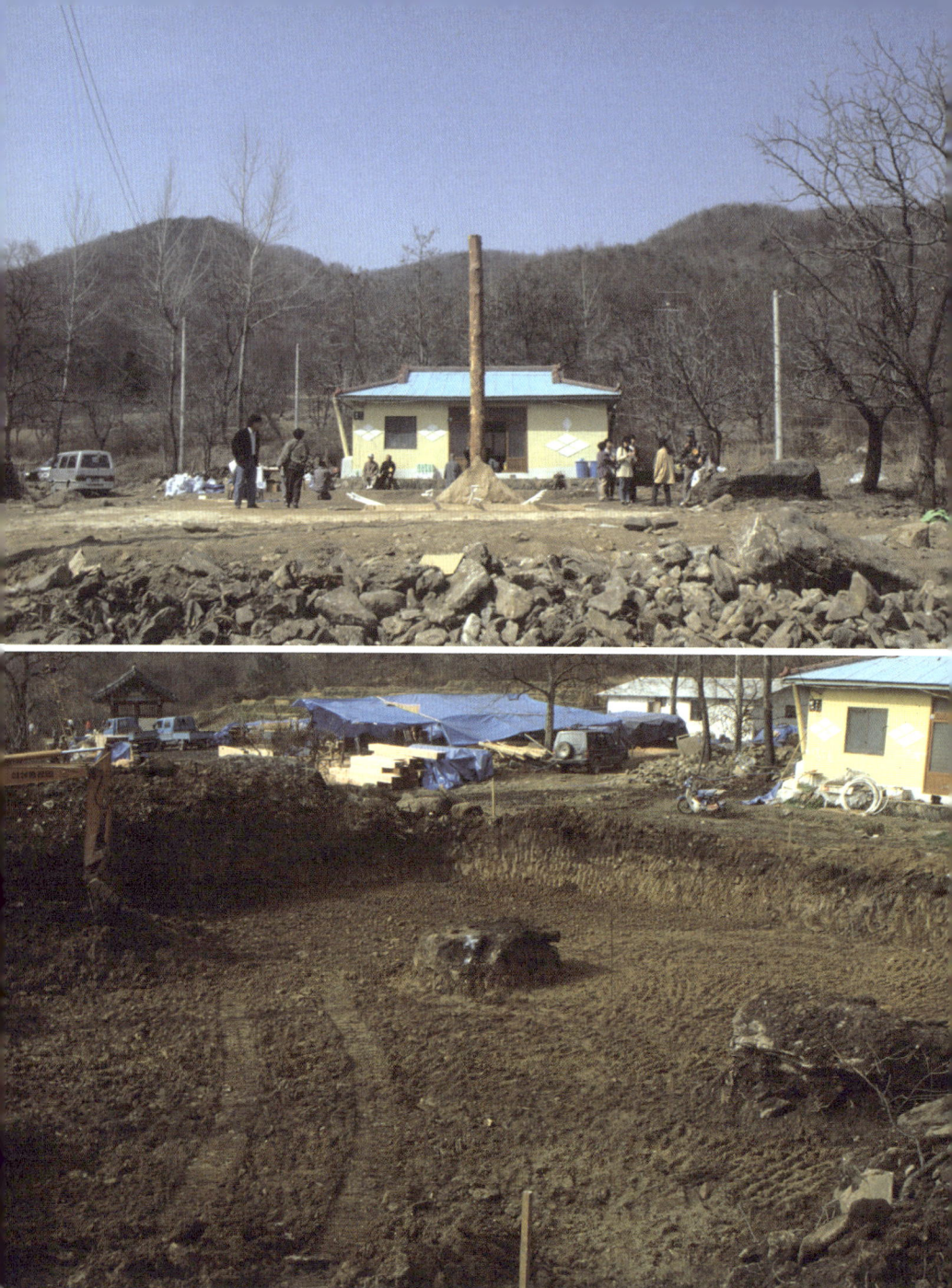

중심부에 박은 말뚝(위), 보탑사 목탑 자리의 땅속 심초석(아래)

심초석(사리함)

말뚝을 박고 기초를 다지기 위해 그 자리를 파다 보니 땅속에서 큼직한 바위 하나가 나왔다. 중심부에 놓을 심초석이 이미 그 위치에 자연적으로 자리를 잡고 있었던 것이다. 우리가 박은 말뚝은 용케도 바위에 생긴 틈새에 박혀 있었다. 말뚝의 위치는 바위 중심부에서 고작 13㎝ 벗어나 있었다. 이런 일은 사람의 뜻대로 일어나는 일이 아니다. 땅속을 들여다보지 않고서야 어떻게 이런 일이 가능할 수 있겠느냐고 흥분했던 기억이 떠오른다.

실제로 그 천연 바위를 심초석의 기반으로 이용했다. 그 자연석 초반 위에 하얀색 화강암을 다듬은 심초석(사리함)을 세웠다. 넙데데하고 펑퍼짐하게 만드는 보통의 심초석과 달리, 보탑사 탑의 심초석은 짧은 팔각기둥으로 만들었다. 그러다 보니 세웠다는 표현이 더 잘 어울렸다. 심초석을 그렇게 만든 이유는 스리랑카에서 모셔 온 부처님 진신사리를 봉안하기 위해서였다.

터 주변에는 크고 작은 바위들이 있었는데, 탑 서편에 있는 바위도 원래 그 자리에 있던 것을 그대로 활용했다. 그 바위는 공사 중에 위치나 높이를 표시하는 기본 표석 구실을 해 준 고마운 바위였다. 그러니 바위에 대한 보답이라는 생각으로 탑이 완성된 후에도 그 자리를 지키게 했다. 잘한 결정이었는지, 그 바위는 지금 지장전 옆에서 뭇사람의 시선을 받으며 자랑스럽게 서 있다.

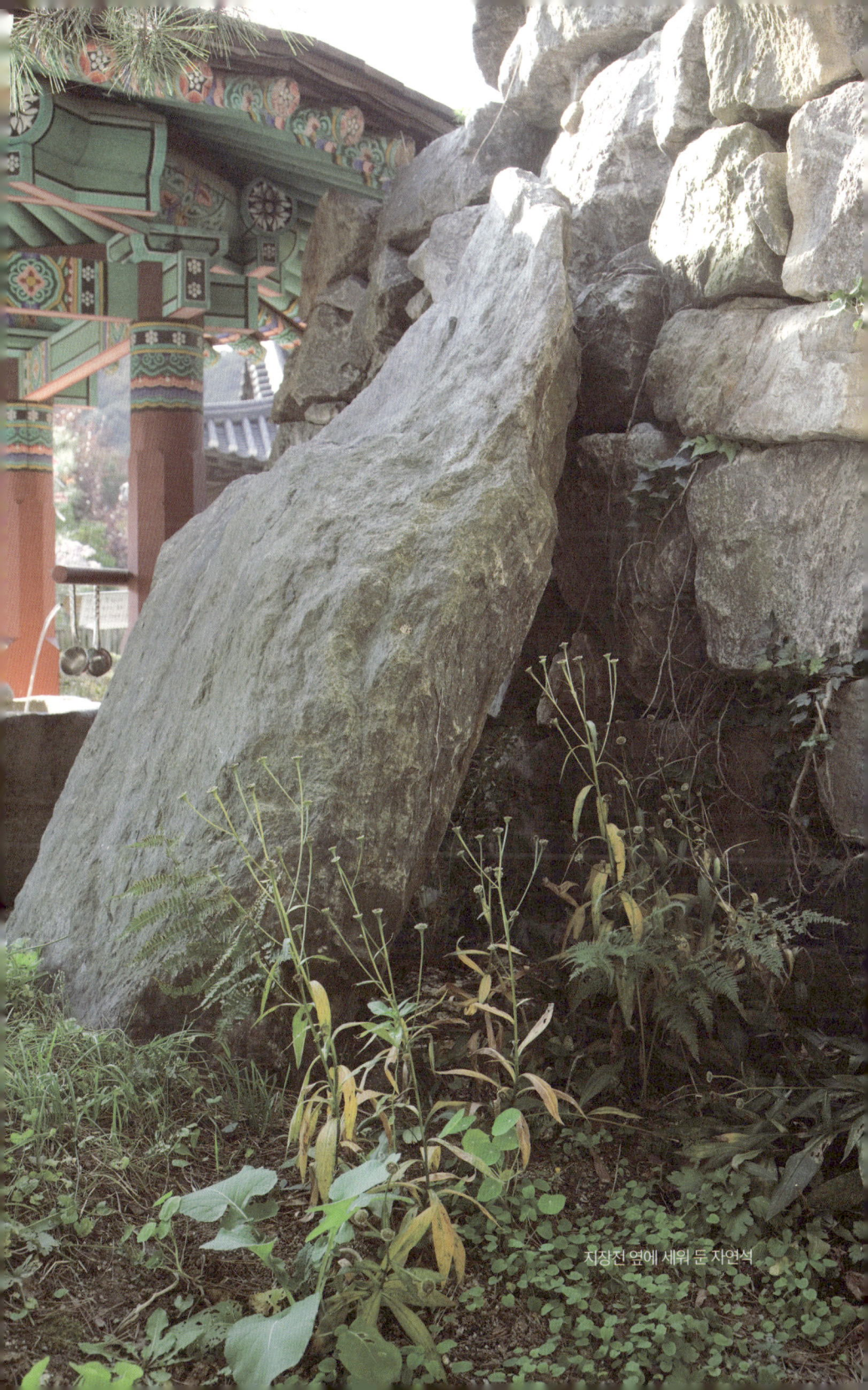

지장전 옆에 세워 둔 자연석

전통 방식에 따라 땅 고르기

목탑 자리는 원래 연못이었다. 장대를 중심으로 기초하기 위해 땅을 걷어 내고 나니, 지구가 생긴 이래 단 한 번도 사람의 손길이 닿은 적 없던 흙이 모습을 드러냈다. 그곳에는 앙금이 가라앉은 개흙이 상당한 퇴적층을 이루고 있었다. 자연이 만들어 준 입사기초立砂基礎였다. 이 기반을 활용하기로 했다. 주초를 놓을 자리만 원토층까지 파내고 석비레(푸석푸석한 돌이 많이 섞인 흙)로 입사기초하였다.

걷어 낸 땅 위로는 잡석을 차로 실어 와 바닥에 깔고, 모래를 부어 넣었다. 그렇게 흙다짐하고는 그 위에 나무틀을 짜 규준틀을 놓고, 비닐을 덮어 물이 새지 않게 한 뒤 물을 모았다. 그렇게 모은 물은 한꺼번에 쏟아부었다. 이는 모래를 잡석 사이사이로 촘촘하게 가라앉혀

잡석다짐(위), 입사기초(아래)

땅을 튼튼하게 다지기 위해서였다. 사람이 아닌 물이 땅을 다지게 한 것이다.

이때 사용되는 흙은 일명 마사토다. 화강암이 오랜 시간 풍화되면서 만들어진 흙의 한 종류다. 우리가 흔히 아는 모래보다는 입자가 커서 '굵은 모래'라고도 불린다. 배수가 잘되고 통기성이 좋은 흙으로 세균이 거의 없어 식물을 키울 때나 지반을 다지는 용도로 자주 사용된다.

잡석 사이를 모래로 꽉 채워 다지는 데 6개월이 걸렸다. 이렇게 기초를 다져 놓으면 100년이 훨씬 지나서도 끄떡없는 건물이 되리라고 생각했다. 보탑사 목탑은 이처럼 기초에서부터 상륜 설치에 이르기까지 철저하게 옛 기법을 지키며 지었다.

보탑사 목탑을 지으면서 가장 신경 썼던 부분은 튼튼하고 안정적인 기초 공사와 하중을 견딜 수 있는 내부 구조, 부재 간의 견고한 결구였다. 물론 이는 건물을 지을 때 당연히 신경 써야 할 부분이지만, 보탑사의 경우 규모가 크고 3층 목탑이라는 양식이 현대에 들어서 처음 시도된 것이었기에 더욱 공을 들일 수밖에 없었다.

그 다음으로 신경 쓴 부분이 목탑과 자연의 조화였다. 자연과의 화합은 내가 집을 지을 때마다 하는 고민이다. 안개가 잔뜩 낀 날이면 비행기가 뜨지 못한다. 아무리 서둘러 비행기를 이륙시키고 싶어도 인간의 힘으로는 안개를 걷을 수 없다. 하지만 이런 무소불위의 힘을

가진 것만 같은 안개도 햇빛만 나타나면 다소곳하게 사라지고 만다. 자연의 순리. 집을 지으려면 그런 자연의 법칙을 알아야 했다. 더구나 목탑을 3층으로 짓겠다고 시작한 나는 이러한 자연의 법칙을 제대로 이해해야 했다.

지금은 대형 건물도 손쉽게 쑥쑥 지어 버리지만 옛날에는 나무 한 그루를 심더라도 인간이 자연과 더불어 사는 방법을 택했다. 지금과 같은 기계적 장비가 없었던 탓이었을까? 바람이나 눈, 비, 불과 같은 자연재해를 피하기 위해 자연과 더 친해져야 했다.

그중 하나로 옛날에는 마을 입구에 커다란 느티나무를 심었다. 몇 백 년에 걸쳐 우람하게 자란 느티나무는 마을로 들어오는 큰 바람을 산들바람으로 바꾼다. 그렇게 바꾼 바람은 곡식을 땅에 널어도 될 정도로 부드러워진다. 회오리바람이 자주 지나는 길에는 장승을 세우거나 대나무를 심어 바람을 막았다. 그렇게 옛날에는 집과 집 주변 구조물들 사이로 바람길을 만들어 강풍 피해를 막았다.

보탑사 입구에도 300년이 넘은 커다란 느티나무 한 그루가 서 있다. 목탑의 위치를 정할 때 그곳에서부터 타고 올라온 바람이 산들바람으로 바뀌어 목탑과 목탑 주변의 부속 건물들을 바람개비처럼 휘감아 지나가도록 했다. 그랬다. 자연을 읽고, 바람길 하나까지도 섬세하게 따져서 목탑을 세웠다. 자연 속에 머물도록 하려면 자연과 더불어 지내는 법을 알아야 한다.

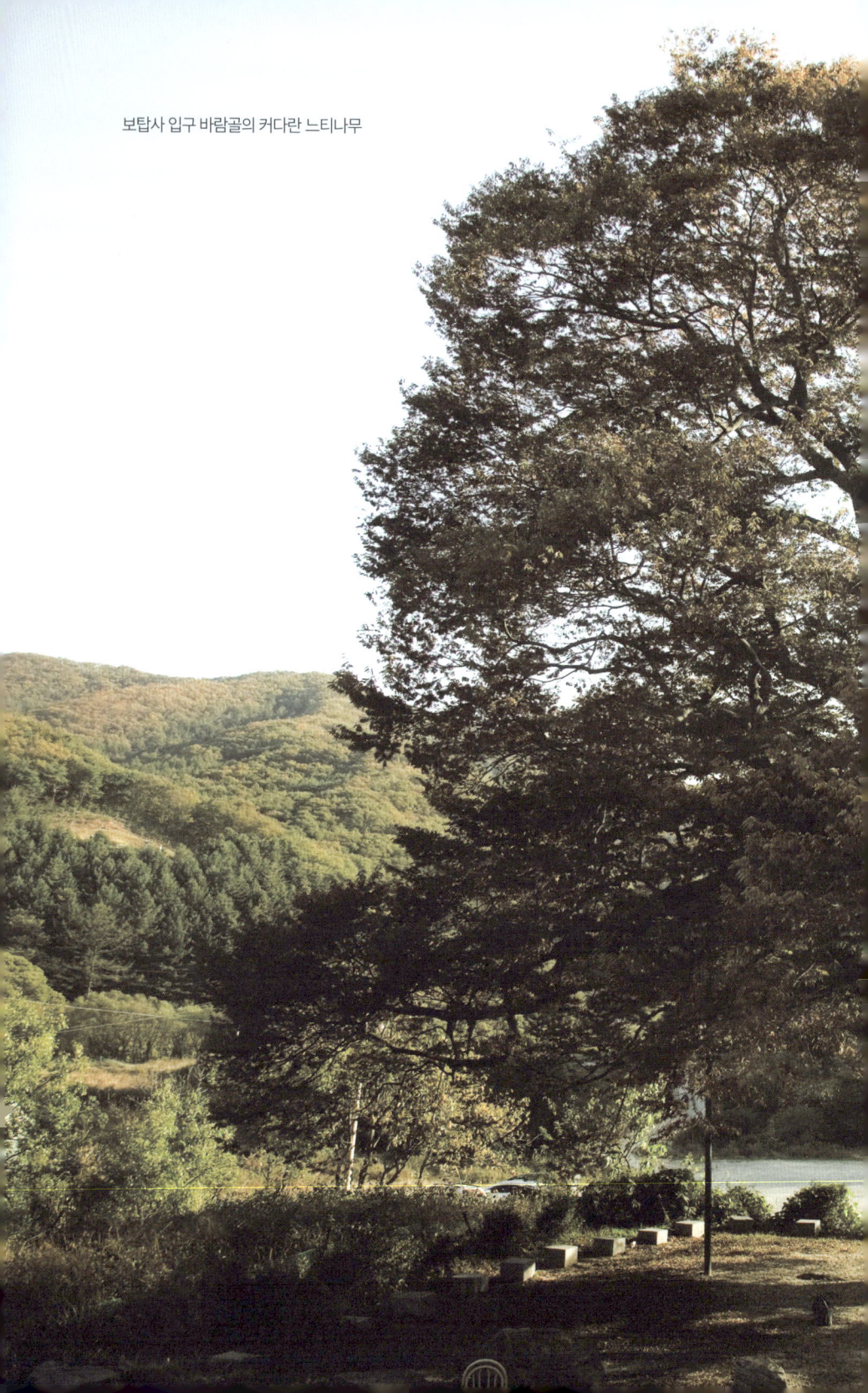

보탑사 입구 바람골의 커다란 느티나무

기능을 더해 기단 쌓기

　기단은 집이나 탑 등의 건축 구조물에 기초가 되도록 놓은 단을 말한다. 오랜 옛날 최초의 주거 형태는 땅을 파고 낮은 지붕을 씌운 움막 형태였다. 그러다 점차 건물 짓는 기술이 발달하고 생활양식도 변하면서 지붕이 들리고 땅에는 기단을 놓아 바닥 높이를 높이기 시작했다. 특히 한옥과 같은 목재 건물의 경우 땅에서 올라오는 습기를 막고자 기단을 쌓았다.
　높이 30㎝의 돌로 기단을 설치할 때는 맨 아래에 놓는 돌은 높이의 3분의 1에 해당하는 10㎝만 보이도록 하고 나머지 20㎝는 땅속에 묻고, 그 위에 3단으로 돌을 놓는 것이 일반적이다. 이처럼 기단을 '3단+1/3'로 조성하는 이유는 기능적인 의미보다는 상징적인 의미가 더 크다. 내가 사는 집이 땅에서 솟아올라 하늘로 올라간다는 의미,

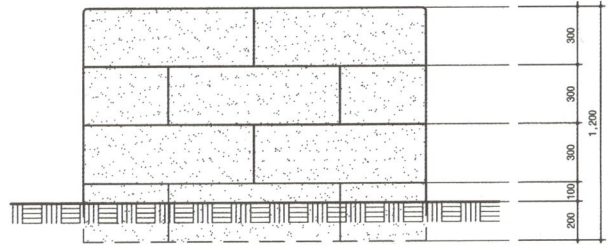

기단 설치 시 높이

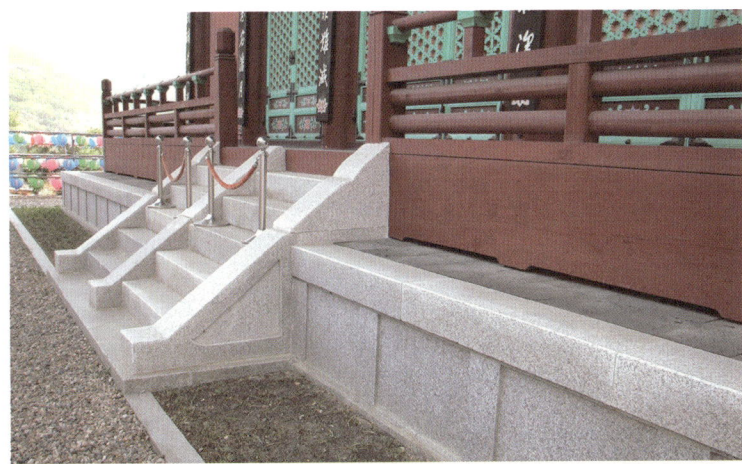

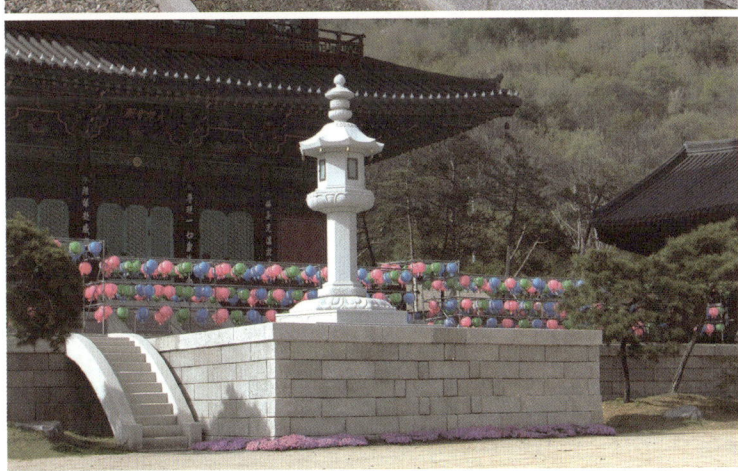

즉 상승세가 지속되어 계속해서 올라가는 중이라는 진행 상태를 표현하는 것이다. 그런 바람을 담아 기단은 항상 '3단+1/3', '5단+1/3' 등 '홀수단+1/3'로 쌓는다.

　기단을 놓은 후에는 기둥을 세우기 위한 주초석柱礎石을 놓는다. 주초석은 기둥을 세울 때 밑을 받치는 돌로, 초석 혹은 주춧돌이라고도 한다. 나무로 된 기둥을 바닥의 습기로부터 보호하며, 기둥이 받는 건물 전체의 하중을 땅으로 전달하는 역할을 한다.
　주초석을 세울 때는 높이 1자(30.3㎝)를 기준으로 밑변보다 윗변의 길이가 10분의 1씩 줄어들게 민흘림으로 만드는 것이 일반적이다. 주초석 위에 나무 기둥을 세울 때는 주초석과 기둥이 맞붙도록 꼭 그랭이질을 해야 건물의 뒤틀어짐이 적고 오래간다. 그랭이질이란 주초석 위에 놓이는 나무 기둥이나 돌 등의 아랫부분을 주초석 모양에 맞추어 깎아 올려놓는 수법이다.
　보탑사 목탑의 주초석 넓이는 가로세로 6자(1.8m)로 설치하였고, 전통적인 법식을 따랐지만 조금 더 추가해서 놓았다. 화강석을 여러 개 겹쳐 쌓아 올리고, 그 사이에 동글동글한 직경 5~10㎜의 콩자갈을 깐 것이다. 일종의 내진 설계에 속하는 기법으로, 땅속에서 지진의 충격이 가해져도 콩자갈이 횡으로 움직이면서 그 충격을 흡수하게 된다. 단층짜리 일반 한옥이라면 이렇게까지 하지 않아도 되지만, 보탑사 목탑은 규모가 크기에 이런 내진 장치가 꼭 필요하다고 판단했다. 이것은 주초석의 기본 역할에 새로운 기능을 더한 것이다.

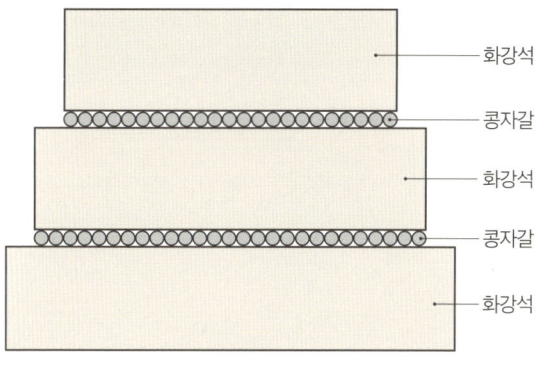

주초석 놓기

보탑사 목탑의 주초석

통돌로 계단 놓기

목탑이라도 기단과 주초석 등은 견고함을 위해 자연석이나 화강암 같은 돌을 사용한다. 이 외에도 돌을 이용한 공사에는 계단 놓기가 있다. 계단은 돌을 이용해 기단이나 석축을 쌓듯이 만들기도 하고, 커다란 통돌을 그대로 가공해서 만들기도 한다. 물론 나무를 깎아서 계단을 만드는 경우도 많다.

보탑사의 계단은 특별히 커다란 화강석 통돌을 구해 일일이 모양을 내어 깎아 만들었다. 90년대에는 기계가 좋지 않아서 석공 3인이 계단 하나를 만드는 데 3개월이 걸렸다. 계단에 무늬를 새기면 아름답기도 하거니와 사람이 오르내릴 때 미끄럼 방지 효과도 있다. 특히 보탑사 1층 금당으로 오르는 서편 출입 계단에는 연꽃무늬를 새겨 사

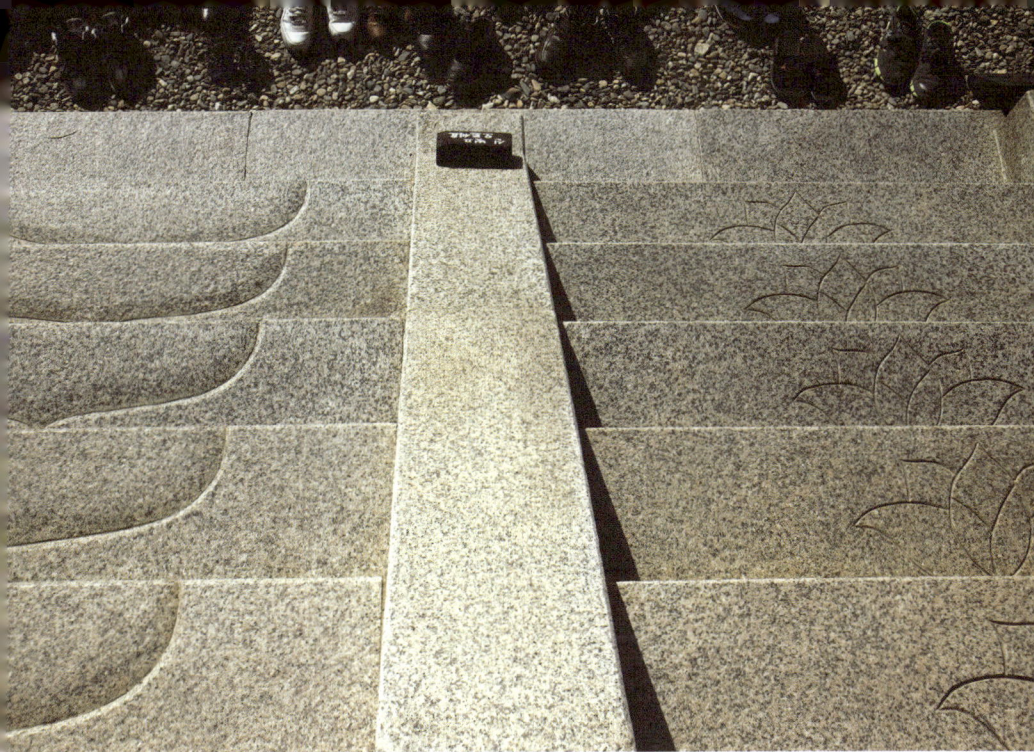

오르는 계단에는 연꽃무늬를, 내려오는 계단에는 연잎무늬를 새긴 금당의 계단

바세계에서 정토로 오르라는 뜻을 담았고, 내려오는 계단에는 연잎 무늬를 새겨 사바세계로 나와서도 부처의 마음으로 맑게 살라는 뜻을 담았다.

이처럼 우리 선조들은 한옥을 지을 때 곳곳에 여러 상징과 은유를 넣었다. 특히 위로 올라가려는 기질과 사상을 반영해 구름 모양을 많이 새겼는데, 이는 구름 위에 짓는 집이라는 것을 상징했다. 그래서 기단을 쌓을 때도 솟아오른다는 뜻을 담은 것이다. 보탑사에도 기단과 계단 등 곳곳에 연꽃과 꽃잎무늬, 구름 문양 등이 새겨져 있다.

한옥의 계단은 일반적으로 3단이나 5단 혹은 7단으로 만든다. 경우에 따라서는 4단이나 6단으로 만들기도 하지만, 계단을 올라갈 때 먼저 내딛는 쪽의 발을 끝날 때도 내디딜 수 있도록 홀수로 맞추는 것이 좋다.

그리고 계단 바닥에 작은 구멍을 뚫고 그 밑에 배수구를 설치하여 계단에서 흐르는 물의 일정 부분은 계단 밑으로 빠지도록 했다.

계단 높이는 3-4-5공법을 써서 계단 폭이 1자(30㎝)일 때 계단 높이는 21㎝가 되도록 만들었다. 이 정도의 높이가 사람 건강에 좋다. 집에서도 운동 효과를 얻을 수 있도록 한 것이다. 옛날에는 집 안에서 걸어 다닐 때도 다리를 높이 들라고 문지방을 높게 만들기도 했다. 그런데 요즘은 계단 높이가 15~18㎝ 정도로 낮아지는 경향이 있다. 시대의 변화에 따라 점차 편의성을 고려하였기 때문이다.

구름 문양을 새긴 계단

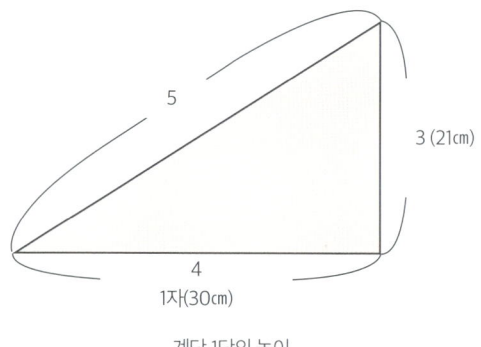

계단 1단의 높이

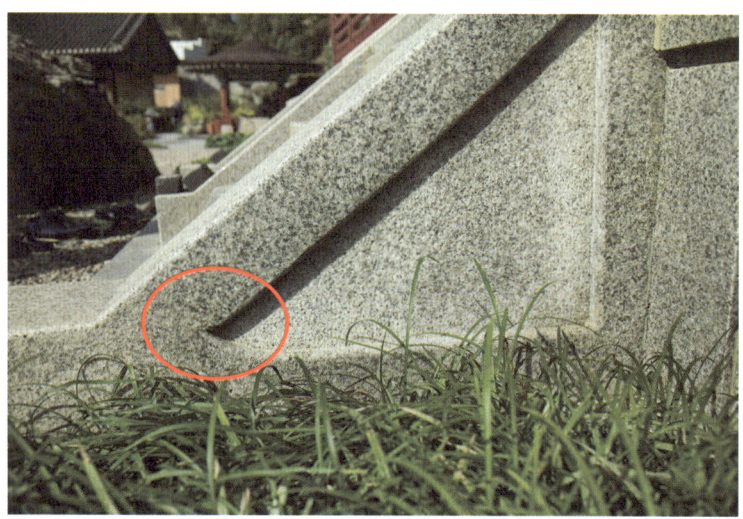

계단 옆면 삼각형의 한쪽 모서리가 버선코 모양으로 살짝 올라가 있다.

이런 점이 조금 아쉽다. 물론 계단 높이를 꼭 21㎝ 정도로 하라는 법칙은 없지만, 계단과 문지방을 높게 했던 깊은 뜻을 알고는 있으면 좋겠다.

간혹 한옥 구조가 불편하다고 불평하는 사람들이 있는데, 그런 불편함 속에는 우리 몸을 생각하는 선조들의 의도가 숨어 있었다는 것을 알았으면 한다.

한편, 보탑사 계단 소맷돌의 옆면을 자세히 보면 직각삼각형의 한쪽 모서리 끝이 살짝 올라가 있다. 자칫 날카롭고 딱딱하게 느껴질 수 있는 것을 버선코 모양으로 부드럽게 표현한 것이다. 불국사 대웅전과 극락전으로 오르는 계단 옆면에도 이렇게 버선코 모양으로 표현되어 있다. 눈에 잘 띄지 않는 곳에서도 아름다움을 추구한 것이다.

나무 기둥 다듬기와 세우기

 목탑은 목조 건물인 만큼 목재가 차지하는 비중이 가장 크다. 그러니 좋은 목재를 고르는 일이 무엇보다 중요하다. 늦가을이나 초겨울에 벌목한 목재는 영양분도 많고 나무 속이 꽉 차 더 강하고 오래간다. 목재를 구입한 다음에는 잘 다듬어야 한다.

 나무 기둥을 치목治木할 때 주의할 점은 나무가 자라면서 서 있던 원래 방향대로 위아래를 맞춰야 한다는 것이다. 비록 베어졌지만 여전히 나무의 기운을 가지고 있기에 나무 기둥은 하늘과 땅의 방향을 맞추어 바로 세워야 잘 썩지 않는다. 또한 나무가 베이기 전에 서 있던 양지와 음지, 즉 남쪽과 북쪽의 방향도 맞춰서 세워야 기둥이 덜 트고 덜 갈라진다. 나무가 자라던 상태, 바로 자연 상태 그대로 해 주

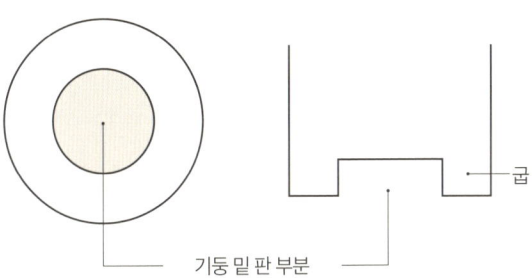

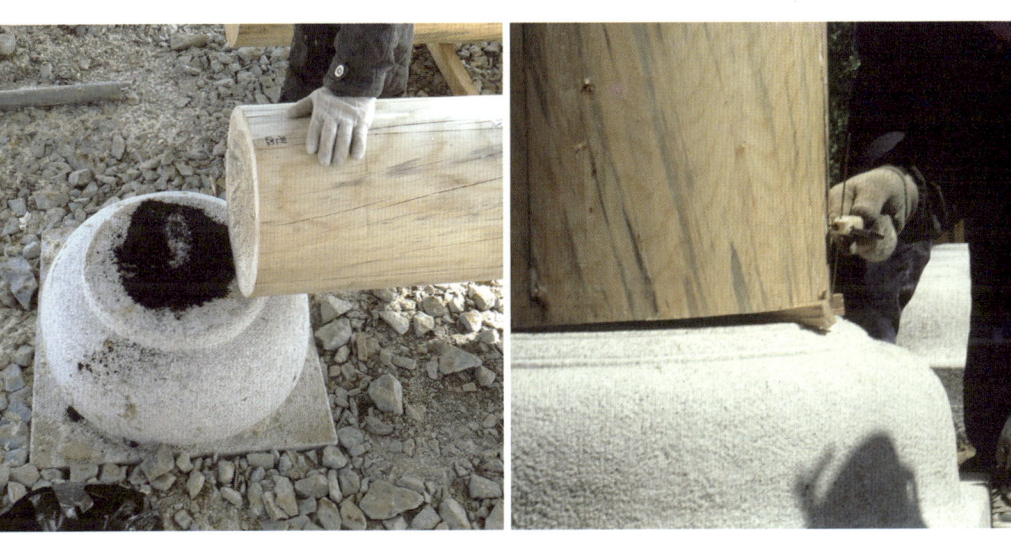

기둥 굽 안쪽에 소금과 숯을 넣어 벌레를 막는다(왼쪽), 그랭이질(오른쪽)

는 것이 좋다.

　기둥을 세울 때는 움직이지 않도록 기둥 밑을 그랭이질 하여 세운다. 굽 안쪽 빈 공간에 소금과 숯을 꽉 채워 두면 벌레가 붙는 걸 막아 준다. 나무에는 보통 두 종류의 벌레가 붙는다. 한 종류는 나무에 구멍을 뚫어 그 안에 알을 낳는 벌레이고, 또 다른 종류는 나무를 파 먹는 흰개미 같은 종류다. 흰개미가 나무 기둥에 들어가면 건물 전체를 다 갉아 먹어 버리기 때문에 그 건물은 더 이상 사용하지 못하게 된다. 그래서 기둥 밑을 판 부분에 소금과 숯을 넣어 이런 벌레가 기둥에 들어가는 것을 예방한다.

　보탑사 목탑의 기둥은 민흘림을 기본으로 하여, 일반 한옥을 지을 때보다 몇 배나 많은 기둥을 치목해야 했지만, 하나도 빼놓지 않고 기본 기법에 맞게 치목을 했다. 그렇게 치목해서 1층 28개 주초석마다 기둥을 세우고, 가운데 심초석에는 찰주를 세웠다. 또한 안정적인 비례를 위해 1층 층고를 2층, 3층보다 높였다.
　2층은 1층보다 건물 폭을 2자(60㎝) 줄여서 세웠다. 이렇게 2층 건물의 폭을 줄이면 2층의 기둥은 1층의 기둥보다 건물 안쪽으로 놓이게 된다. 2층의 기둥을 1층 건물의 기둥보다 안쪽으로 들여놓은 이유는 밖에서 봤을 때 시각적으로 편안해 보이게 하고, 하중이 분산되도록 하기 위해서였다. 그런데 2층 안기둥은 아무런 고정 장치 없이 작은 나무토막 같은 촉이라는 부재를 끼워 세웠다. 그러다 보니 언뜻

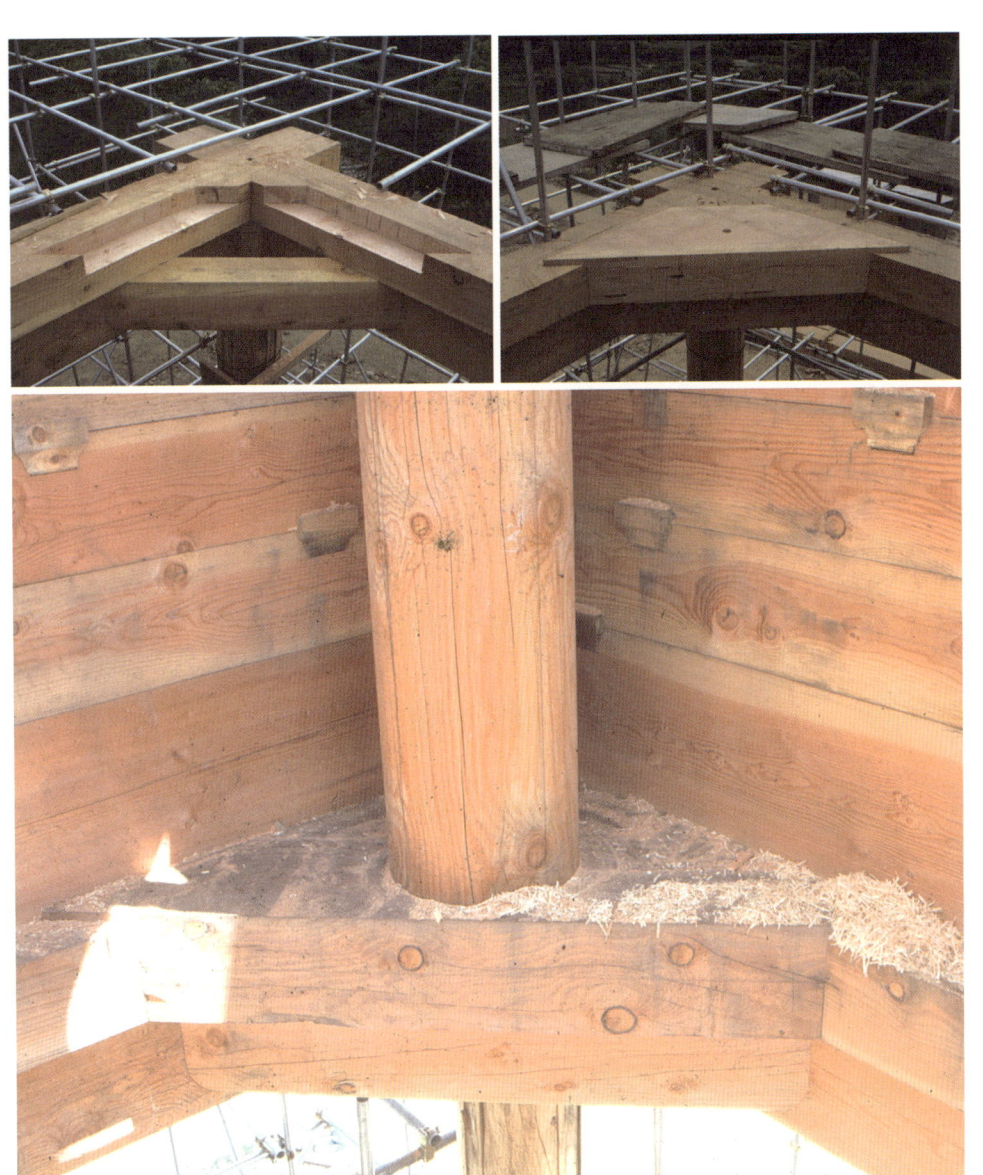

귀잡이보와 귀잡이 평방(평좌) 위에 촉이음으로 상층 기둥 결구

봐서는 이 거대한 구조물이 어떻게 이렇게 허술하게 걸쳐져 있는지 이해되지 않을 수도 있다. 그러나 기둥 위의 부재들은 철교보다도 단단하게 서로를 붙들고 있어서 절대 무너지지 않는다.

내가 이런 목탑의 구조를 바로 떠올렸던 것은 아니었다. 역사 속에서 숨 쉬던 것을 현실로 끄집어내는 일은 그동안의 경험이 아무리 풍부하다 해도 쉽지 않은 일이었다. 지금껏 나는 작업에 들어가기 전에 결과물을 미리 머릿속으로 완벽하게 그려 내곤 했다. 어떻게 작업물을 만들어 낼지를 상상할 수 있었다는 말이다. 하지만 그랬던 내가 보탑사 목탑만큼은 완벽한 결과물이 그려지지 않아 고민이 많았다.

그러던 어느 날 밤이었다. 목탑의 기초를 다지고 난 이후의 일이었다. 1층의 기둥을 세우고 나서도 사실, 누구도 해 본 적이 없던 일이라 3층이나 되는 목탑이 어떤 결과물로 나올지 잘 그려지지 않아 힘들었다. 그날도 현장에 마련된 임시 숙소에서 잠을 자고 있었다. 원래 나는 한번 잠이 들면 옆에서 누가 춤을 춰도 잘 깨지 않는다. 그렇지만 비 오는 소리에는 아주 민감하다. 현장에서 비가 오면 나무들이 젖기 때문에 걱정이 되어서 그런 모양이다.

그날도 새벽부터 일어나 부지런히 일한 탓에 아주 피곤한 상태로 잠이 들었다. 그런데 잠결에 후드득 빗방울 떨어지는 소리가 들렸다. 화들짝 놀라 일어나 앉았다. 새벽 3시였다. 밖을 살펴보러 나갔는데, 비는 오지 않았다. 이상했다. 분명 빗소리 때문에 잠에서 깼는데 밖은 멀쩡했다.

고개를 갸웃하며 돌아서는데, 옆에 있던 버드나무 세 그루가 바람에 흔들리며 '쏴' 하는 소리를 냈다. 눈을 감고 들으니 영락없이 비 오는 소리였다. 범인은 버드나무였다. 버드나무가 바람에 흔들리면서 내는 소리가 마치 비 오는 소리처럼 들린 것이다.

나무 흔들리는 소리를 빗소리로 착각하고 깨다니, 별일이었다. 잠이 다 달아나 버려, 백비(보물 제404호인 진천 연곡리 석비)가 있던 자리에 서서 물끄러미 공사 현장 쪽을 바라보았다. 어둠 속에 우두커니 서 있는 기둥이 보였다. 그 모습을 보면서 저걸 어떻게 지어야 하나 걱정하고 있었다. 그렇게 가만히 들여다보는 순간 그곳에서 목탑의 형상이 아른아른 나타났다. 나는 그대로 무릎을 꿇었다. 마음을 가다듬고 다시 현장을 쳐다보자 흐릿한 목탑이 서 있었다.

'저거구나. 저게 바로 내가 짓고 싶은 목탑이구나!'

그 새벽에 사무실로 가서 도면을 펼쳐 보았다. 그동안 도면을 보면서도 좀처럼 머릿속으로 그려지지 않던 목탑의 형상이 마침내 그 모습을 드러냈다. 그런데 문제가 생겼다. 나타난 형상대로 목탑을 지으려면 지금껏 도면을 따라 작업해 두었던 재료들을 전부 다시 손봐야 했다. 하지만 나는 확신했다. 그러니 그 정도 수고스러움은 감당할 수 있었다.

날이 밝자마자 현장에 나온 석공과 목수들에게 12자 너비로 가공해 둔 기단을 모두 9자로 줄이고, 기둥의 높이도 15자로 바꾸라고 했

보탑사 목탑 기둥을 세우는 모습

다. 그러자니 미리 치목해 둔 서까래도 너무 길어 전부 한 자씩 잘라 내야 했다. 준비해 두었던 서까래는 모두 천 개가 넘었다. 하룻밤 사이에 무슨 마음이 바뀌어 그걸 다 잘라 내라고 하니, 다들 의아해할 수밖에 없었다.

"도대체 간밤에 무슨 일이 있었던 겁니까?"
"미안하게 됐네. 하지만 그래야 이 목탑이 제대로 설 수 있네."

확신에 찬 내 말에 석공과 목수들도 더 이상 말하지 않고 손놀림만 분주해졌다.

이음과 맞춤으로만
기둥과 보, 창방을 짜 올리기

　1층 기둥을 다 세운 뒤, 창방昌枋과 보를 치목하고 올려 조립했다. 창방은 기둥과 기둥 사이를 연결해 주는 역할을 한다. 창방을 올릴 때는 나무의 나이테 간격이 촘촘한 음지(북쪽) 부분이 아래로, 나이테 간격이 넓은 양지(남쪽) 부분이 위로 향하게 해야 덜 휜다. 철근 콘크리트 공사에서 아랫부분에 철근이 더 많이 들어가는 것과 같은 원리다. 사소해 보여도 이런 원칙을 무시하고 반대로 올리면 더 많이 휘어서 나중에 보면 집이 아래로 처지게 된다. 이런 일을 막으려면 목수들이 나무의 방향을 잘 보고 올려야 한다. 기둥의 앞뒤를 가로지르는 보 역시 이와 같은 방법으로 치목하여 올린다.

　목탑의 기둥을 세우고 나서 창방을 결합하는 공사가 한창일 때, 관

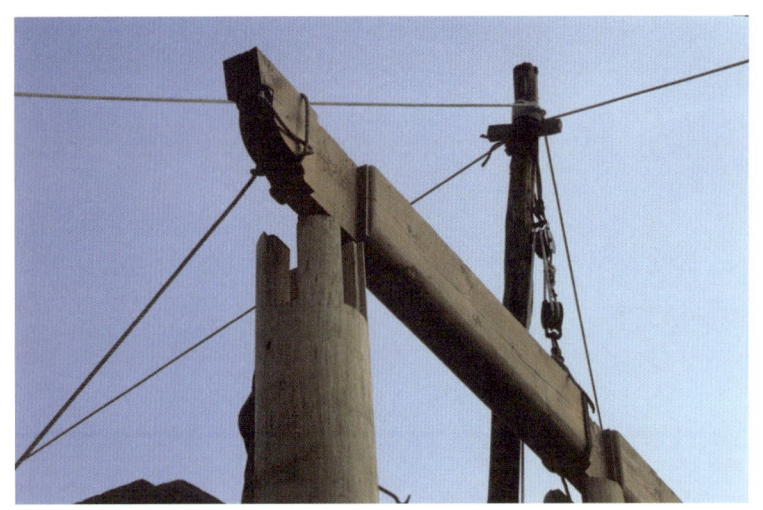
기둥머리 창방 결구. 한식진폴을 이용하여 창방을 기둥머리에 내리는 모습

에서 안전 관리 요원 세 사람이 나왔다. 그들은 현장을 이리저리 살펴보고는 공사를 중지시켰다. 이렇게 큰 건물을 짓는데 기둥이 너무 허술해 보인다는 것이 그 이유였다. 그들의 눈에는 콘크리트가 발려 있는 것도 아니고, 하다못해 눈에 띄는 대못조차 없으니 허술하기 짝이 없는 구조물이었던 것이다. 하지만 한옥의 특성을 몰라도 너무 모르고 하는 소리였다. 나는 그들에게 말했다.

"당신들 세 사람이 힘을 합쳐 있는 힘껏 이 기둥을 밀어 보시오. 만약 이 기둥이 넘어진다면 그 즉시 공사를 중단하는 건 물론이고, 내가 당신들에게 아파트 한 채씩 주겠소."

엉뚱한 나의 제의에 안전 관리 요원들은 기막혀 하더니 있는 힘껏 기둥을 밀었다. 그러나 세 명이나 되는 장정들의 힘에도 기둥은 꿈쩍하지 않았다. 겉으로 보이는 것과 달리 서로가 엮여 단단하게 결구해 주는 한옥의 특성을 그들은 몰랐던 것이다. 결국 그들은 미안하다는 사과의 말을 남기고 돌아갔다. 이후로 준공 때까지 단 한 건의 사고도 없었다. 그리고 무재해 안전 상패까지 받았다.

　흔히 땅속부터 튼튼하게 붙들고 있어야 기초 공사를 잘하는 것으로 생각한다. 하지만 한옥은 그렇게 하면 집이 오래 못 간다. 한옥은 이음과 맞춤으로 단단하게 짜여 있기 때문에 기둥에 따로 고정 장치를 하지 않고도 안정적으로 구조물을 올릴 수 있다. 보탑사 목탑 공사에도 이러한 원칙을 적용했고, 극대화했다.

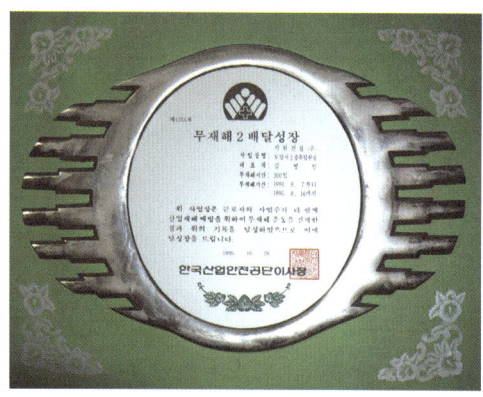

무재해 안전 상패

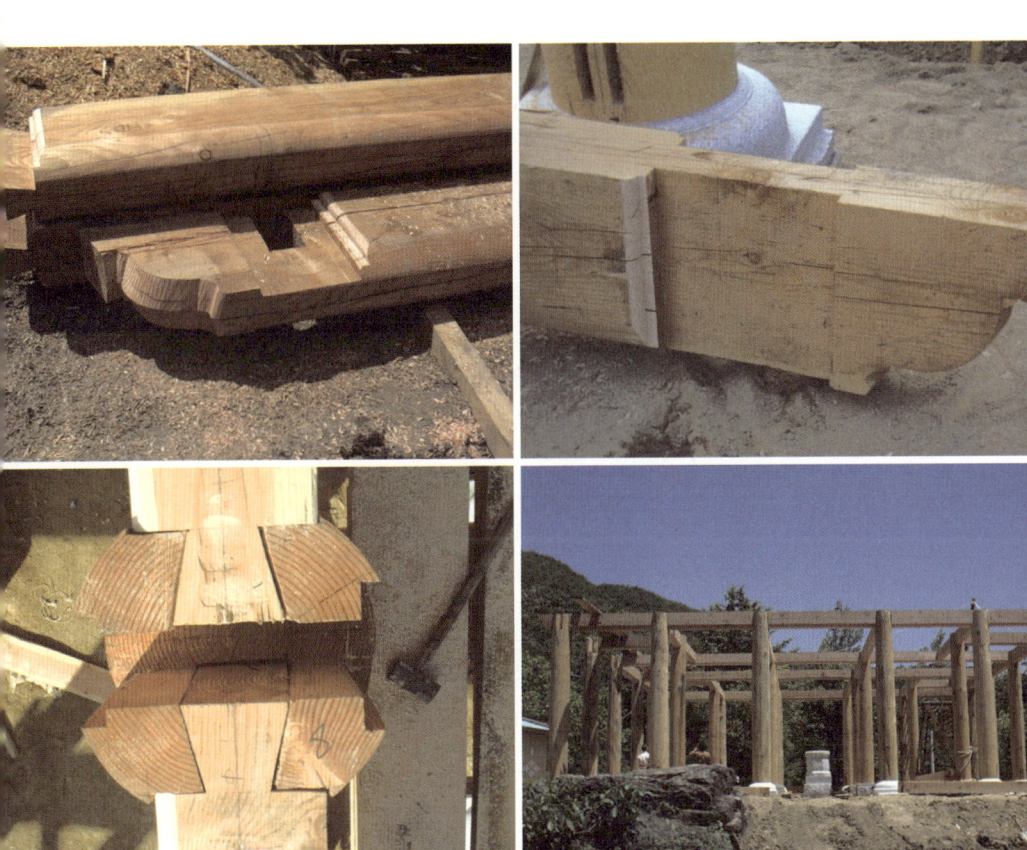

1층 기둥 상부 창방 결구

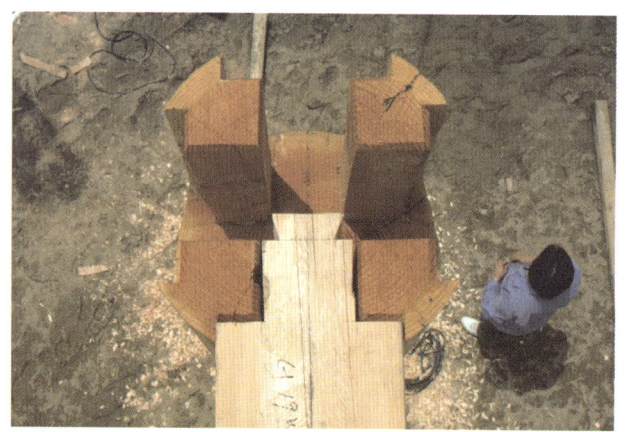
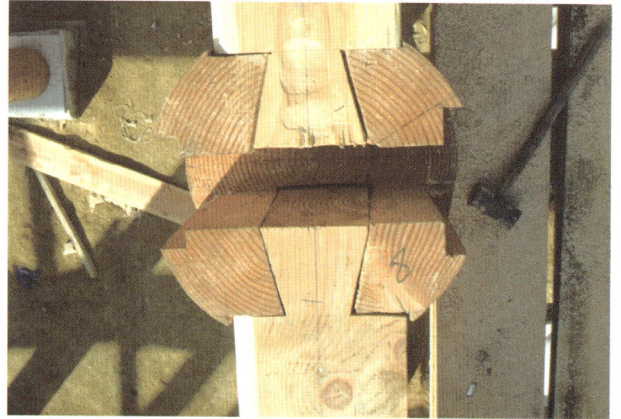
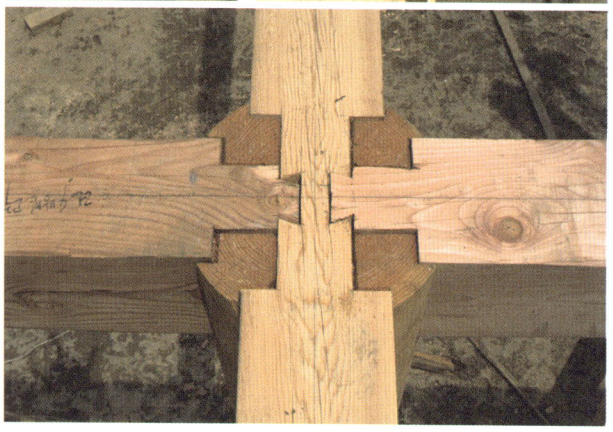

기둥머리 사개맞춤

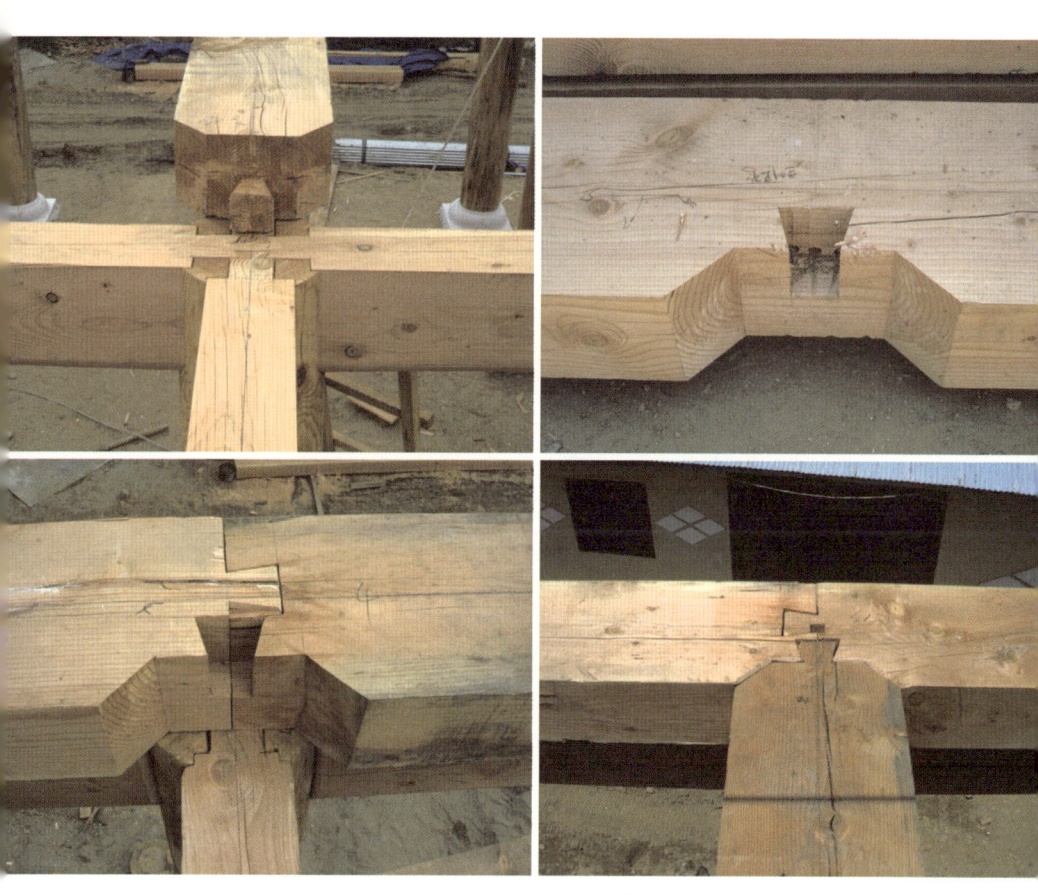

주먹장 이음, 맞춤

하중을 견뎌 내는 공포 짜기

공포栱包는 처마 끝을 내리누르는 무거운 지붕의 무게를 받치기 위해 기둥머리에 짜 맞춰 버팀목으로 댄 나무 구조를 말한다. 학계에서는 공포를 모양과 형식에 따라 주심포(공포를 기둥머리 위에만 놓는 방식), 다포(공포를 기둥머리 위뿐만 아니라 기둥과 기둥 사이에도 놓는 방식), 익공(기둥 상부에서 창방과 직교하여 보를 받치는 새 날개 모양의 익공이라는 부재를 결구한 유형) 등으로 나누는데, 주심포는 고려 중기, 다포는 고려 말기, 익공은 조선 초기에 형성되어 지금에 이르고 있다고 본다.

보탑사는 3층으로 구성된 중층 목탑이다. 기둥 위로 다시 기둥을 얹고, 그 위에 다시 중첩하여 기둥이 쌓이다 보면 위에서부터 전달되는 하중이 엄청나다. 공포는 그 하중을 분산시키면서도 균형을 잡아

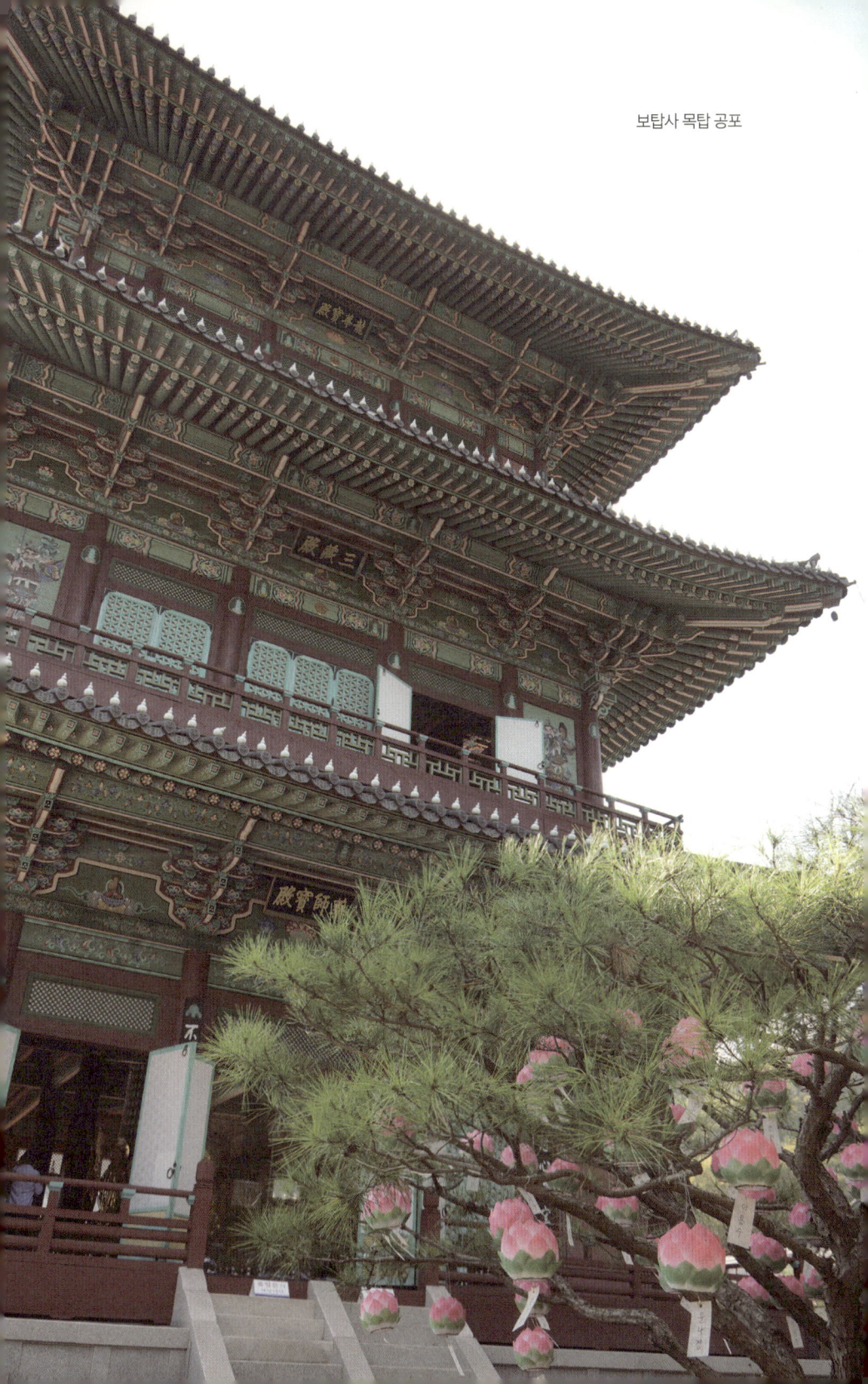

보탑사 목탑 공포

주는 역할을 한다.

 보탑사 목탑의 공포를 굳이 분류한다면 기본적으로는 각 기둥 위에만 공포 부재를 올린 주심포이지만, 엄밀히 따지면 주심포와 다포의 중간이라고 할 수 있다. 다층 구조의 목탑이다 보니, 기둥의 하중을 줄이는 데 중요한 역할을 하는 서까래를 더 튼튼하게 받치기 위해 창방 위에 다포 양식에 들어가는 평방(공포 등을 떠받치기 위해 기둥과 창방 위에 올려놓은 널찍하고 두꺼운 가로재)이라는 부재를 올렸기 때문이다. 이로써 주심포이면서 다포인 보탑사만의 독특한 공포 양식이 만들어졌다.

 공포 위에는 장여, 도리, 서까래, 초매기 평고대, 부연, 이매기 평고대, 연함 등과 같은 부재를 차례로 올린다. 도리는 들보와 직각으로 기둥과 기둥을 연결하고, 장여는 그 도리를 받치는 부재이다. 여기까지를 흔히 축부재軸部材라고 한다. 서까래는 지붕틀을 구성하는 가늘고 긴 부재이고, 부연은 처마 서까래의 끝에 덧얹는 직사각형의 서까래로, 처마 서까래보다 밖으로 내민 부재다. 평고대는 처마 서까래나 부연의 끝에 가로로 걸쳐 댄다. 마지막으로 연함은 반달 모양으로 깎아 평고대 위에 올린 부재인데, 그 위에 암막새 또는 암키와를 놓는다. 이렇게 여러 부재가 차곡차곡 쌓이면서 횡과 종으로 결구되는 과정에서 한옥의 견고함이 나온다. 따라서 어느 한 부재도 소홀히 다룰 수 없다.

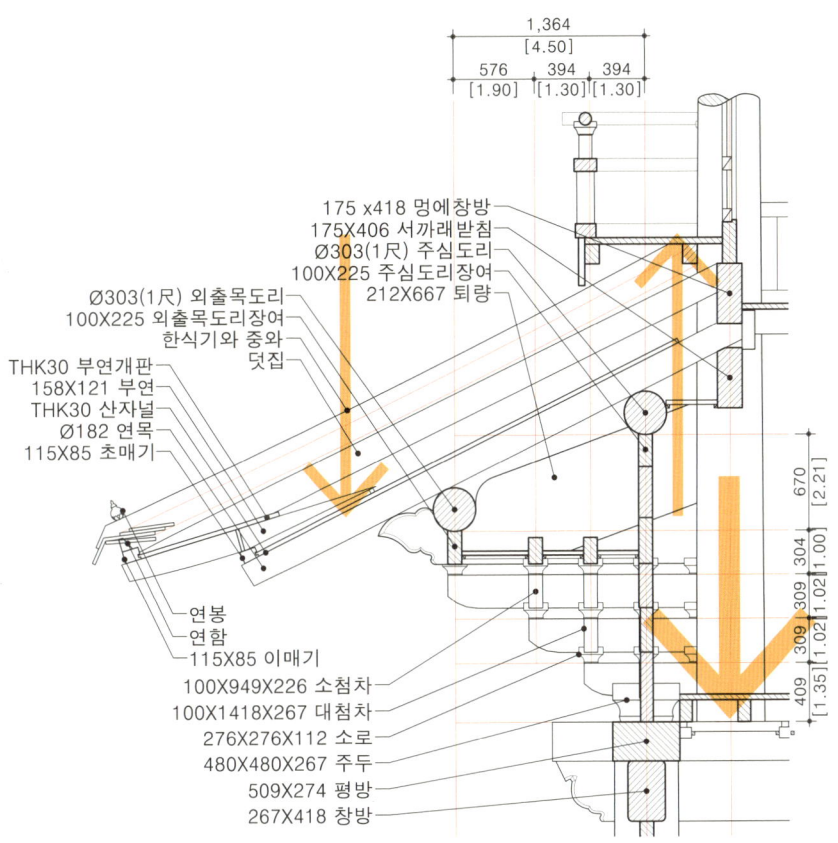

2층 공포 단면도

목탑 건축에서 가장 중요한 것은 균형을 잡는 일이다. 추녀와 서까래는 도리를 기준으로 그 힘을 앞과 뒤로 나눈다. 추녀와 서까래의 머리가 무거우면 뒷몸이 들린다. 들린다는 것은 내리누르는 힘이 상쇄된다는 뜻이다. 추녀와 서까래의 뒷몸이 기둥을 들고 있으면, 위에서부터 작용하는 하중을 그만큼 줄일 수 있게 된다.

이것이 보탑사 목탑의 성공 법칙이다. 다만 도리가 그 자리를 굳건하게 지키지 못하면 공포가 일그러지고 만다. 공포가 일그러지면 처마가 왜곡된다. 따라서 도리를 완고하게 해 주는 일은 기본 중의 기본이다.

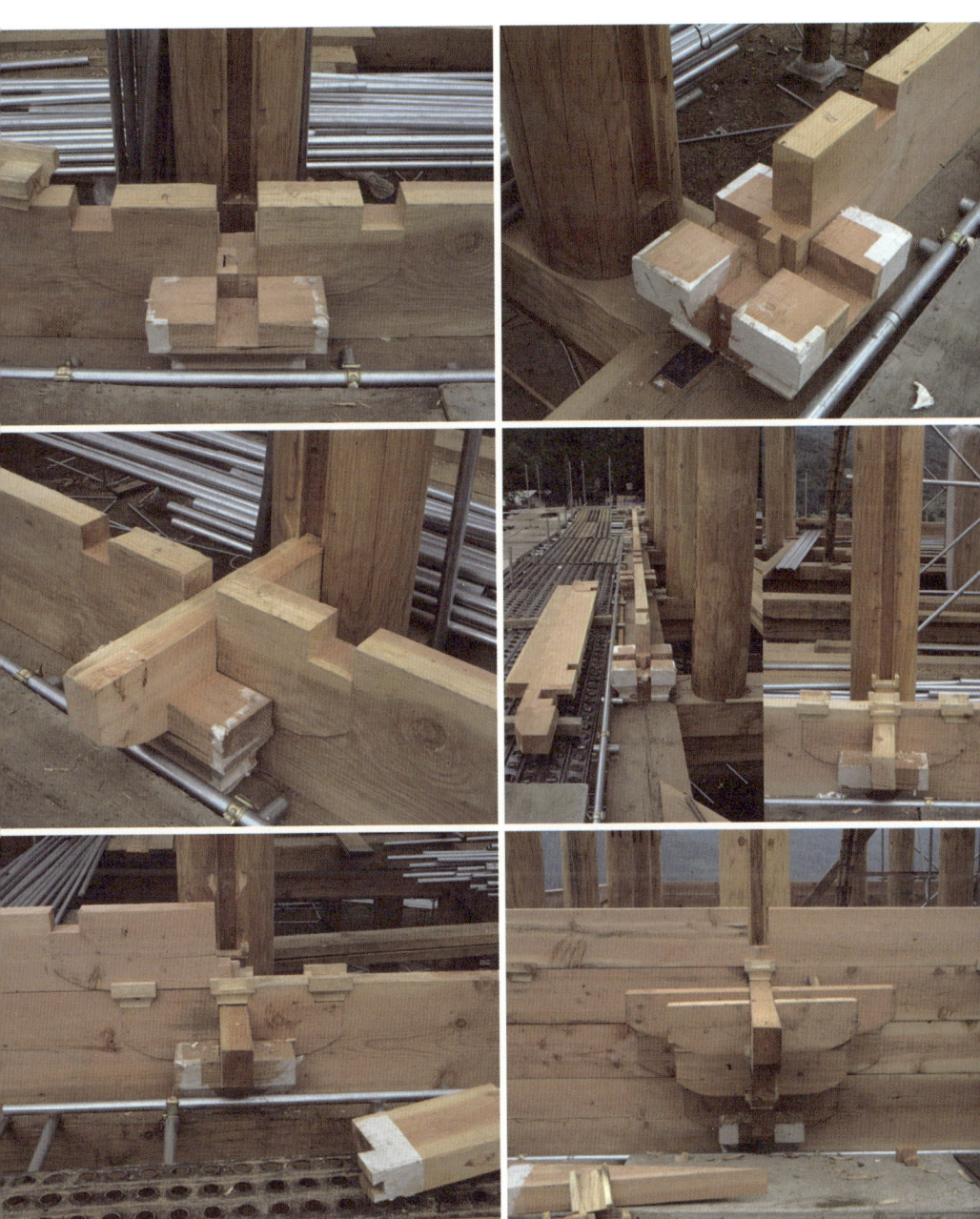

2층 기둥 처짐 방지 처리

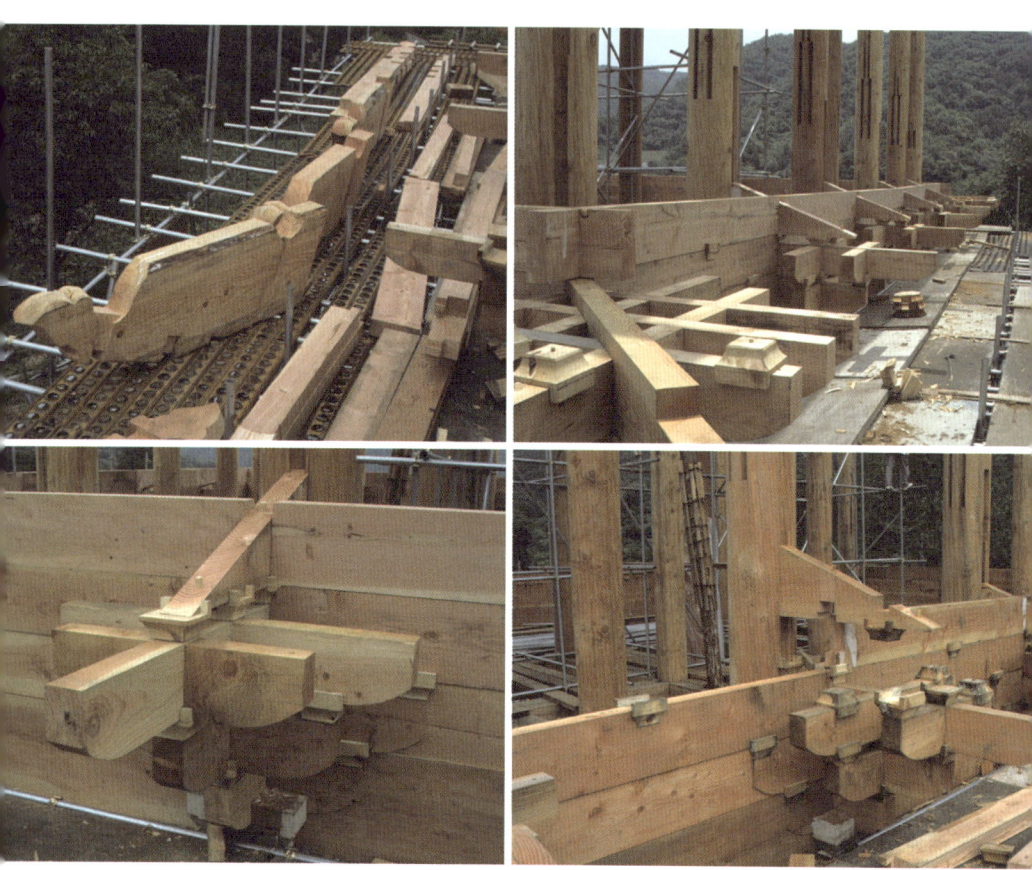

2층 포작

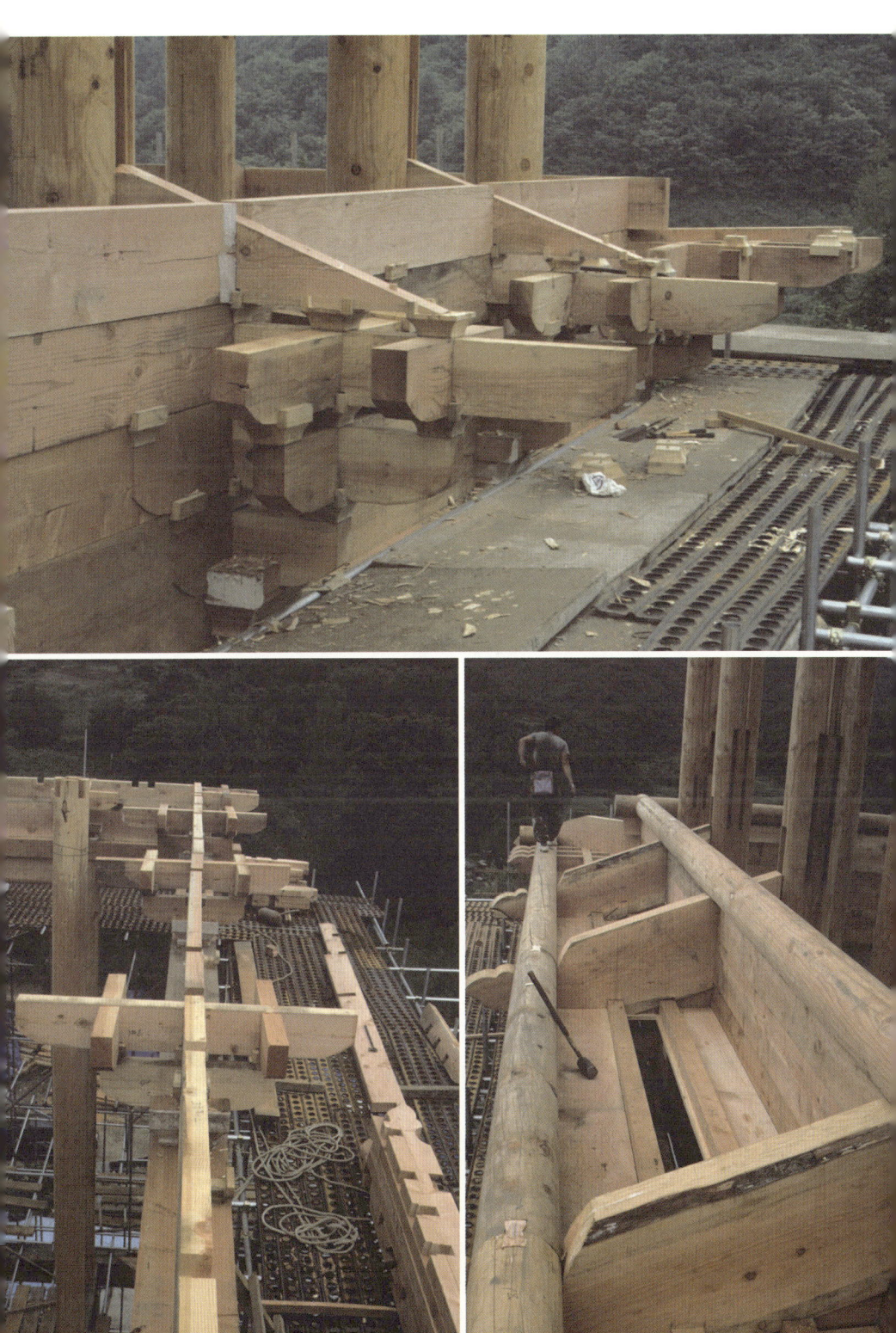

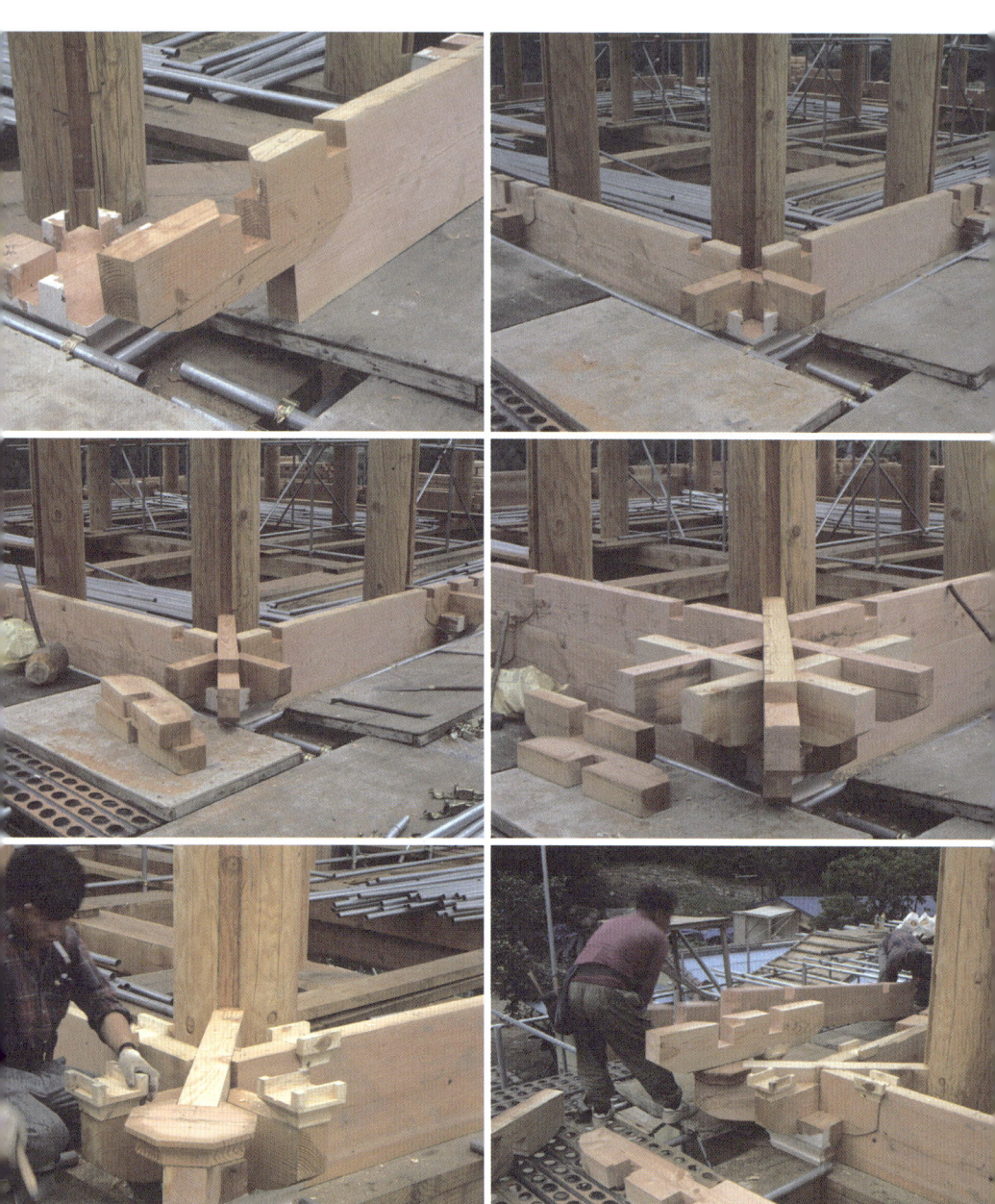

공포 짜기

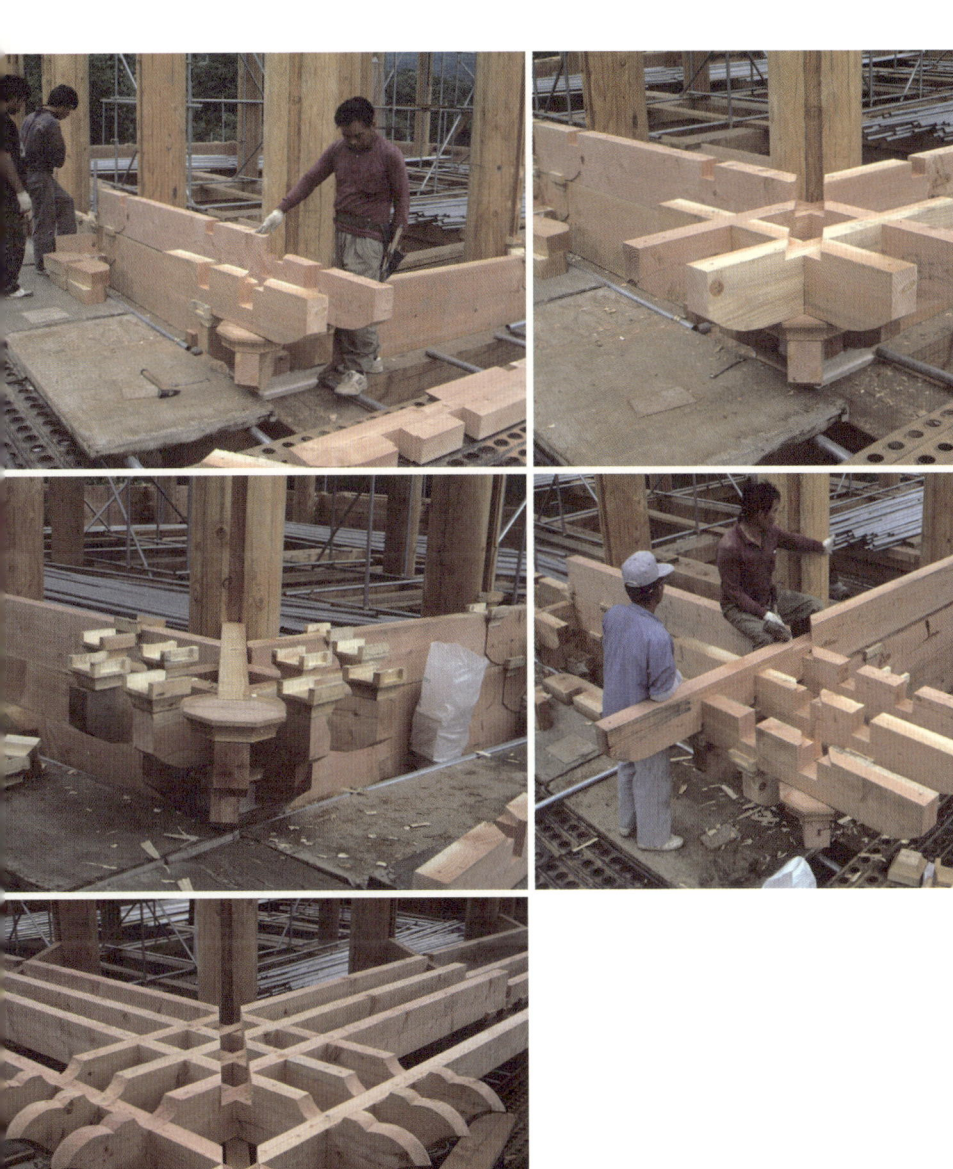

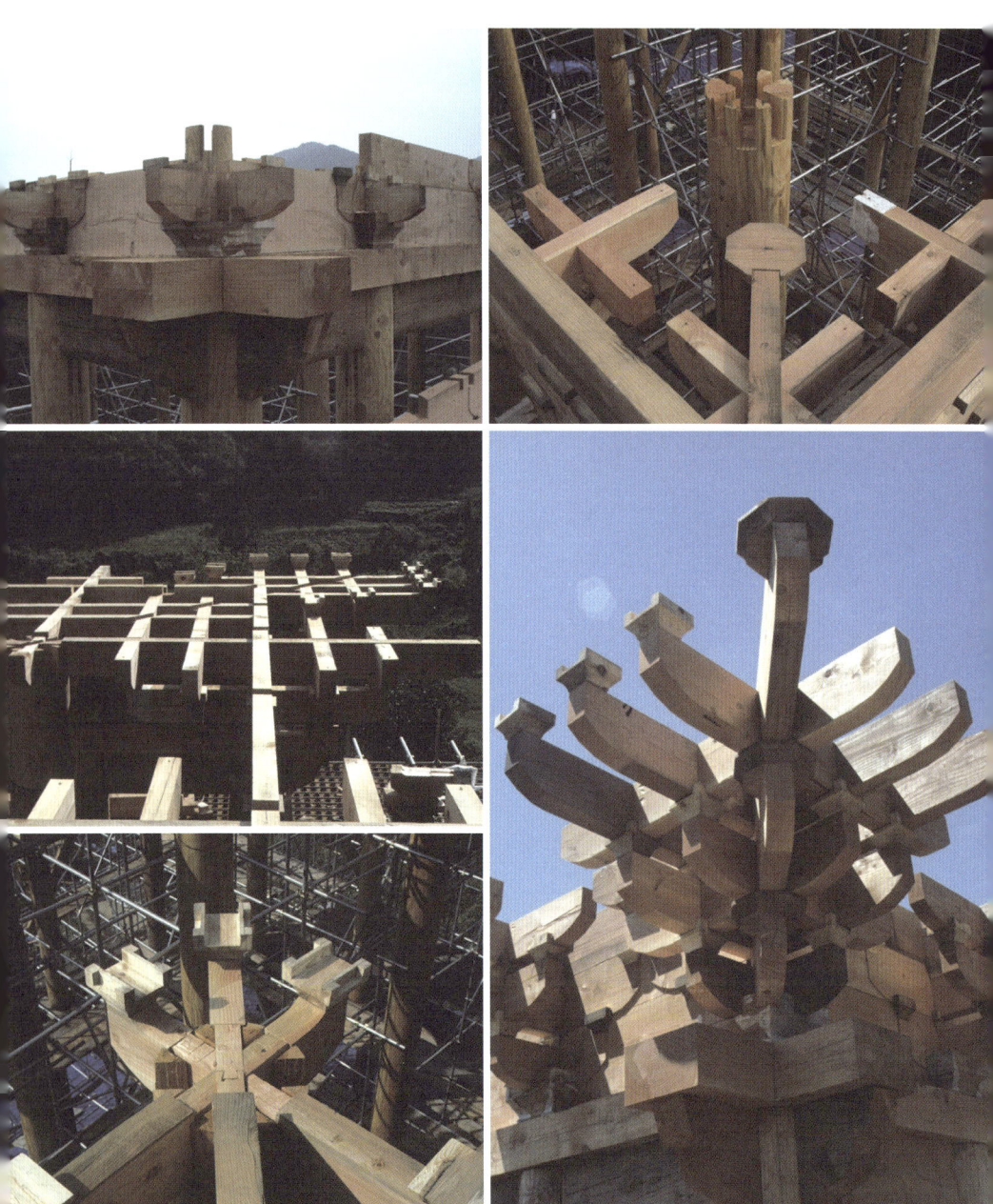

3층 귀포(귀기둥 위에 얹은 공포)

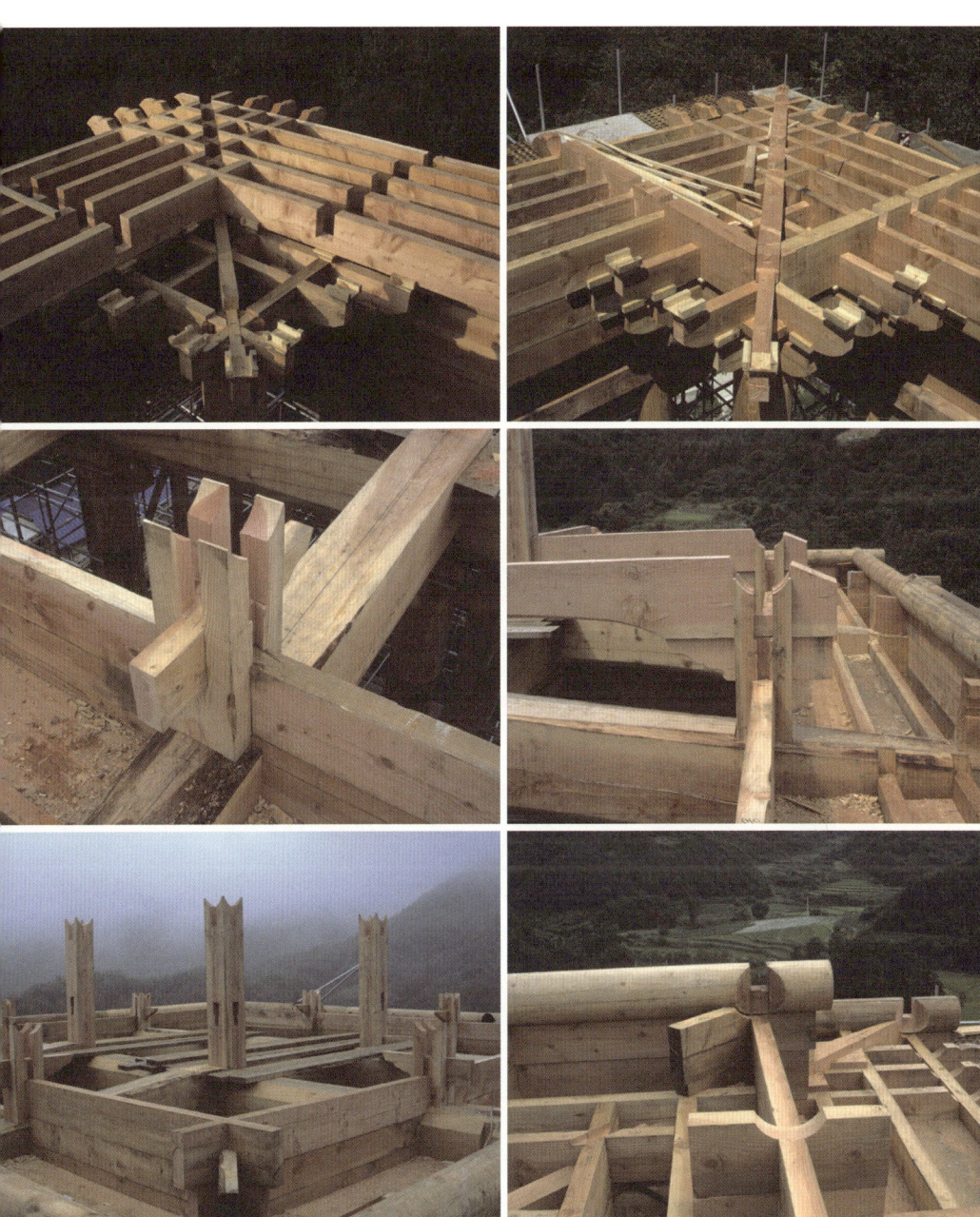

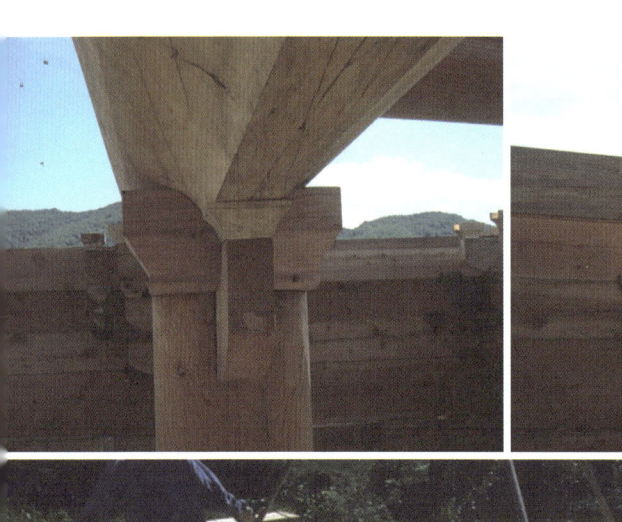
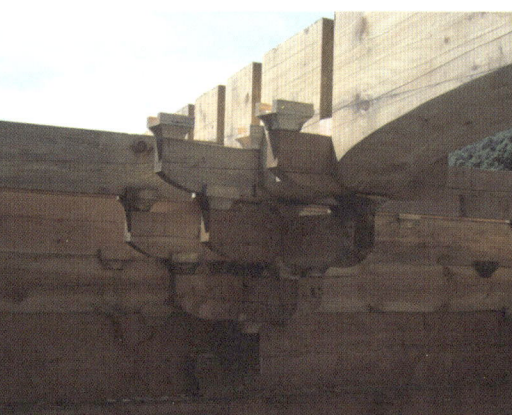

3층 대량

깊고 아름다우면서도 안정적인 처마

처마(지붕면이 도리 밖으로 나온 끝부분)는 한옥 지붕의 대표적인 특징 중 하나다. 처마는 서까래를 걸어 만드는데, 지붕의 모양과 크기에 맞춰 서까래의 개수를 정하고 지붕틀을 짜야 한다. 서까래를 치목할 때는 전부 일자로 곧게 하는 것이 아니라 미리 계산된 처마 곡선에 맞춰 나무의 휜 부분을 살려 치목해야 서까래를 걸었을 때 들뜨는 부분이 없이 오래간다.

보탑사 목탑의 처마는 깊다. '깊다'라는 표현은 처마의 길이가 기둥 선 밖으로 많이 돌출되어 있음을 의미한다. 기둥 높이를 기준으로 50~60%만큼의 비율로 처마가 돌출되어 있으면 '얕다'라고 표현하고, 60~70%면 '보통'이라 한다. 70~80%나 그 이상 돌출되어 있으면

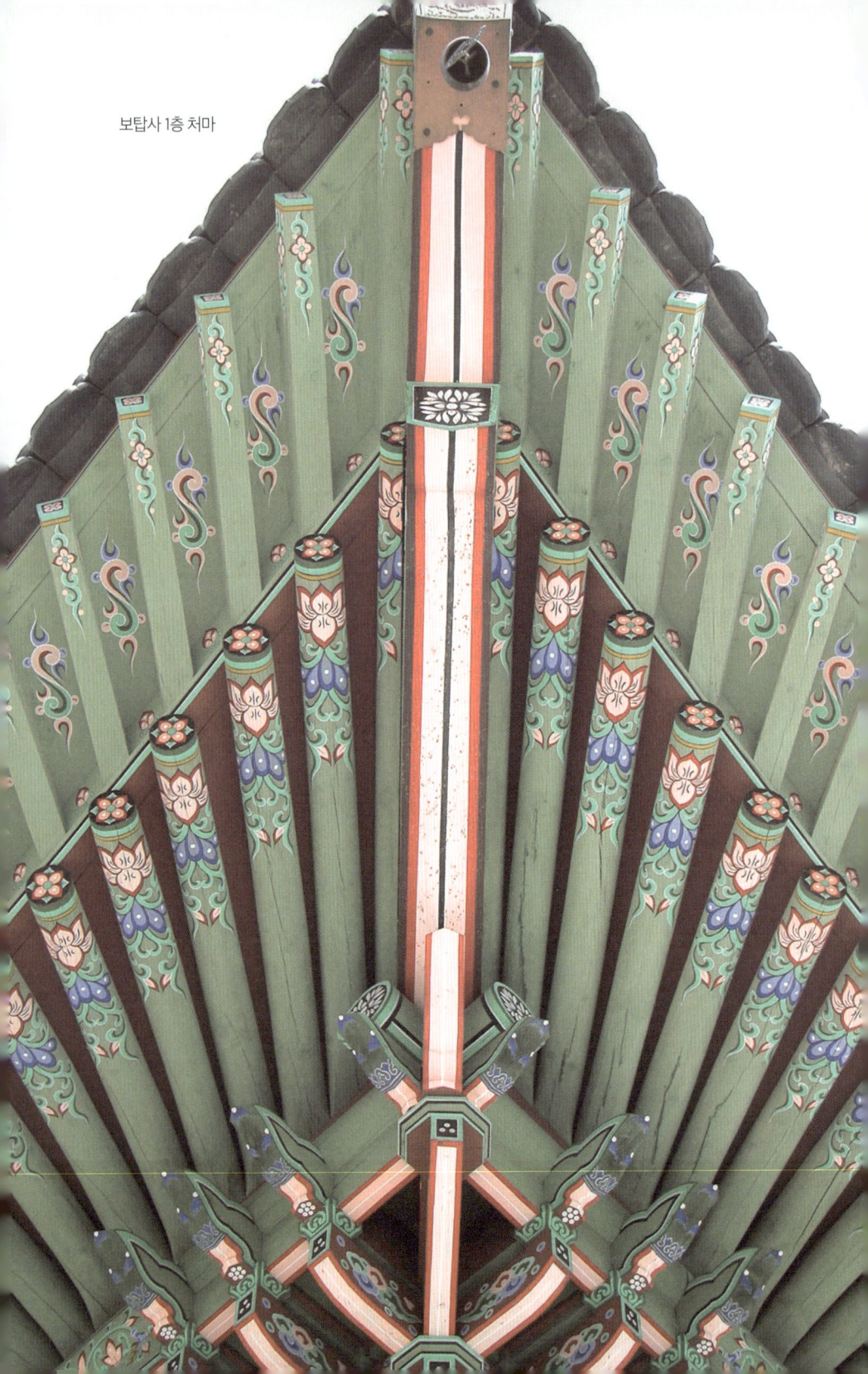

보탑사 1층 처마

'깊다'라고 표현하는데, 보탑사 목탑은 그 이상에 해당한다. 보탑사 목탑의 처마는 서까래만 천여 개 가까이 들어갔다.

처마의 우아한 곡선은 한옥의 백미다. 바로 이 처마 곡선의 각도를 좌우하는 것이 추녀와 선자 서까래다. 추녀를 사이에 두고 서까래를 추녀 쪽으로 부챗살 모양으로 붙여 나가는 것을 선자 서까래라고 한다. 선자 서까래는 처음부터 휘어진 목재를 구하고, 서까래보다 한두 치 더 큰 나무를 구해서 맞춘다. 이는 매우 까다로운 작업이다. 보탑사 목탑 앞에 서서 추녀와 선자 서까래 부분을 올려다보면 새의 날개가 펼쳐진 것 같은 아름다움이 느껴진다. 이처럼 보탑사 처마는 정적이지 않고 생동감이 넘쳐흐른다.

한옥 지붕의 물매(경사의 정도)는 오랜 세월을 거치며 내린 강우량에 맞게 형성되었다. 바람, 비, 햇빛 등 자연 현상을 고려하면서 지붕 공사를 하다 보면 지붕 경사가 문제 되는 경우가 많다. 경사가 잘못되면 제대로 지은 한옥이라도 그 멋이 나오지 않는다. 보탑사 목탑 지붕은 층마다 물매 각도가 다르며, 여느 지붕의 물매보다 경사가 급한 편이다. 물매의 종류는 낙숫물이 흐르는 지붕의 각도가 어느 정도인지에 따라 나뉘는데, 45도 이상으로 경사도가 급하면 '된물매'라 하고, 45도 미만으로 경사도가 완만하면 '뜬물매'라 한다.

건물 규모가 클수록 밑에서 보는 사람들의 시선을 생각해야 한다.

설계 도면으로 보는 눈높이와 실제로 건물 앞에서 바라보는 사람들의 눈높이는 완전히 다르기 때문이다. 특히 보탑사 목탑처럼 규모가 큰 건물을 지을 경우 지붕의 물매를 층마다 똑같이 만들면 사람들의 눈에 제대로 된 탑의 모습이 보이지 않는다. 즉, 지붕의 물매는 실제로 보이는 각도와 만들어서 위에 올려놓는 각도가 달라야 제대로 보인다.

편액을 다는 것도 마찬가지다. 층마다 똑같은 각도로 편액을 달면 우리 눈에는 제대로 된 편액의 모습이 들어오지 않는다. 편액은 매다는 위치에 따라 앞으로 비스듬하게 놓아야 우리가 지면에서 볼 때 똑같은 위치에 있는 것처럼 보인다.

이처럼 규모가 큰 건물은 실제로 보이는 각도와 시공하는 각도에 차이가 있다. 이를 '시각의 착각', '착시'라고 한다. 사람도 자연의 일부라는 관점에서 시각적으로 부담 없이 편안하게 보이는 건축물을 짓는 것은 우리나라 전통 건축의 매우 중요한 부분이라고 생각한다. 보탑사 3층 목탑은 그러한 기본에 충실한 건축물이 되도록 했다.

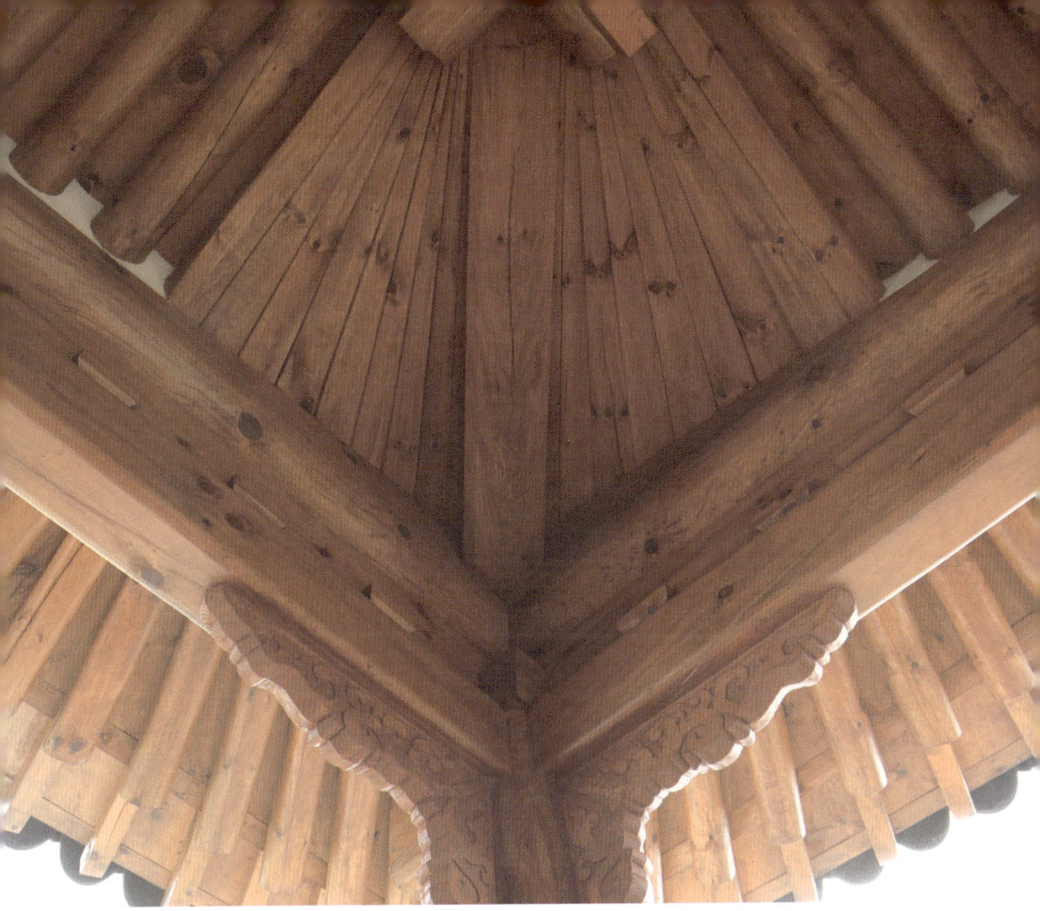

일반적인 선자 서까래의 겹처마

추녀 걸기(위), 추녀 뒷뿌리 결구(아래)

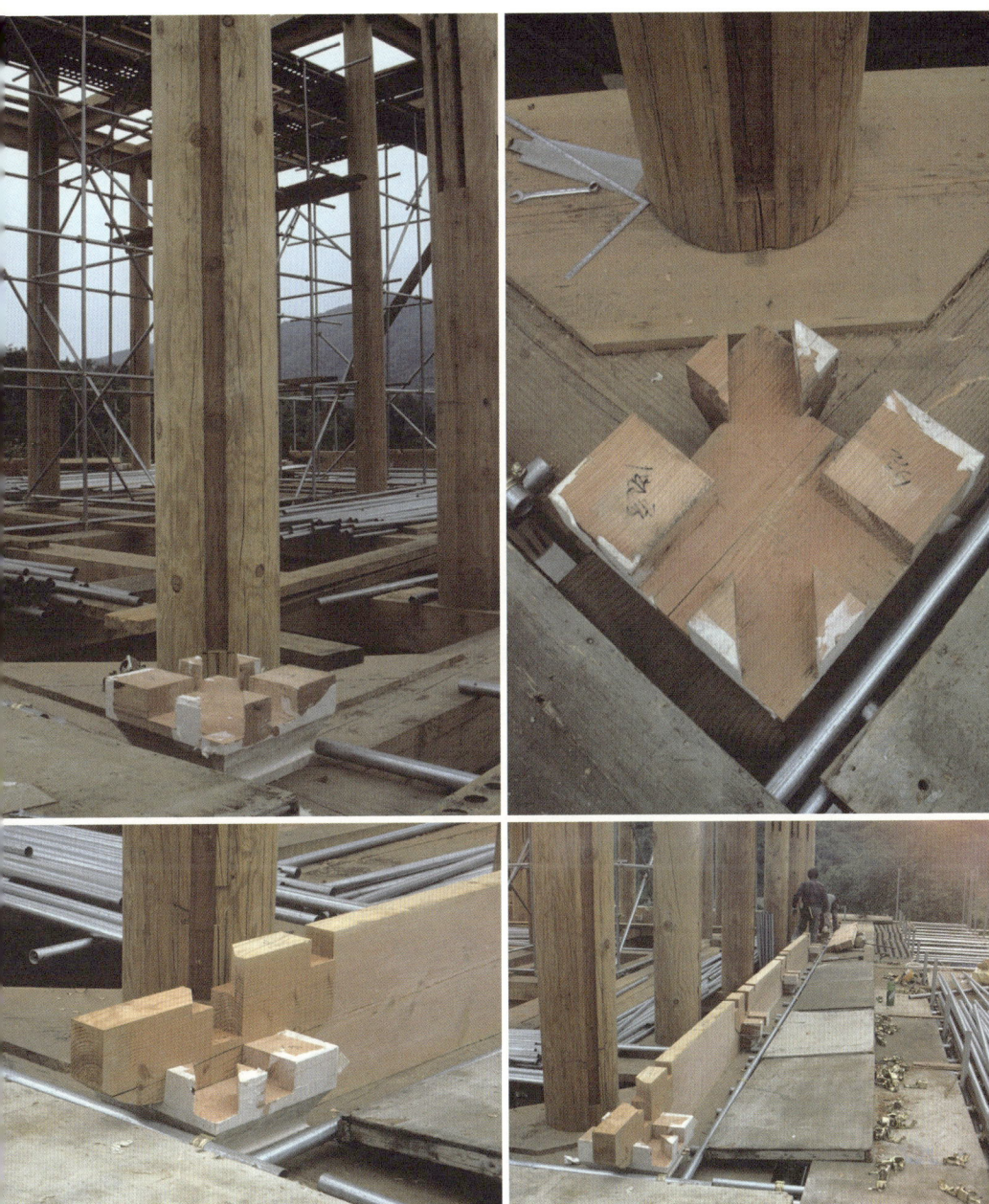

3층 기둥

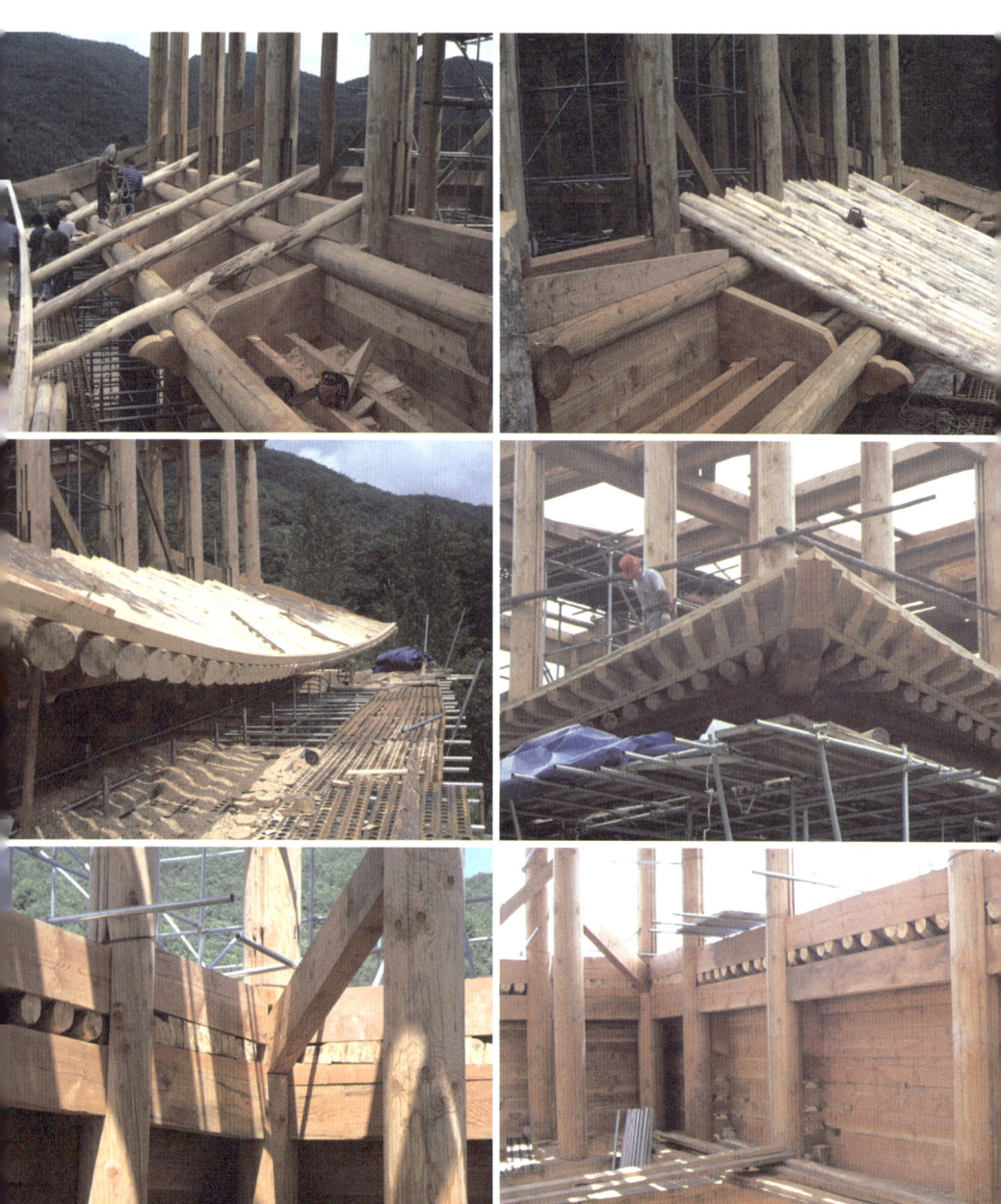

1~2층 서까래 걸기

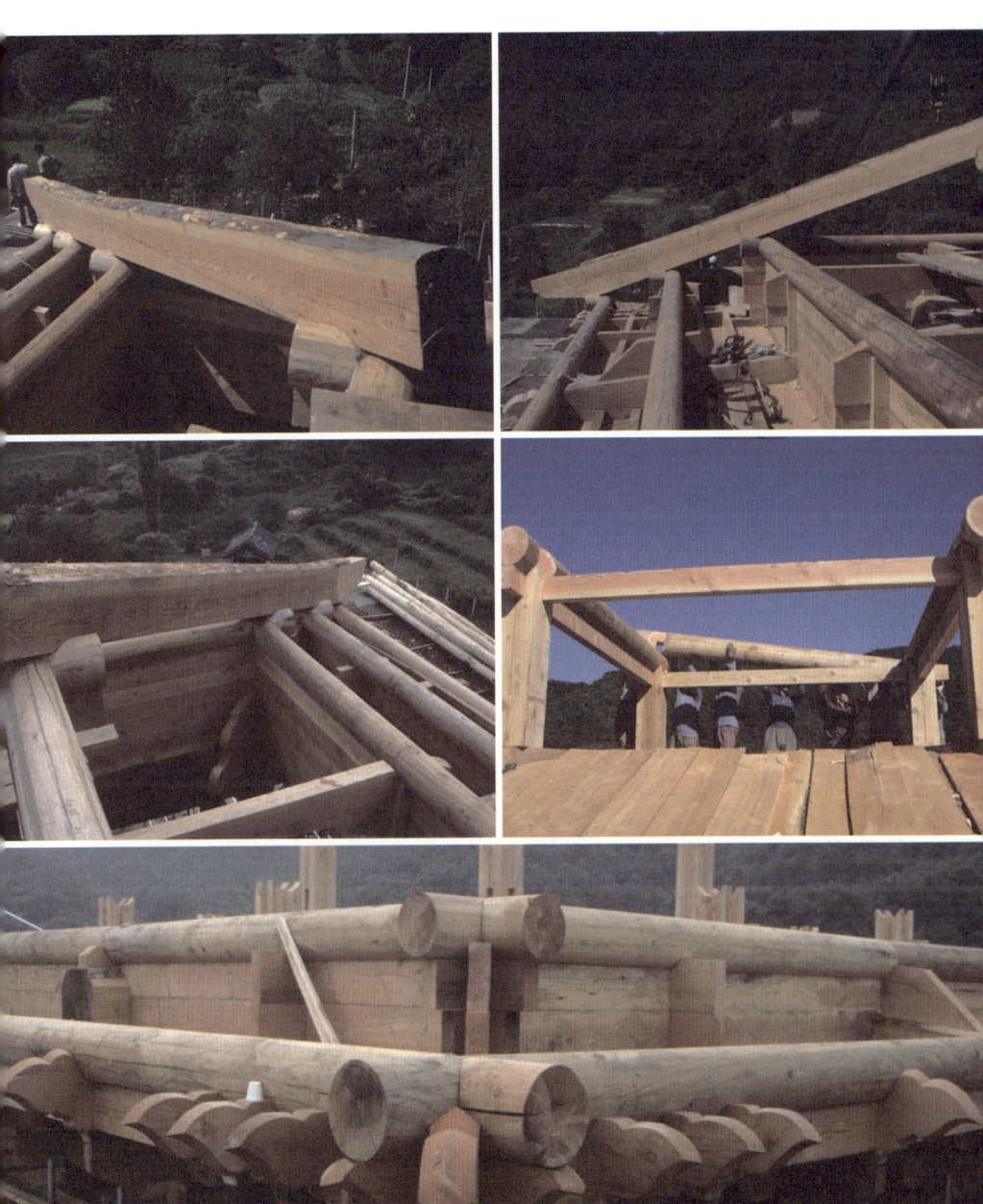

3층 추녀 걸기

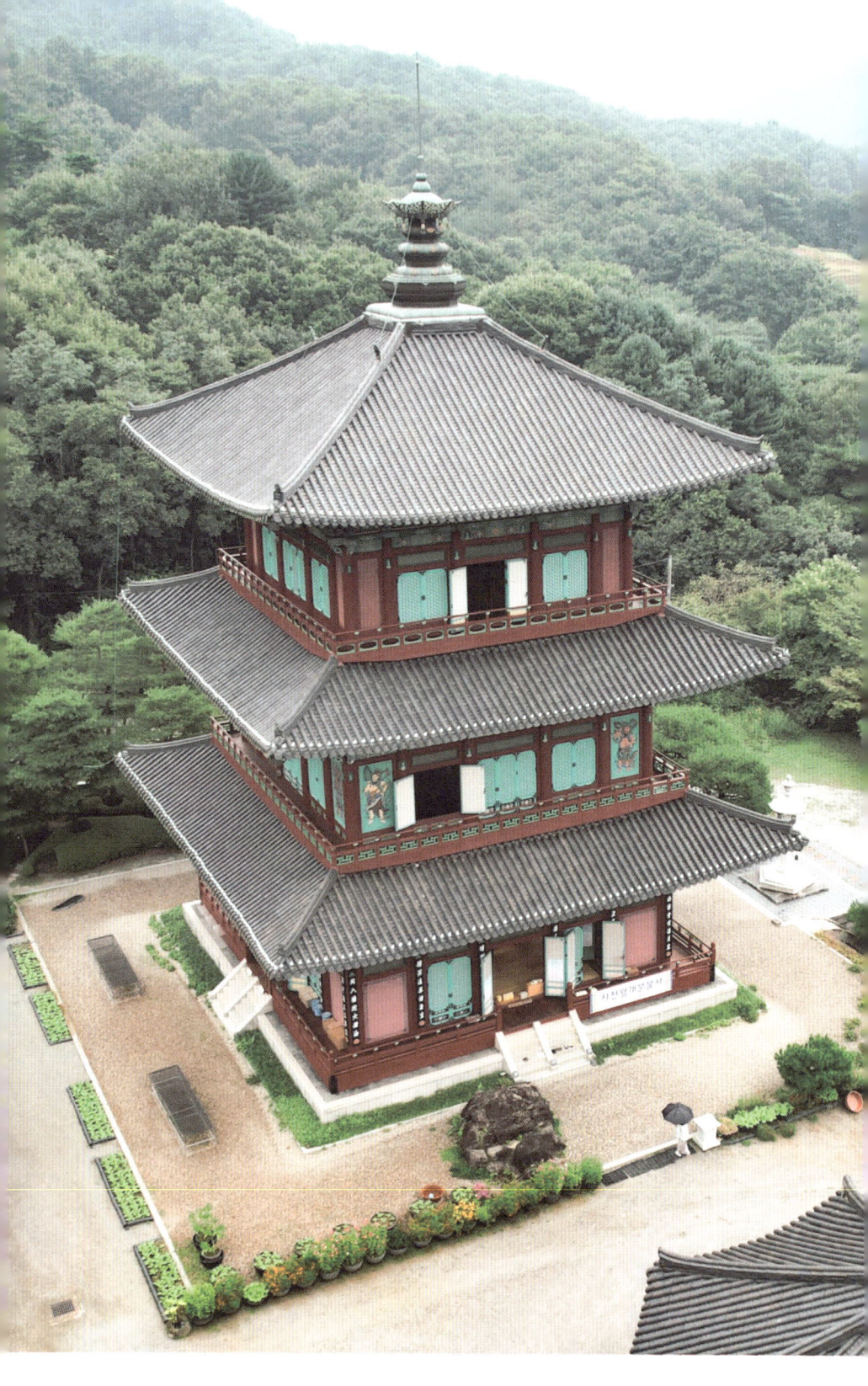

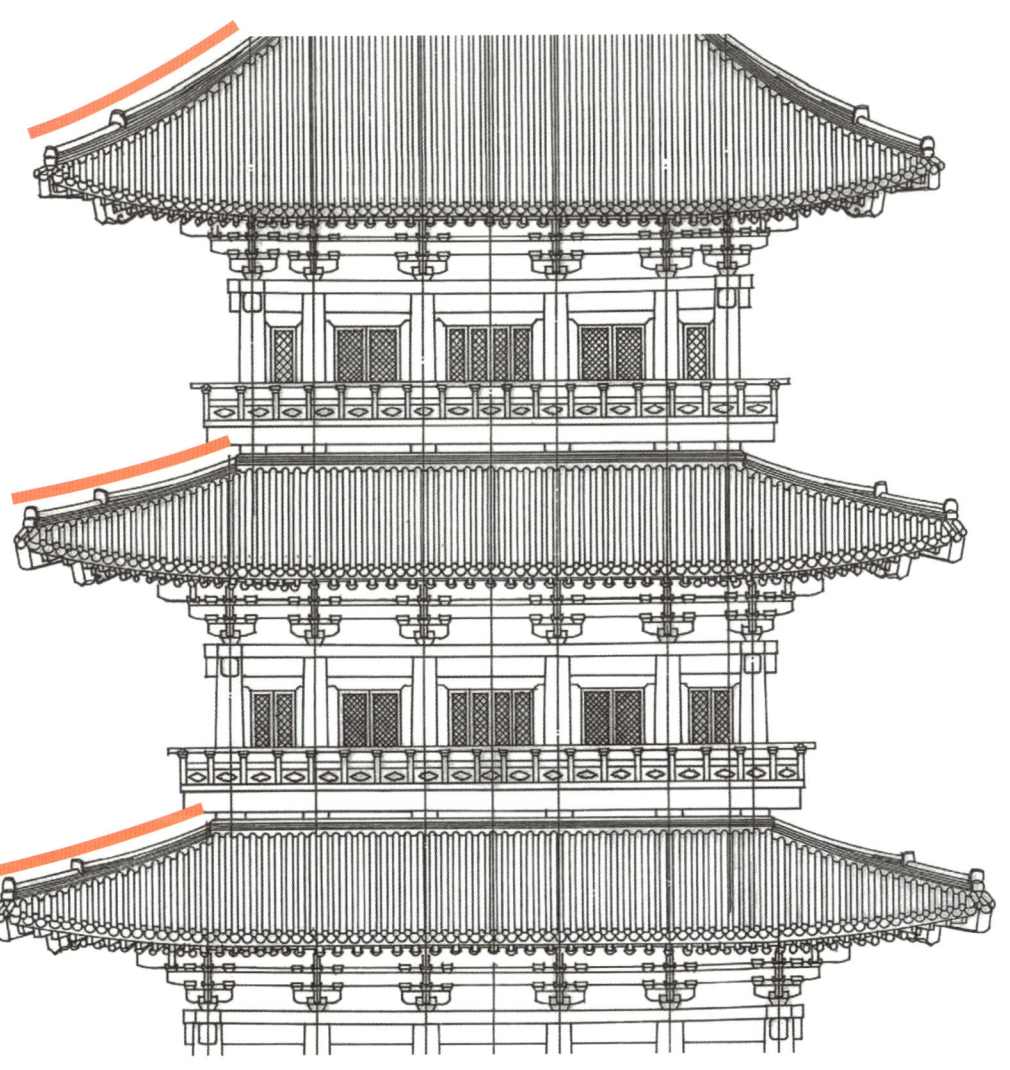

보탑사 목탑 지붕의 경사(물매)는 층마다 다르다.

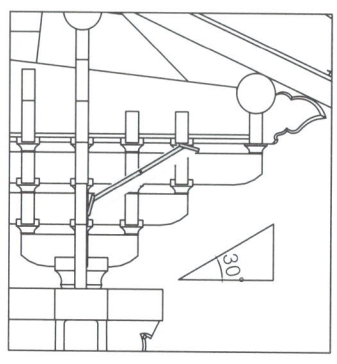 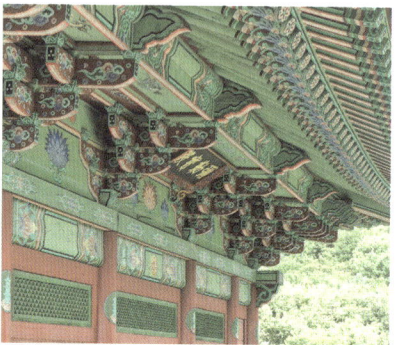

보탑사 목탑 3층 편액(SCALE: 1/20)과 실제 3층 편액 사진

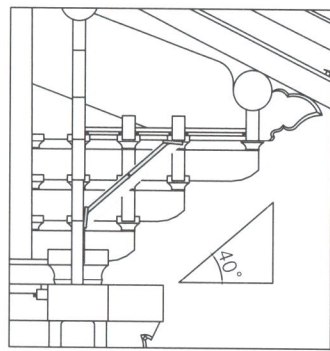 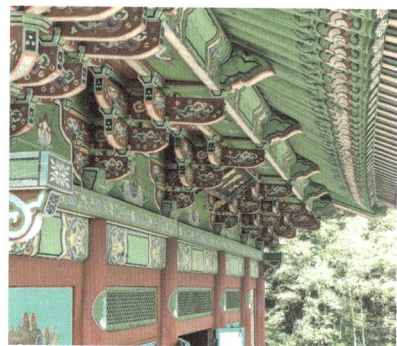

보탑사 목탑 2층 편액(SCALE: 1/20)과 실제 2층 편액 사진

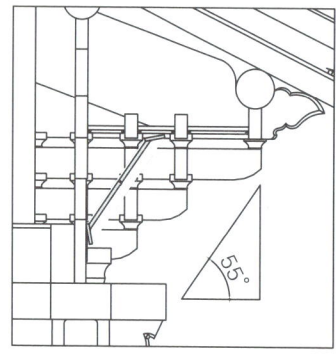 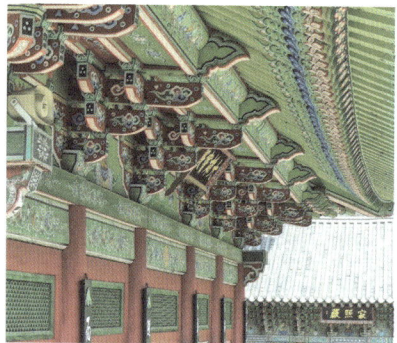

보탑사 목탑 1층 편액(SCALE: 1/20)과 실제 1층 편액 사진

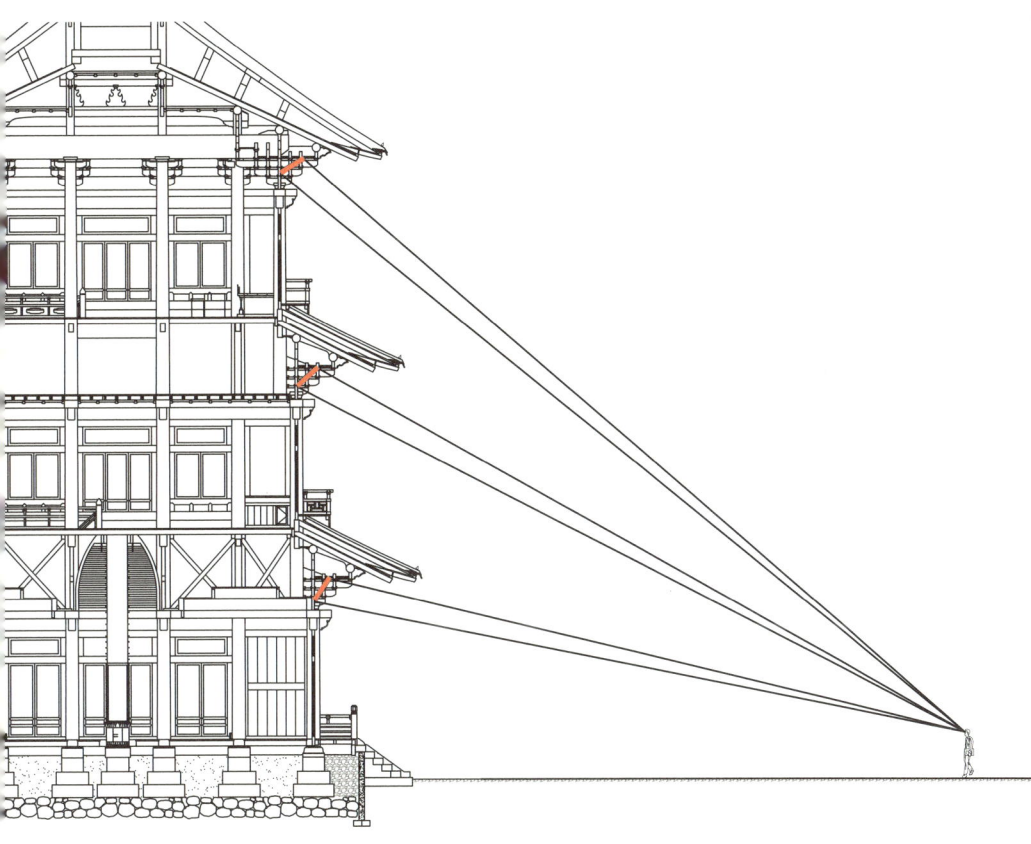

지면에서 바라본 편액의 각도

보첨

처마를 좀 더 길게 빼려고 처음부터 서까래를 길게 쓰기도 하지만, 자칫 지붕이 무거워 보일 수 있기 때문에 서까래를 길게 치목하는 것만이 능사가 아니다. 그럴 때는 서까래 위에 이중으로 덧붙이는 보첨補簷을 하기도 한다.

덧처마라고도 부르는 보첨과 관련한 재미있는 자료가 있는데, 바로 단원 김홍도의 그림 <삼공불환도三公不換圖>이다. 이 그림의 일부에서 조선 후기 사대부들이 살았던 한옥의 형태를 볼 수 있다. 이 그림에 그려진 사랑채의 처마에 송첨松簷이 되어 있는 것이 보인다.

송첨이란 소나무 가지를 잘라서 묶은 서까래로, 처마에 걸어 놓으면 집 안으로 솔향기가 은은하게 들어오면서 햇빛과 비를 막아 준다.

김홍도의 <삼공불환도> 중 일부(리움미술관 소장)

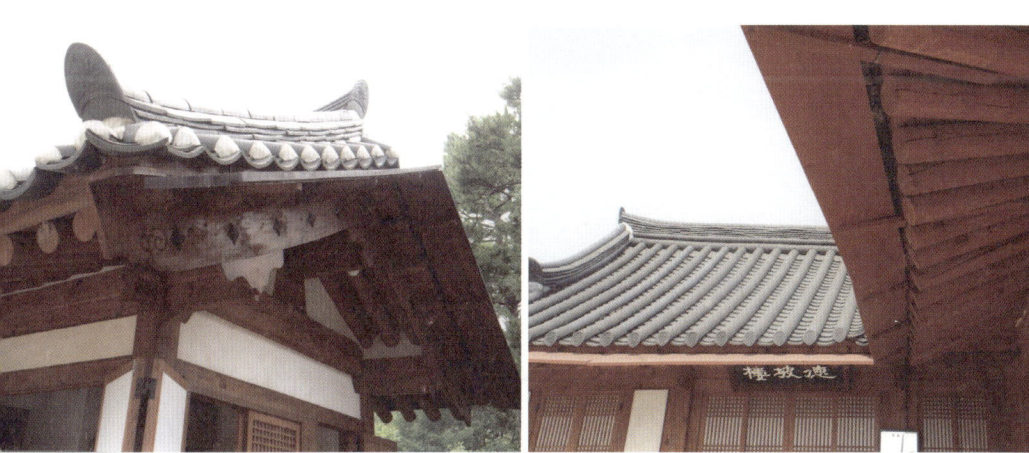

보탑사 미소실의 보첨(왼쪽), 해주 오씨 덕파루의 보첨(오른쪽)

소나무 가지를 처마 밑에 달면 향기도 좋고 소독 효과도 있다. 소나무 밑에서 1시간 쉬는 게 다른 나무 밑에서 10시간 쉬는 것보다 몸에 좋다. 소나무 밑에서는 잡풀도 자라지 않는다. 그래서 우리나라 소나무를 최고라고 한다.

하지만 이런 송첨은 사시사철 즐길 수 없다. 여름 더위와 장마가 지나고 나면 솔잎이 다 말라 버리기 때문이다. 가을이 되어 푸른 솔잎이 붉게 변하면 송첨을 걷어 낸다. 가을에는 비도 적게 오고 집 안에도 햇빛이 들어와야 하므로 걷어 내는 것이 오히려 좋다. 그리고 걷어 낸 소나무는 겨울에 불쏘시개로 썼다. 그러다 이듬해 봄이 되면 다시 소나무 가지를 꺾어 처마 밑에 쫙 걸어 놓았다. 송첨은 일반 백성은 엄두도 못 내고 재력과 권력을 갖춘 양반이나 누릴 수 있는 호사였다.

요즘에는 돈이 있어도 소나무를 함부로 베면 법에 저촉되므로 옛날 양반처럼 송첨을 할 수가 없다. 그래서 재목으로 나온 소나무로 판을 짜서 서까래에 덧붙인다. 그게 보첨이다. 보첨은 처마를 넓게 쓰기 위해 처음 집을 지을 때부터 계획해서 붙이기도 하고, 나중에 필요에 따라 붙이기도 한다.

숨겨진 공간, 암층

 암층은 일반 단층 구조의 건물에서는 찾아볼 수 없는 공간이다. 이 암층의 존재가 높이 42.73m에 이르는 보탑사 목탑이 30년이 넘는 세월을 지나면서도 견고함을 유지할 수 있는 비결이다.

 암층은 목탑의 1층과 2층, 2층과 3층 사이에 있으며, 각 층 지붕의 무게를 분산시키고 구조를 안정적으로 만드는 역할을 한다. 그래서 보탑사 목탑은 겉으로 보기에는 3층 건물이지만, 내부는 2개의 암층을 포함하여 총 5층의 구조를 가진다.

 1층과 2층 사이의 암층은 1층에 사방불이 모셔져 있기 때문에 부처님의 머리를 밟지 않는다는 의미에서 개방하지 않고 있지만, 2층과 3층 사이의 암층에는 세계의 각종 탑파 사진을 전시하고 있으며, 강의실로도 사용하고 있다. 이곳에서 강의를 하면 목재의 공명통 효

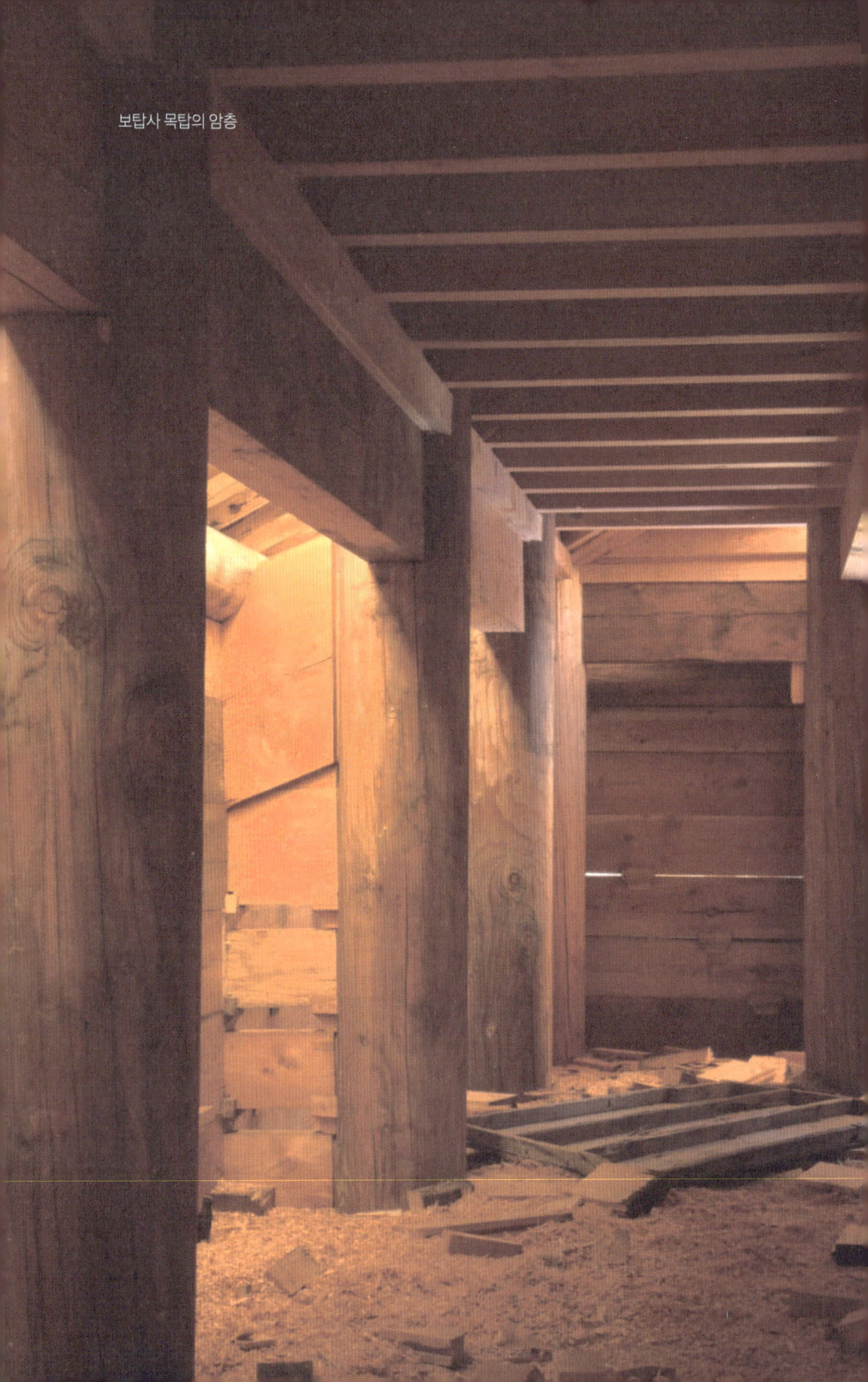

보탑사 목탑의 암층

과 덕에 마이크가 없어도 소리가 구석구석까지 잘 들린다.

지붕의 경사가 급할수록 지붕과 천장 사이에 큰 공간이 생기는데, 암층은 그 공간을 활용해 만든 일종의 다락방 같은 개념이다. 보탑사에 만들어진 암층은 웬만한 건물 1층 높이 정도의 공간이다. 이 암층이 존재하기 때문에 내부 계단으로 오르내리며 각 층을 활용할 수 있는 것이다.

암층 상부는 버팀목에 고정하고 하부는 고정하지 않았다. 상부와 하부를 전부 고정하면 지진이나 흔들림에 약하고 뒤틀림이 있기 때문이다.

연봉으로 장식한 기와 잇기

보탑사 목탑의 지붕에 올릴 기와는 폭이 대와(32㎝)보다는 작고, 중와(30㎝)보다는 큰 31.5㎝ 크기의 기와를 별도로 제작해 사용하였다. 기와를 이을 때는 흙을 최대한 줄여서 작업했다. 홍두깨흙(수키와가 붙어 있도록 그 밑에 괴는 반죽한 흙)을 제외하고는 바닥 흙도 사용하지 않았다. 대신에 이중으로 바닥을 만들어 바닥기와를 고정하는 기법을 개발하였다. 이는 만일 기와가 깨져도 비가 새지 않도록 하자는 생각에서 시작했는데, 작업은 쉽지 않았지만 중도에 번와翻瓦 할 일은 드물게 되었다.

일반적으로 한옥은 기와를 잇기 전 지붕에 강회다짐과 보토補土를 하는데, 이 과정을 생략한 것이다. 가뜩이나 중층으로 인해 하방의 무게가 무거운 터라, 흙의 무게로 지붕이 무거워지면 탑 전체가 받는

보탑사 기와 잇기

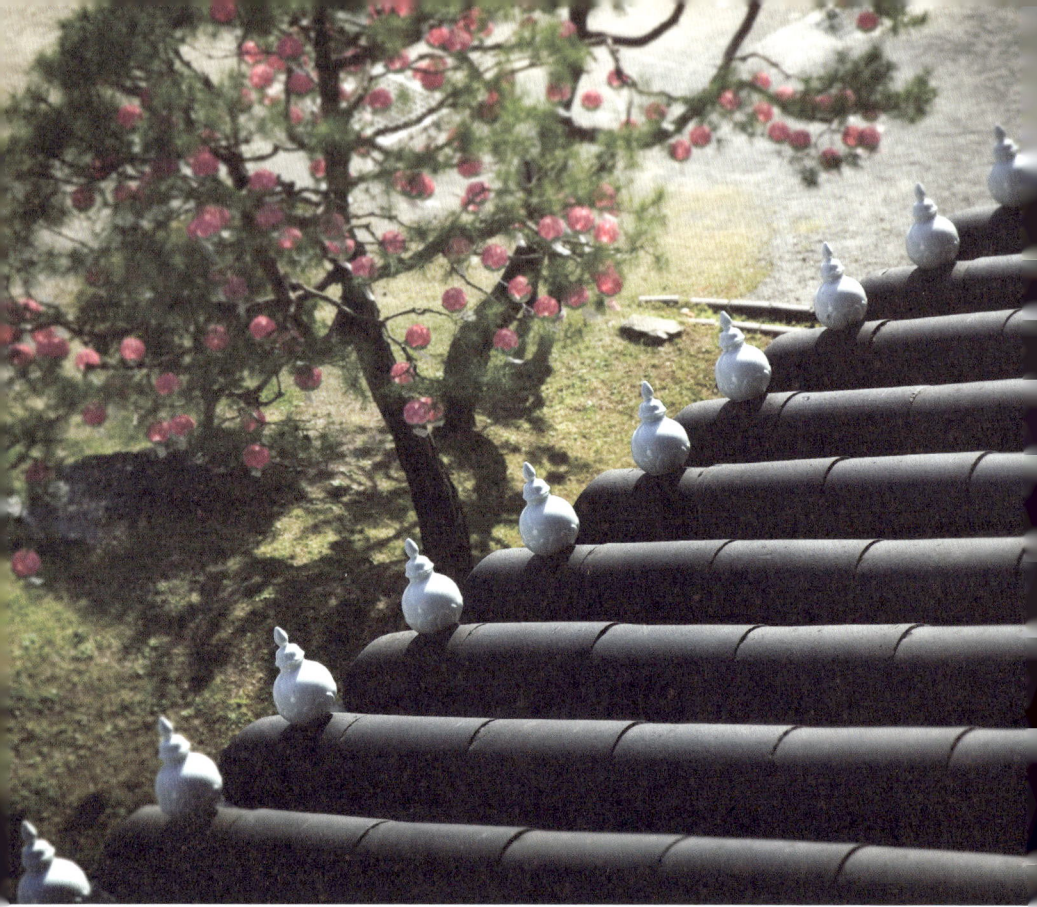

보탑사 목탑 처마 끝의 백자 연봉

하중이 더 커질 것을 우려했기 때문이다. 대신 삼각형 나무틀로 기와 골을 짜고 그 위에 기와를 얹었다. 그리고 기와는 바람에 날아가지 않도록 구리줄로 묶어 처마 끝 수막새 등에 연정椽釘을 박아 고정시켰다. 이때 기와 밖으로 노출된 무쇠로 만든 연정은 쉬이 부식할 수 있기 때문에 이를 방지하고자 백자로 연봉蓮峰을 만들어 꽂았다. 경험에서 터득한 지혜이다. 중국에서는 주로 동물 형태의 연봉을 만들어 썼지만 우리나라에서는 주로 연꽃 같은 식물 형태의 연봉을 만들어 썼다.

대개 여름 장마가 시작되기 전, 혹은 추운 겨울이 시작되기 전까지 지붕을 완성하도록 작업 일정을 짠다. 만약 장마나 혹한이 닥치기 전에 지붕을 올리기 힘든 시기라면 아예 시작하지 말고 장마나 혹한이 끝난 뒤로 공사를 미루는 것이 현명하다.

특히 기와 잇기는 흙을 바르는 작업이 함께 이루어지기 때문에 비나 눈이 올 때는 작업하기 힘들다. 일단 기와 잇기까지 끝나면 나머지 작업은 비가 와도 지붕 아래서 할 수 있으니 여러모로 유리하다. 하지만 벽선이나 내부 목공사는 지붕을 끝낸 후 3일이나 5일 후에 해야 한다. 그래야 목재가 휘어지는 것을 막을 수 있다.

꼭대기를 장식하는 상륜 올리기

보탑사 목탑의 3층 지붕 공사를 마무리한 뒤 꼭대기에 상륜을 설치했다. 상륜이란 불탑 꼭대기에 올리는 원기둥 모양의 쇠붙이를 말한다. 이 장식이 피뢰침 역할까지 할 수 있도록 시공했다.

목조 건물에서 가장 우려되는 것은 벼락이다. 지금 우리가 사용하는 피뢰침은 18세기에 서양에서 고안해 낸 것이다. 그렇다면 그 옛날 우리 선조들은 벼락을 어떻게 해결했을까? 그 해답을 찾기 위해 공사를 하다 말고 인도로 건너가 보름 정도 머물며 그곳의 방식을 조사해 보니, 인도에서는 주로 구리철사를 이용하고 있었다.

돌아와서 곧바로 상륜 제작에 들어갔다. 상륜은 최교준 야철장이

만들었는데, 옛날식으로 만들지 현대식으로 만들지 고민하다 결국 두 가지 방식을 적절히 혼합하기로 했다. 우선 동(구리)으로 상륜의 몸체를 만들고, 백금으로 벼락을 막기 위한 피뢰침을 설치하기로 하였다. 여기에 들어간 백금만 해도 80냥 정도나 되었다.

상륜을 다 만들었다면 그 위에 옻칠을 해야 상륜에 벼락이 떨어지는 것을 막을 수 있다. 나이가 지긋하신 옻칠 전문가를 모셔 왔다. 그는 동 표면이 뜨거워야 옻이 잘 입혀진다며 큰 온돌방에 상륜을 집어넣고는 아궁이에 장작불을 때게 했다. 그렇게 달궈진 방은 온도가 어찌나 높은지 숨을 쉬기도 어려울 정도였다. 그런 곳에 들어가 옻칠을 하다니, 전문가는 전문가였다.

그렇게 제작된 상륜은 높이가 33자(약 10m)나 되었다. 땅 위에서 일차로 조립해 보니 크기가 상당해서 너무 큰 게 아닌가 걱정이 되었다. 하지만 제자리에 올려놓고 보니 크기가 적당했다. 여간 다행스러운 게 아니었다.

상륜 중앙에 세운 피뢰침 봉은 생각보다 짧아서 제구실을 하기 어렵다는 지적을 받았다. 어떻게 해결해야 할지 또다시 고민에 빠졌다. 계획한 것에서 벗어나면 자칫 균형이 깨지지 않을까 걱정스러웠다. 단순히 쇠막대를 더 높이는 건 성의 없게 느껴졌다. 그래서 둥근 구슬 두 개를 장식으로 끼워 올렸다. 결과적으로 비례도 딱 맞고 보기

에도 좋았다.

　상륜이 자리를 잡은 후에는 사방으로 동자상을 세워 상륜과 줄로 연결하였다. 이 부분은 보탑사 목탑이 어떤 심성으로 일반에게 보여질 것인가를 고민한 결과로, 천상에서 네 동자승이 목탑에 줄을 매고 내려오는 장면을 연출한 것이다. 불교에서 말하는 '미륵 하생경(미륵불이 세상에 내려와 중생을 구제한다는 내용의 경전)'의 뜻을 담고자 했다. 밑에서 올려다보면 동자상의 크기가 작아 보이지만 실제 크기는 80㎝가 넘는다. 처음에는 동자상을 30㎝ 정도 크기로 만들었다. 그런데 지붕 위에 설치하고 밑에서 보니 작은 점으로밖에 보이지 않았다. 그래서 다시 크게 만든 것이다.

　이처럼 보탑사 목탑은 어느 한 곳도 그저 만들지 않았다. 세세한 부분까지 시각적으로도 많은 신경을 썼다. 보탑사 목탑의 상륜과 동자상은 그러한 노력의 산물이라고 할 수 있다.

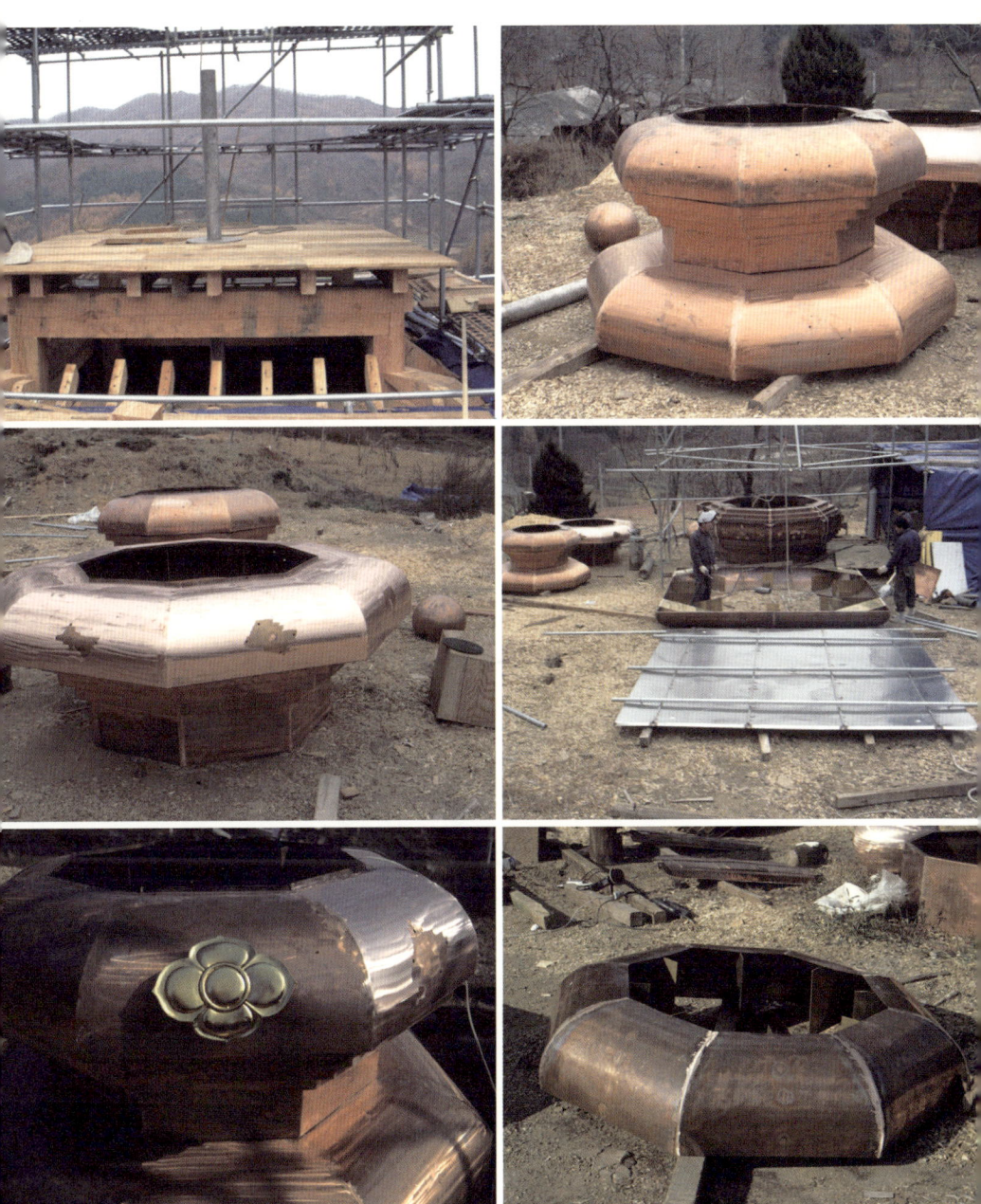

상륜 시공 과정

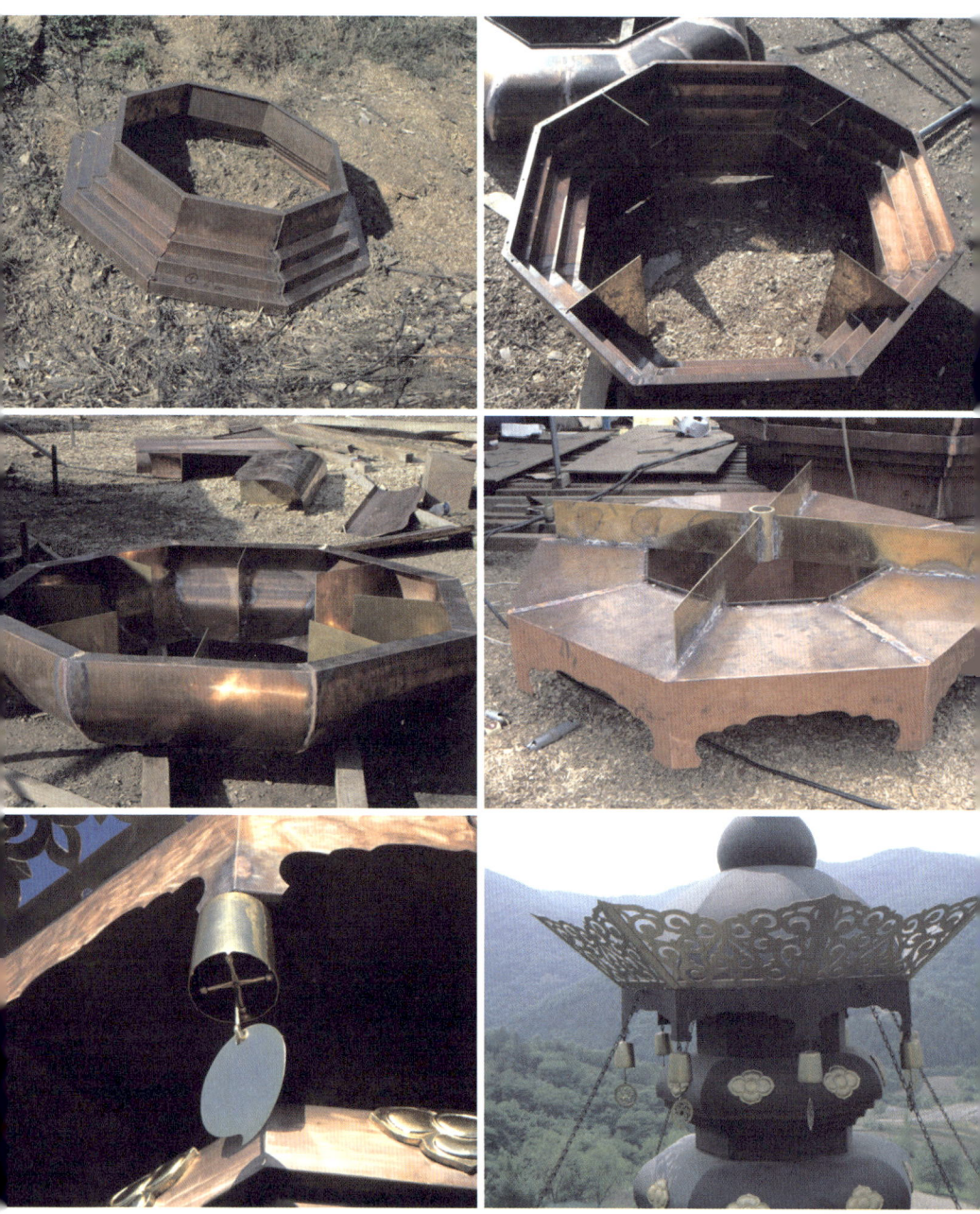

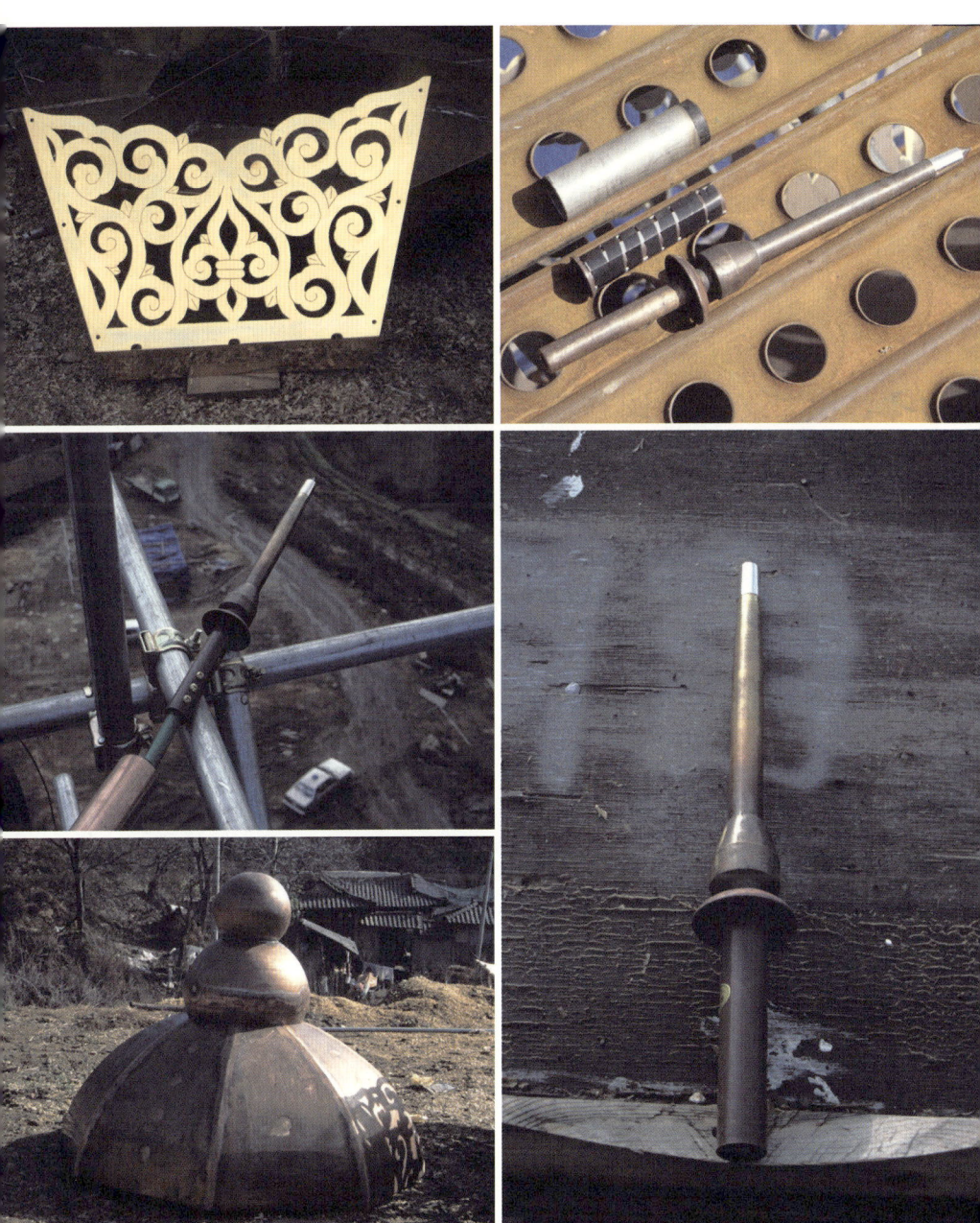

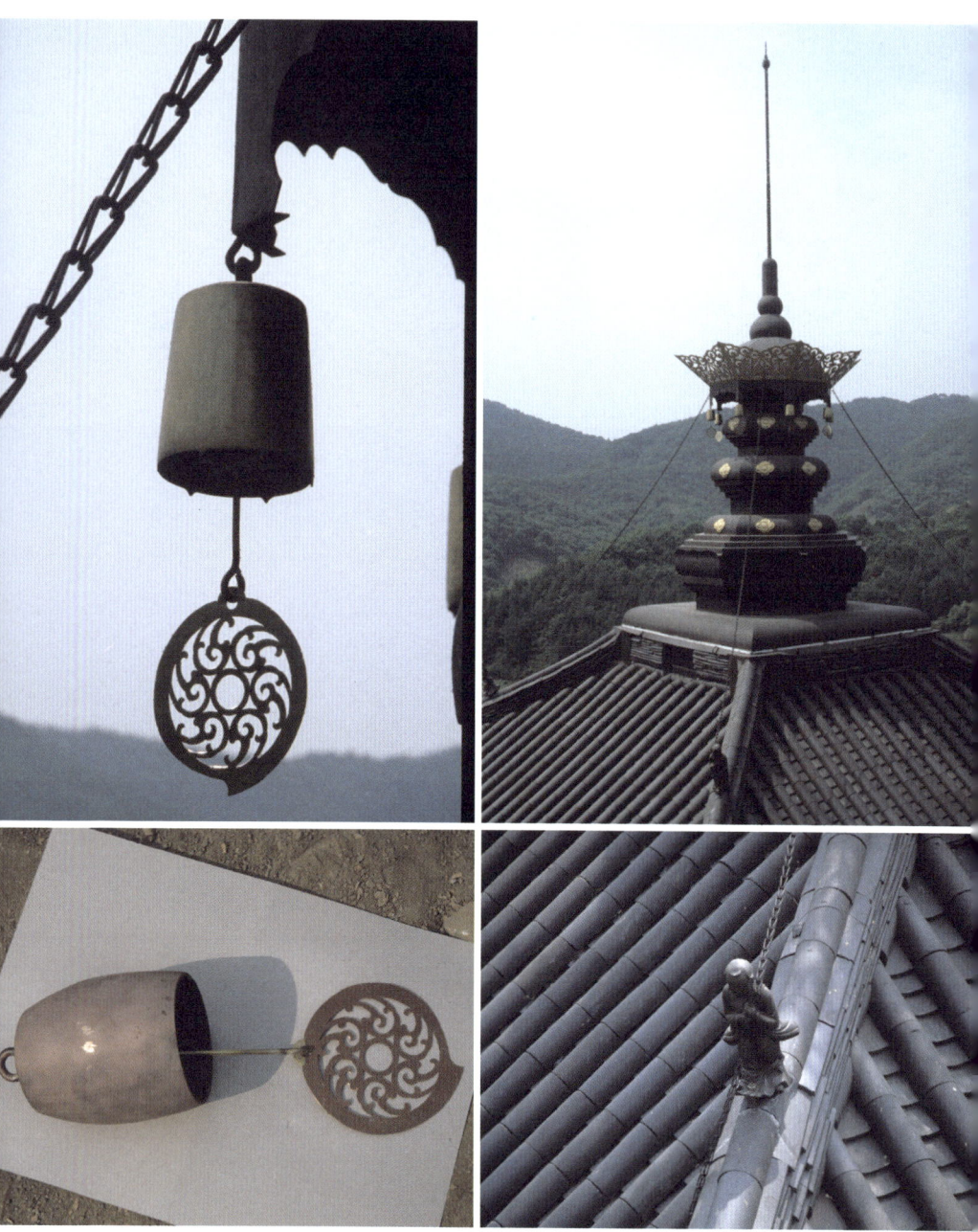

보탑사 상륜과 동자상

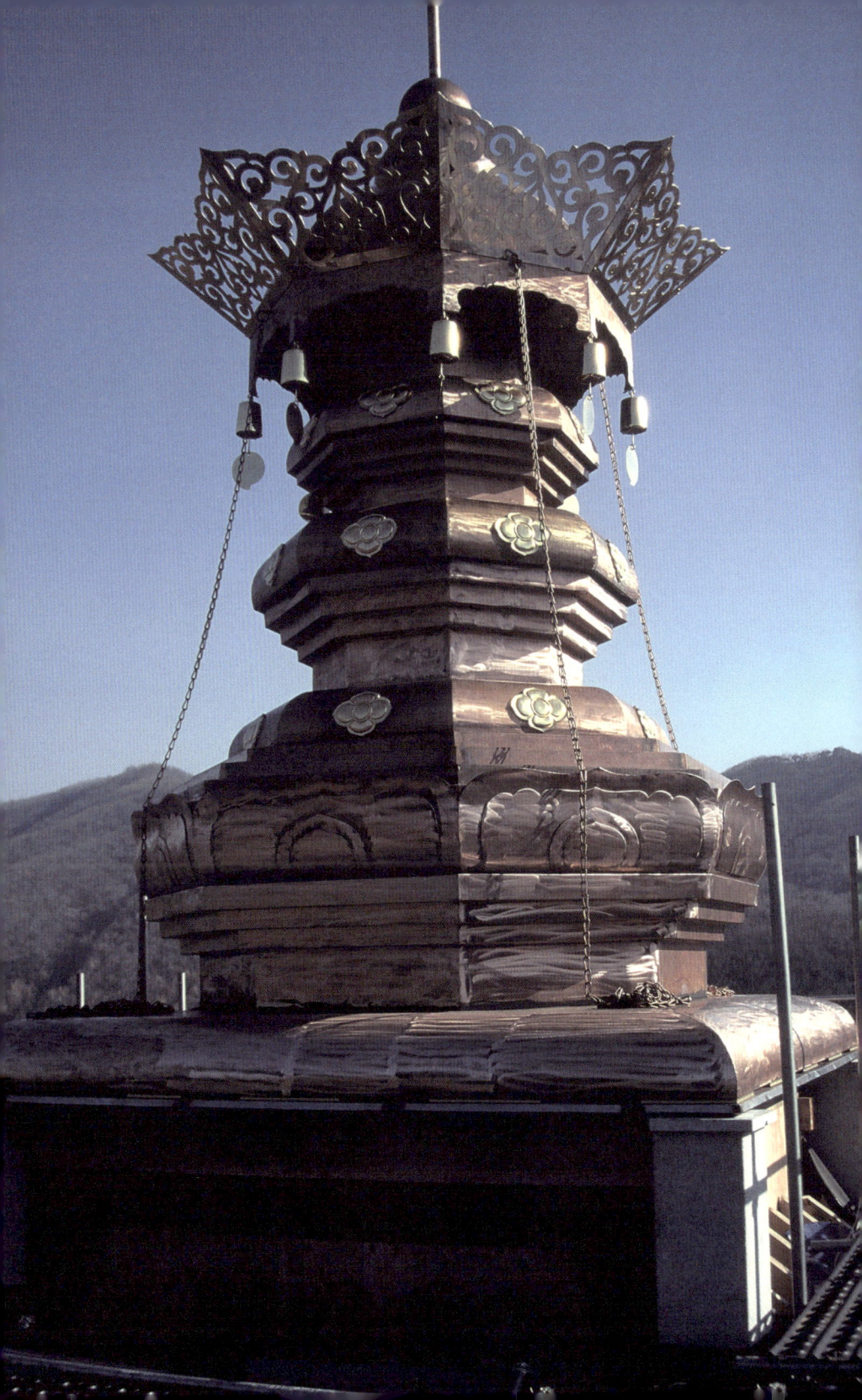

오래도록 빛나는 단청

보탑사의 단청은 지금은 세상을 떠나신 한석성 선생께서 작업해 주셨다. 당시 내가 선생께 단청 작업을 의뢰하면서 드렸던 말이 있다.

"선생님께서 달라시는 금액을 드리겠습니다. 내일 아침에 단청을 다 그렸다고 하셔도 그 금액을 드릴 겁니다. 하얗게 칠해도, 까맣게 칠해도 그 금액을 다 드릴 겁니다. 그러니 선생님 손과 마음이 가는 대로 한번 해 보십시오. 그리고 지금 이 시간부터 설계하시는 분이나 감리하시는 분이나 스님에게 선생님께서 단청으로 뭘 그리시든 아무 소리도 하지 말라고 하겠습니다. 까마귀를 그리든, 까치를 그리든, 참새를 그리든, 연꽃을 그리든 아무도 선생님께 말하지 말라고 하겠습니다. 저는 보탑사 목탑의 단청이 선생님의 작품으로 후대에 길이

길이 남는다면 그것으로 됐습니다."

그러고 나서 6개월 뒤에 단청이 마무리되었다. 일이 끝나고 내가 약속한 금액을 드렸더니 선생께서는 그중 1,200만 원을 돌려주면서 이렇게 말씀하셨다.

"이 사람아, 내가 이번에 단청 한번 마음대로 해 봤네. 이 돈은 작업 중에 들어간 돈을 뺀 내 수입인데 내가 안 가지려네. 자네가 공사비에 보태 쓰게나."

그러고는 미련 없이 뒤돌아 가시는 모습을 보며, 장인의 마음이라는 게 이런 것이라는 걸 다시 한번 느꼈다. 이후에 선생께서는 한 TV 프로그램에 출연해 이렇게 말씀하셨다.

"내 평생 단청을 딱 한 번 제대로 한 것 같다. …… 그동안 많은 단청을 그렸지만 아무런 간섭을 받지 않고 내 마음대로 단청을 그린 것은 보탑사 목탑 하나뿐이다."

자신의 최고 작품으로 보탑사 목탑을 꼽으신 것이다. 그 말씀에 내가 도로 고맙고 기뻤다. 한석성 선생이 1996년에 끝마친 보탑사 목탑의 단청은 아직까지도 깨끗하다. 그때 당시 재료도 천연 안료로 좋은 걸 썼다. 그림도 더할 나위 없이 잘 그려 지금 봐도 참 아름답다. 혼신

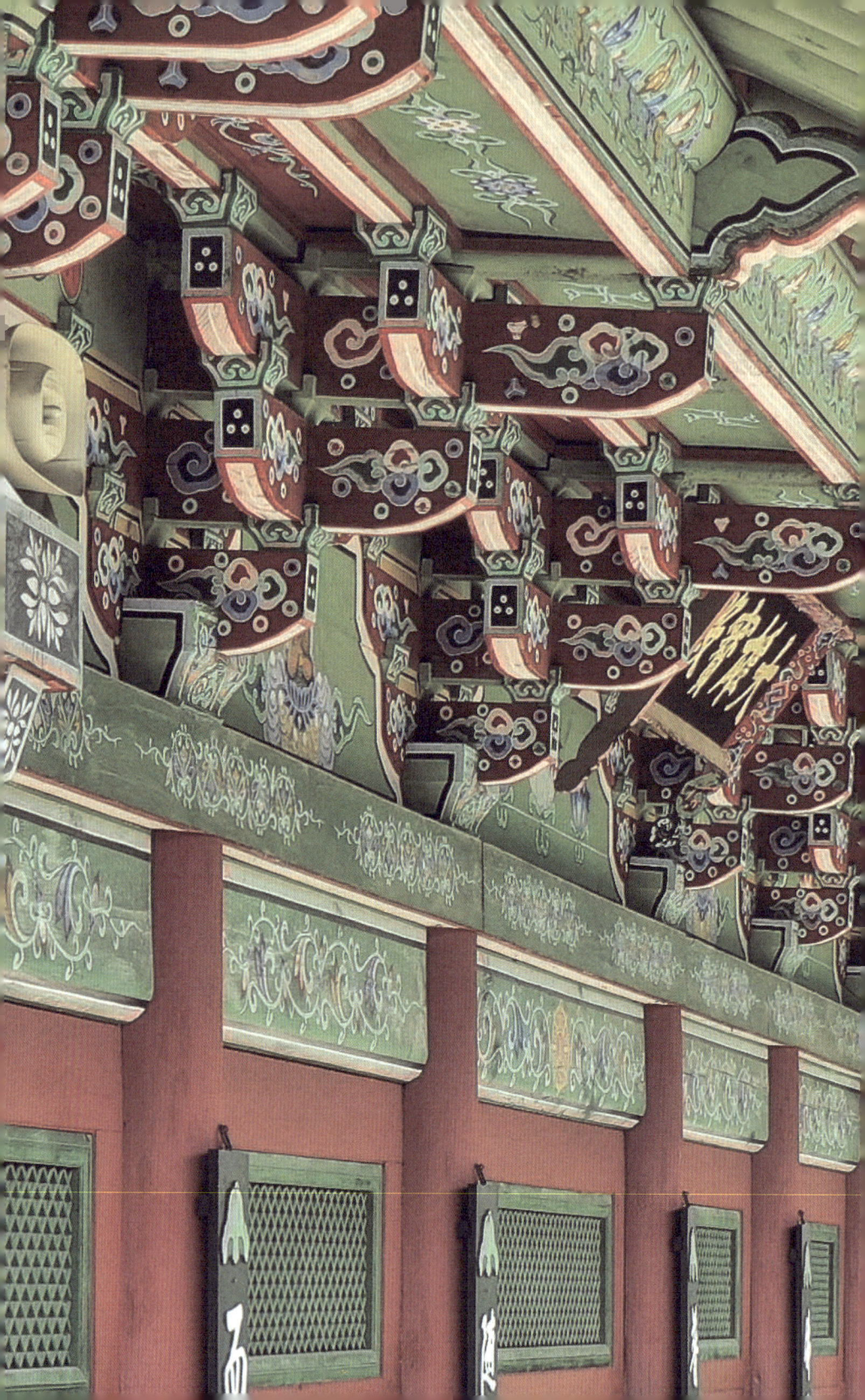

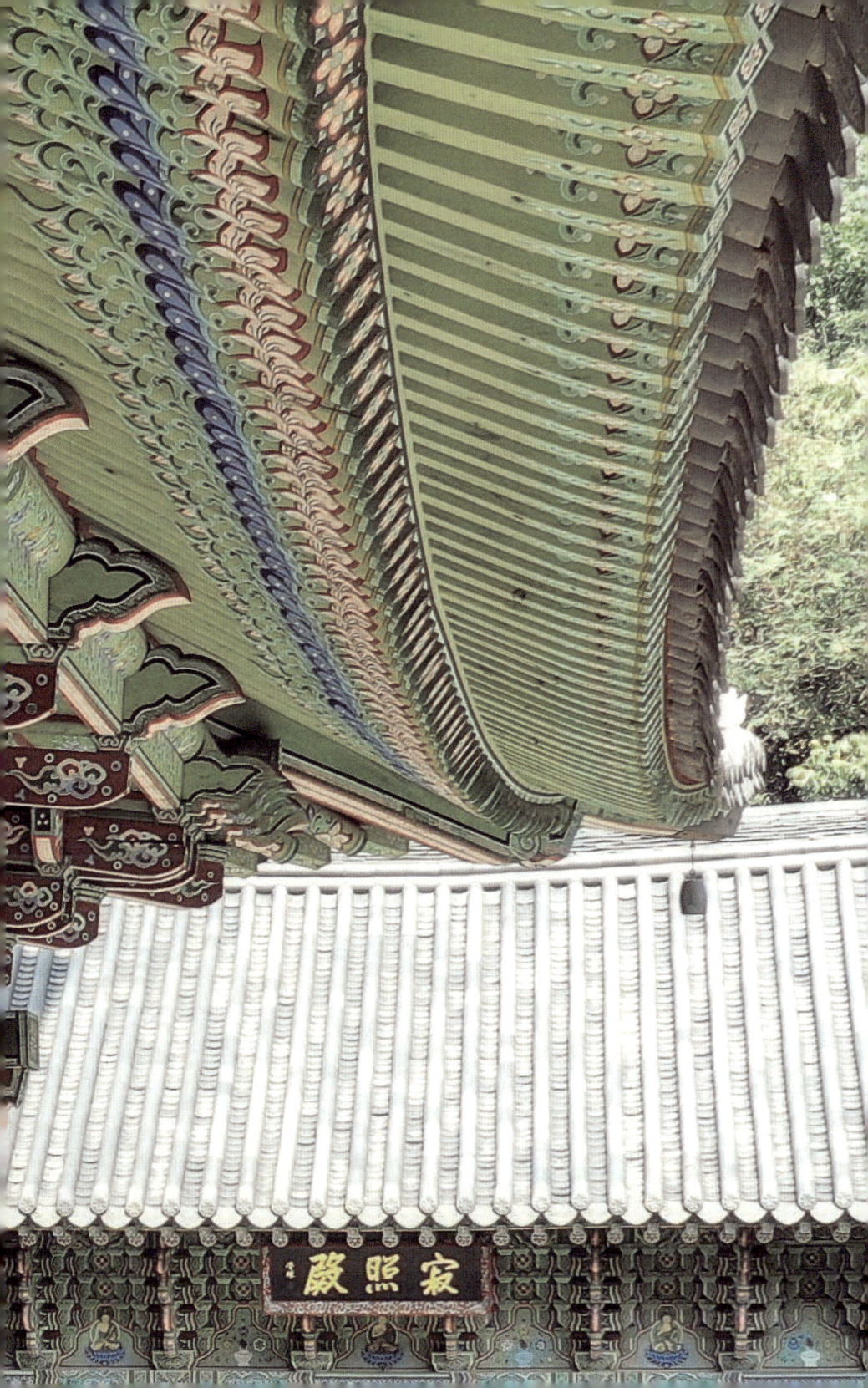

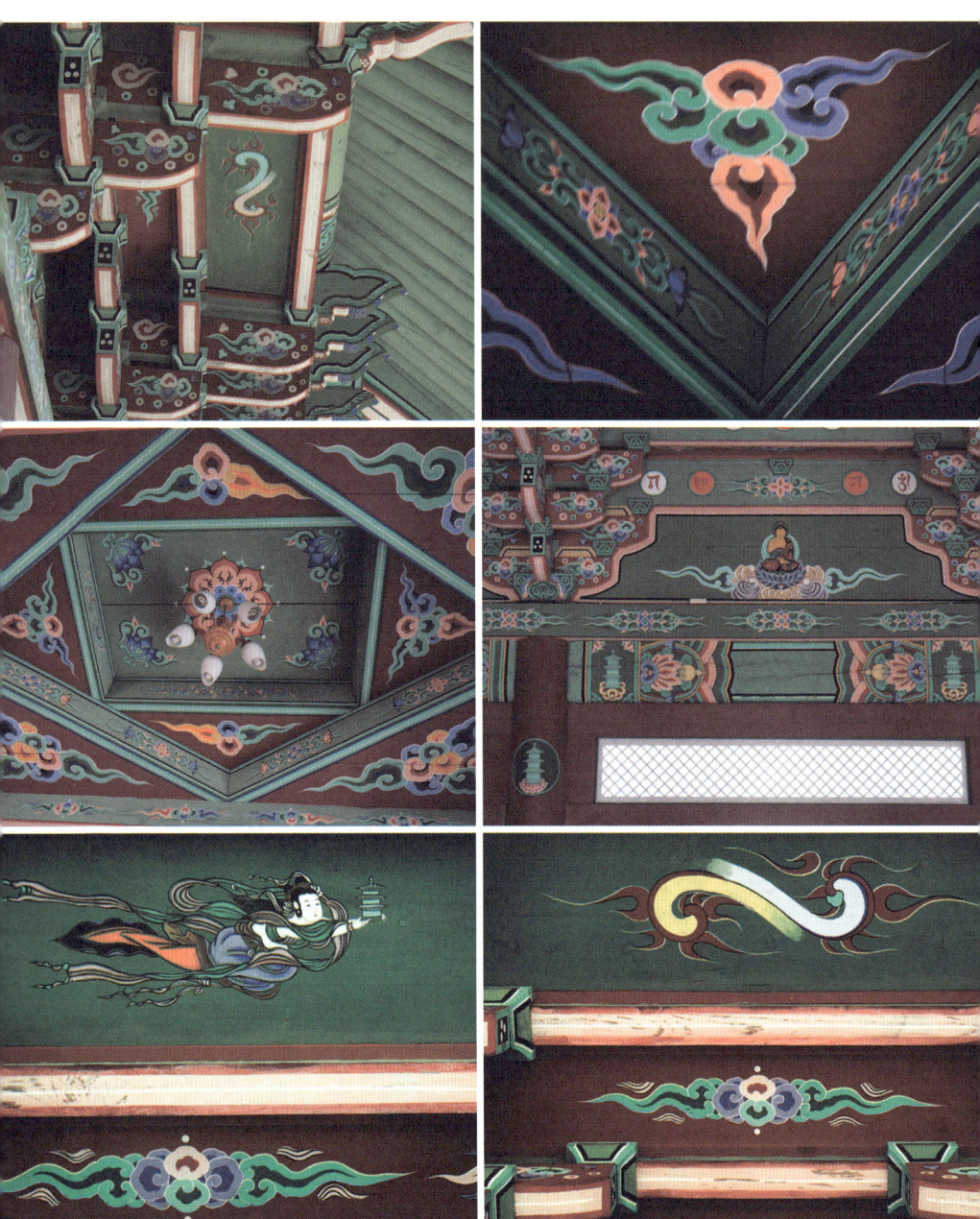

보탑사의 아름다운 단청

의 힘을 다한 장인의 손길이 담긴 이 단청은 아주 오래도록 빛날 것이다.

보탑사 목탑의 단청은 여느 단청에서는 볼 수 없는 장엄함을 보여준다. 탑을 지을 때부터 미리 출목의 간격을 넓게 하여 비천상飛天像을 그릴 바탕을 마련하는 등 사전 준비가 철저하기도 하였지만, 한석성 화사가 파격적인 무늬를 구사하면서 심혈을 기울여 완전한 창작물을 숙성시켰기 때문이다.

보탑사 단청의 무늬는 그 구성 기조가 층마다 제각기 다르다. 그러나 서로 다른 특색을 유지하면서도 탑 전체가 하나의 단청으로 정리되어 보인다. 이런 조화로운 통일성 덕분에 보는 이에게는 보탑사가 더 아름답게 완성된 모습으로 다가온다.

층마다 개성이 넘치는 내부 모습

1층 금당

보탑사 목탑 1층은 본당인데, 금당金堂이라고도 불린다. 가운데 찰주를 중심으로 네 귀퉁이에 사천주를 세우고, 사천주 사이의 동서남북 각 방향에 비로자나불, 석가모니불, 아미타여래불, 약사유리광불을 모셨다. 이를 사방불이라 하는데, 모든 곳에 부처가 존재한다는 의미다. 흔히 불전은 탱화 앞에 부처님을 모신 형식이 일반적이어서 이 사방불 형식이 낯설지도 모른다. 이는 보탑사 목탑을 삼국 시대의 양식으로 재현하면서 그 내부 역시 그 시대의 형식에 따라 부처를 모신 것이다.

사방불은 부처의 진리가 사방으로 퍼져 나가길 기원하는 것인 동시에 남북통일의 염원을 담고 있다. 그래서 보탑사 목탑을 통일대탑

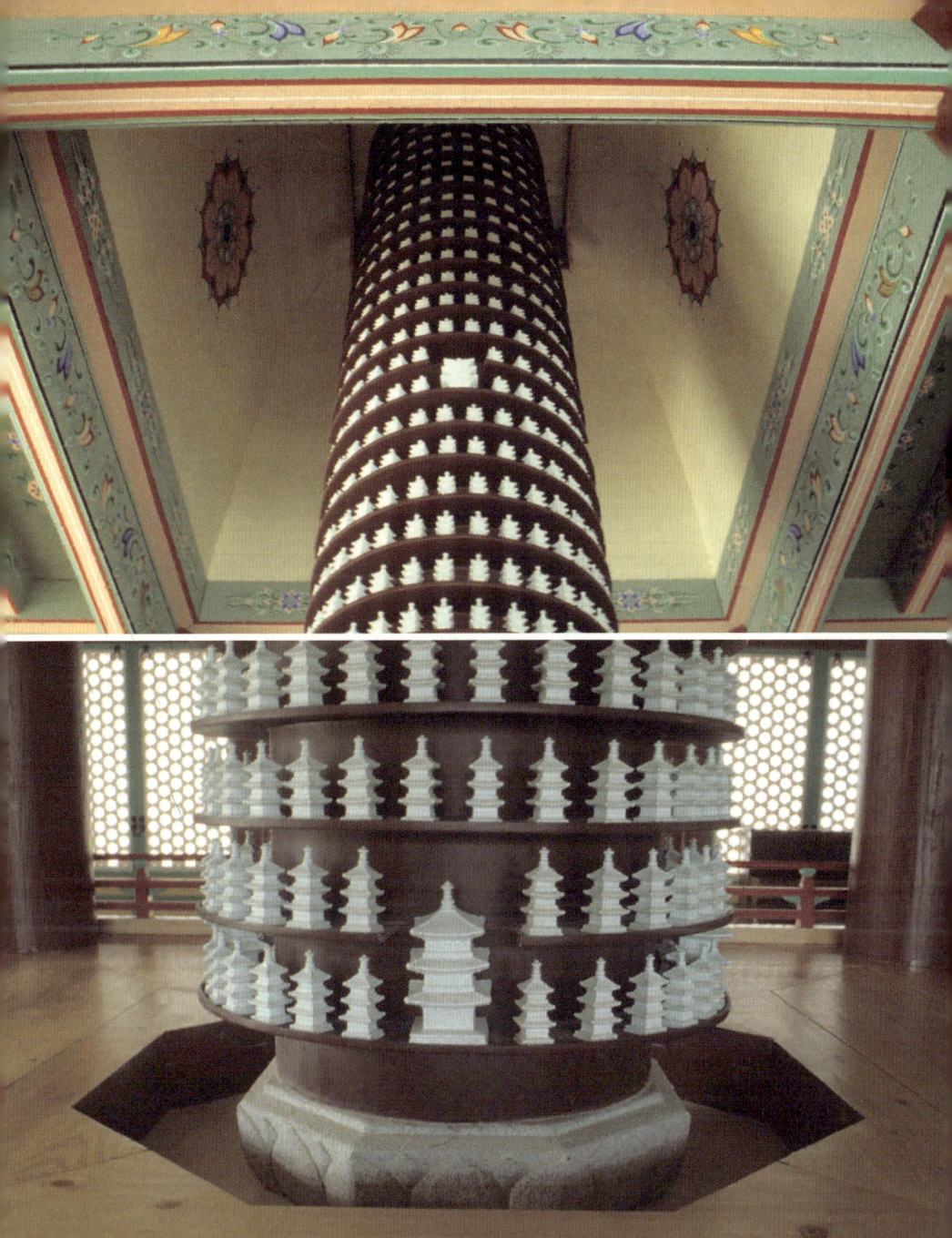

중앙 찰주에 봉안한 999기의 백자 소탑

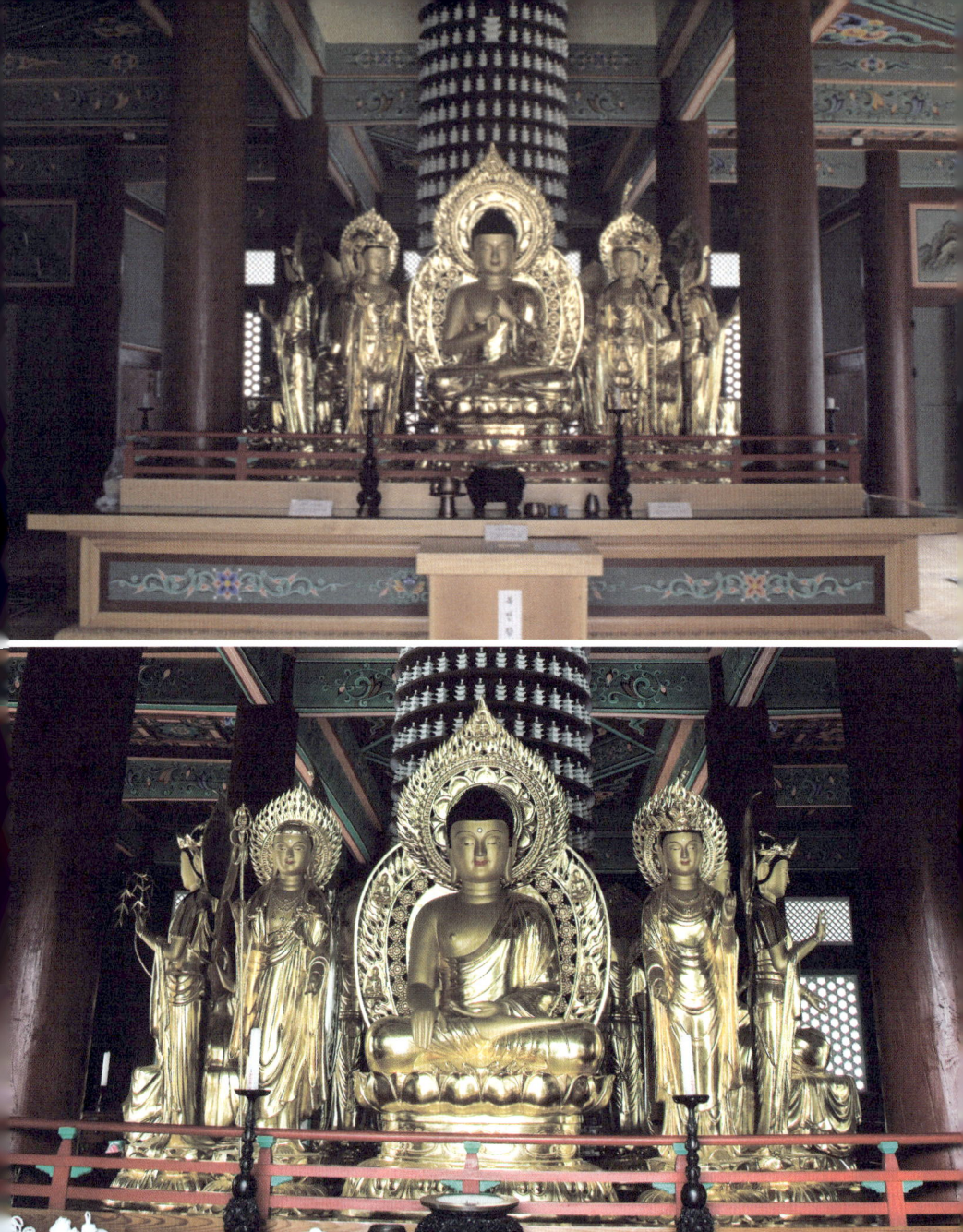

북방 적광보전 비로자나불(위), 남방 대웅보전 석가모니불(아래)

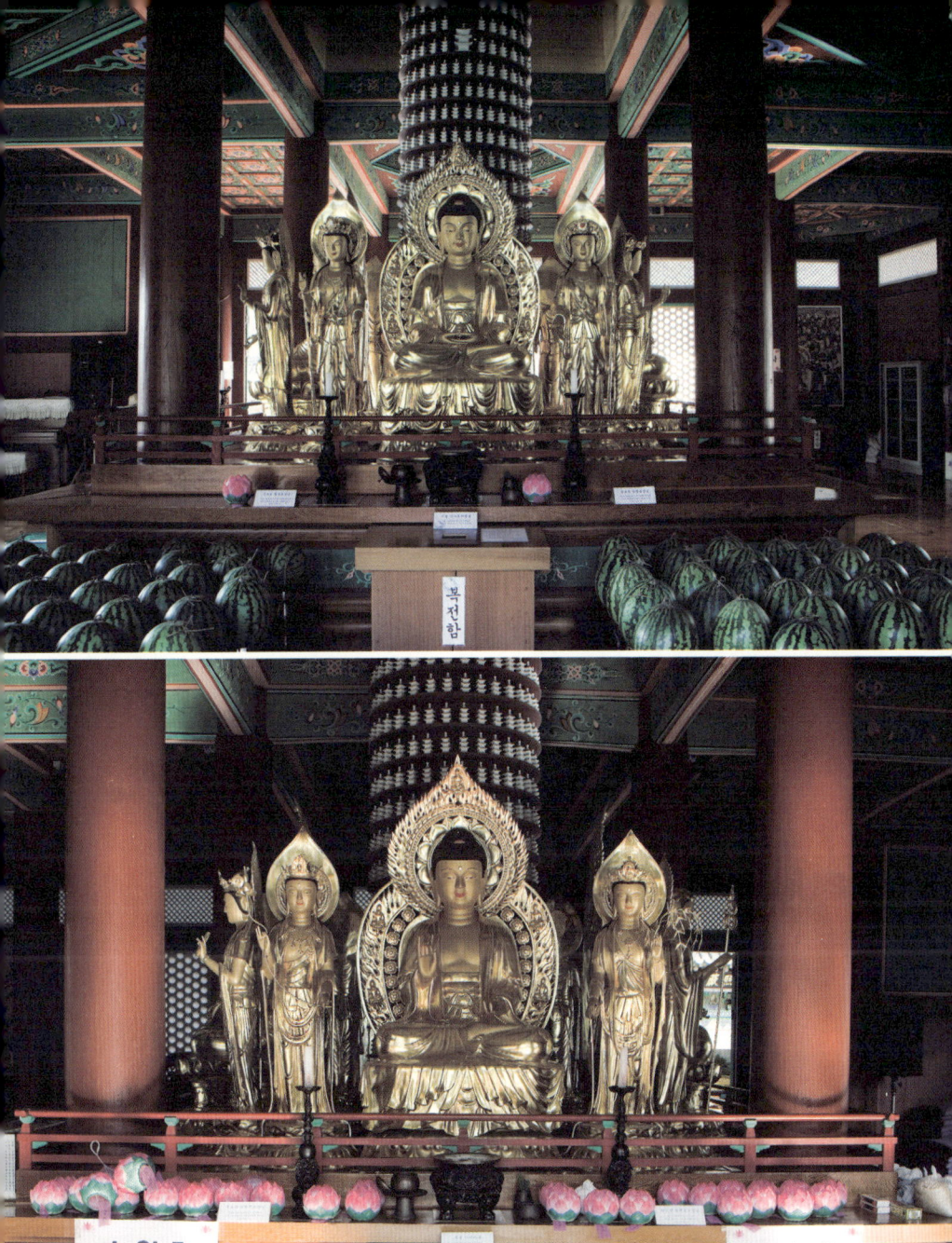

동방 약사보전 약사유리광불(위), 서방 극락보전 아미타여래불(아래)

이라고도 부른다. 사방불 안쪽 중앙 찰주에는 신도들의 불심과 정성이 담긴 999기의 백자 소탑을 봉안했다.

이 중 중생의 고통을 없애 준다는 약사유리광여래 앞은 특별한 공간이다. 4월 초파일 그 앞에 여름 수박을 올리면 동짓날까지 썩지 않고 그대로 있다. 신기한 일이 아닐 수 없다. 이 수박은 11월 동짓날 기도를 올린 후 신도들이 함께 나눠 먹는다.

2층 법보전

목탑의 2층 법보전法寶殿에는 부처님을 모시는 대신, 부처님 말씀이 들어 있는 회전형 서가인 윤장대輪藏臺를 설치했다. 티베트나 네팔에 가면 손으로 돌리는 마니차摩尼車라는 것이 있는데, 그와 같은 원리로 만들었다. 경전을 넣어 둔 윤장대를 돌리면 그 안에 있는 불교의 가르침이 내 안으로 들어온다는 믿음이 담겨 있다. 글을 몰라 교리를 공부할 수 없었던 사람들을 위해 만든 윤장대와 팔만대장경 번역본이 안치되어 있다.

암층

보탑사 목탑의 2층과 3층 사이에 숨어 있는 공간이다. 전시실과 강연장으로 유용하게 사용되고 있다. 건물 외부에서 보았을 때는 보이지 않아 암층이라 부르지만, 천장이 높아서 전혀 불편함이 없는 공간이다.

2층 법보전(위), 2층과 3층 사이의 암층(아래)

2, 3층 외부에는 난간을 설치해 탑을 한 바퀴 돌아볼 수 있도록 했다.

3층 미륵전

3층 미륵전

보탑사 목탑의 3층은 인자한 미소를 머금은 미륵불을 모신 미륵전 彌勒殿이다. 이곳에 올라서서 주변 경관을 바라보는 것만으로도 경건한 마음을 갖게 한다. 마치 연화산의 아홉 봉우리가 보탑사를 둘러싸며 지켜 주는 듯한 인상을 준다.

2층 법보전과 3층 미륵전 주위로 마루 난간을 설치해 탑돌이하듯 한 바퀴 돌아볼 수 있도록 했는데, 지금은 안전상 출입을 제한하고 있다. 마루 난간의 각도가 살짝 기울어져 있는 이유는 빗물이 잘 빠지게 하기 위해서이다.

보탑사를 구성하고 있는 건물들

보탑사에는 3층 목탑 외에도 여러 부속 건물이 있다. 그 건물들 가운데 어느 것 하나도 똑같이 지은 것이 없다. 기와집, 너와집, 귀틀집 등 그 종류도 다양하다. 같은 기와집이라도 지붕 형태를 팔작지붕, 맞배지붕, 모임지붕으로 다르게 지었다. 용마루가 없이 모든 지붕면이 지붕 꼭대기의 한 지점으로 모이는 모임지붕은 다시 지붕의 각을 4각, 7각, 8각, 9각으로 다양하게 만들었다. 상륜 역시 토기, 돌, 구리, 놋쇠 등 다양한 재료를 사용하여 건물을 바라보는 재미를 더했다.

지장전과 영산전

지장전地藏殿은 지장보살을 주불主佛로 모신 전각이다. 지장보살은 석가모니 부처님으로부터 사바세계에 미륵불이 출현하기까지 죽은

지장전과 그 옆에 세워진 자연석

영산전(나한전) 외부와 내부

이의 영혼을 모든 고통에서 벗어나도록 구원해 주는 보살이다.

영산전靈山殿은 500나한五百羅漢을 모신 전각이다. 영산전의 지붕은 8각이고, 상륜은 구리로 만들어졌다. 영산전에 모셔져 있는 500나한의 모습은 크기도 모양도 제각각이다. 반듯하게 획일적으로 줄 서 있는 나한이 아니다. 그런 다양한 모습의 500나한 속에 신도 한 사람, 한 사람의 기원이 담기도록 조성했다. 영산전 벽에는 벽화를 그려 넣었는데, 북쪽에는 히말라야 설산을, 동쪽에는 중국 환인에 있는 고구려의 오녀산성을, 남쪽에는 아름답게 꽃이 피어난 모습을 그렸다. 내 나름대로 불교가 우리나라에 전파되어 들어온 과정을 표현하고 싶었다. 앞으로 전통 건축가들이 다양한 상상력을 발휘해 아름다운 절을 많이 지었으면 하는 바람에서 시도해 본 것이다.

적조전

적조전에는 열반상을 모셨다. 그 열반상을 제작하기 위해 부처님이 열반에 이르렀다고 알려진 장소인 인도의 쿠시나가르에 가서 그곳 부처님의 전신을 측량해 왔다. 그리고 측량한 것과 똑같이 만들어서 모셨다.

산신각과 삼소실

산신각은 우리나라 전통 가옥 양식 중 하나인 귀틀집으로 지었다. 언뜻 보기에 서양의 통나무집과 비슷하게 생겼지만, 서양의 통나무집은 나무와 나무를 깎아서 붙이는 반면, 보탑사의 귀틀집은 생긴 대

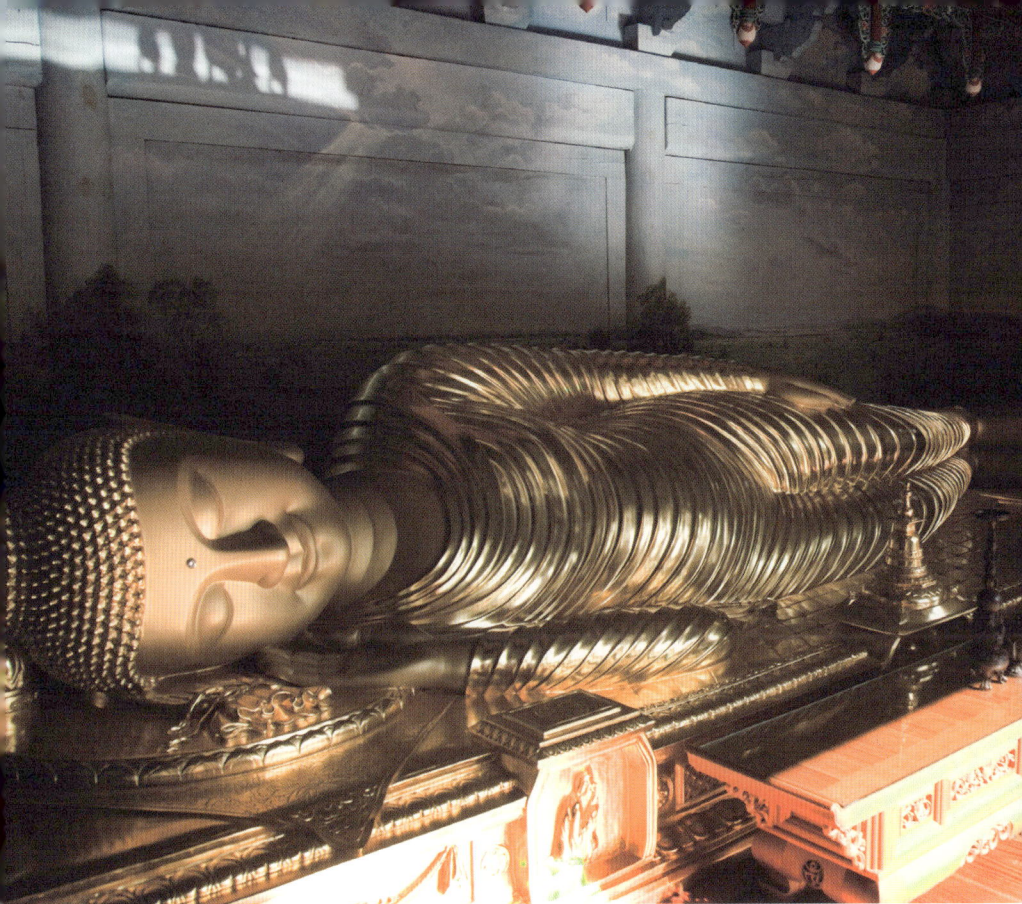

부처님의 열반상을 모신 적조전

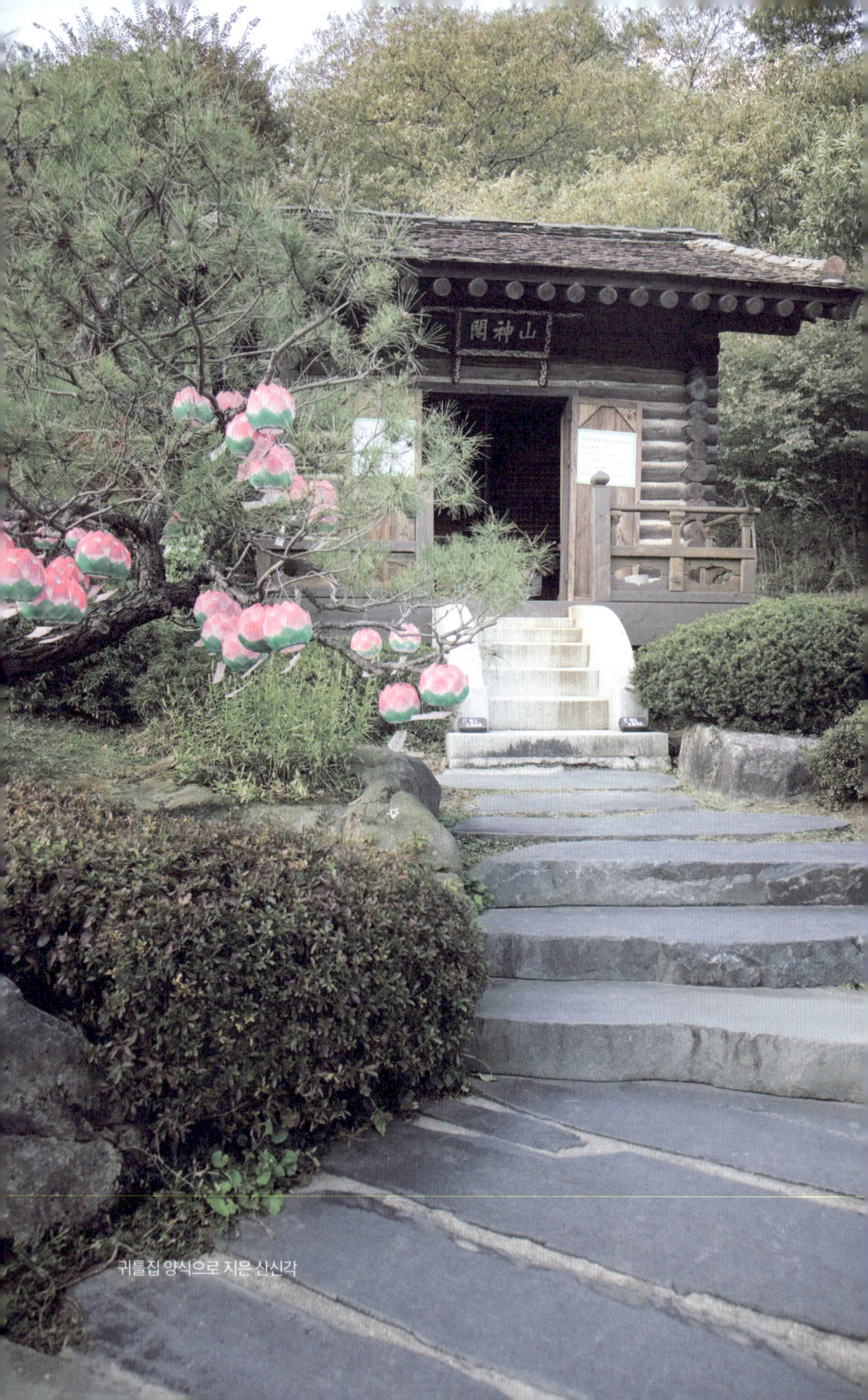

귀틀집 양식으로 지은 산신각

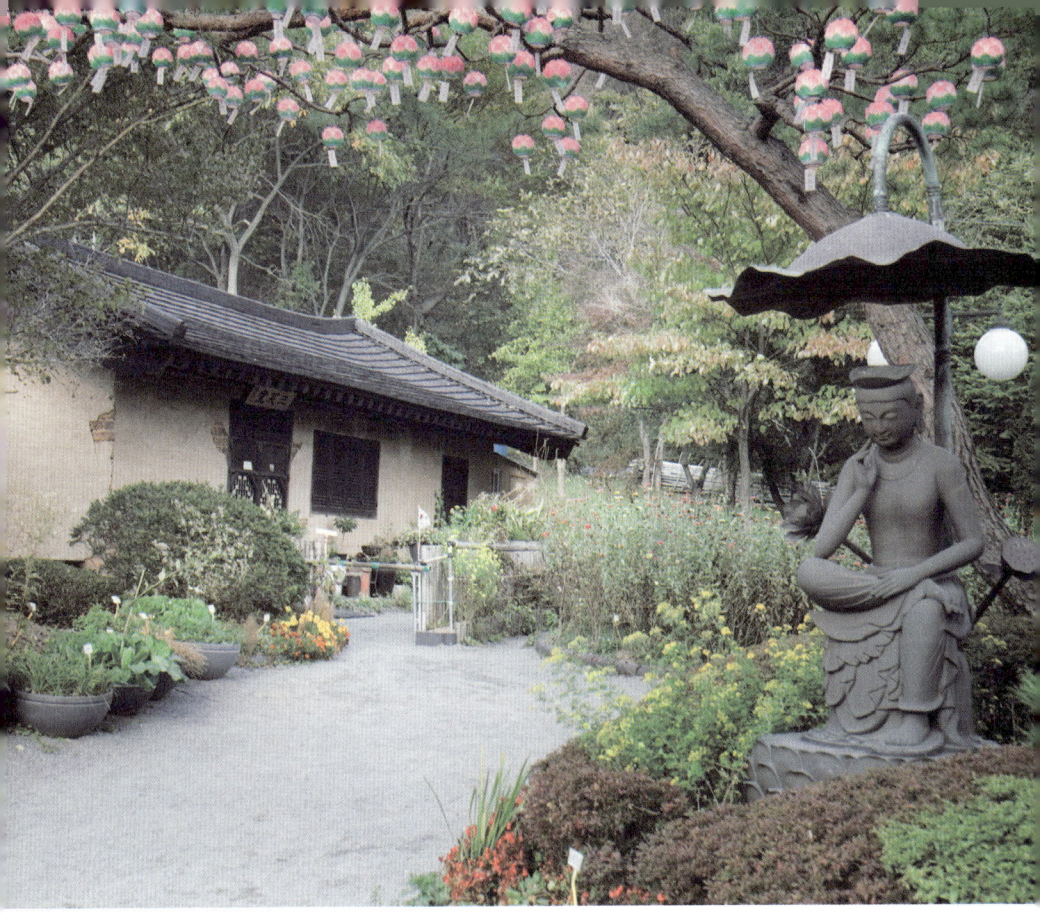

삼소실

로 나무를 쌓은 후 그 사이를 흙으로 막았다.

삼소실三笑室 건물은 원래 공사 기간에 사용한 현장 사무실로, 조립식 건물이었다. 공사가 끝나고 철거하려니 아까워서 벽에 황토 벽돌을 쌓고 미장을 해서 한옥 느낌이 나도록 개조했다. 출입문을 새로 달고 생활하기 편하게 내부도 고쳤다. 지붕은 너와를 얹어 분위기를 내니 운치 있는 집으로 변했다. 지금은 원장스님이 기거하고 계신다.

범종각과 법고각

보탑사의 대문인 천왕문을 지나면 범종각과 법고각이 마주 보고 서 있다. 불교에서는 범종을 쳐서 지옥 중생을 교화하고, 법고를 두드려 네 발 달린 짐승을 교화하고, 목어를 두드려 바다의 물고기를 교화하고, 운판을 두드려 날아다니는 새를 교화한다 하여 이 모두를 합쳐 사물四物이라고 한다. 이 범종과 법고가 설치된 범종각과 법고각 지붕은 각각 7각과 9각으로 지었다.

우리 전통 건축에서 7각과 9각은 흔치 않다. 마침 고구려의 다각형 건물을 답사하며 연구하던 중 알아낸 7각과 9각의 작도법을 적용해 본 것이다. 지붕 위의 각에 맞춰 수막새의 연꽃잎도 각각 7개와 9개로 올리고, 상륜은 각각 돌과 토기로 만들어 개성을 더했다.

수각

보탑사는 물맛이 좋기로 유명하다. 그래서 따로 수각水閣을 만들어 신도와 방문객들이 청정한 물맛을 볼 수 있게 하였다. 이 수각은

보탑사의 대문 천왕문

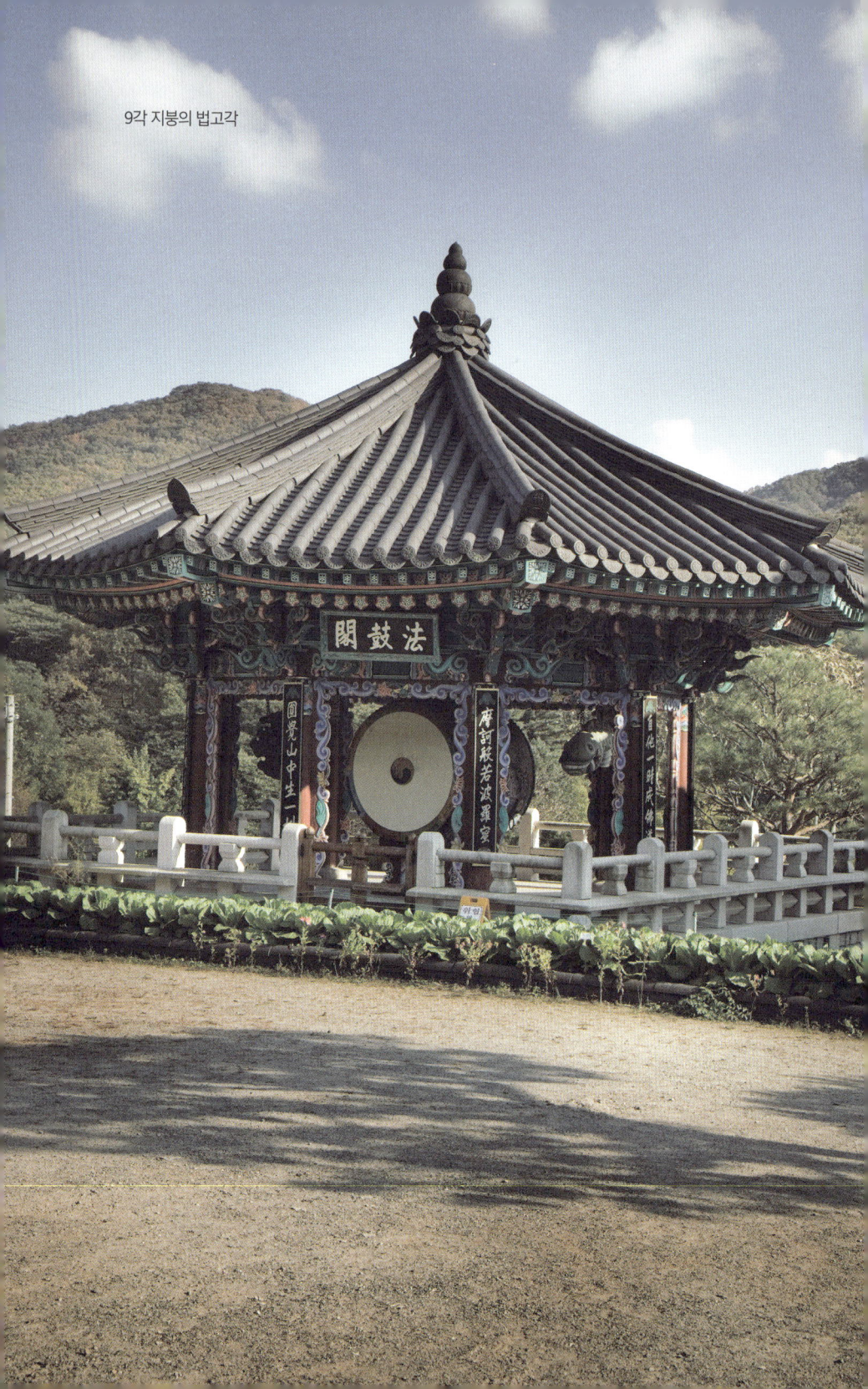

9각 지붕의 법고각

7각 지붕의 범종각

수각

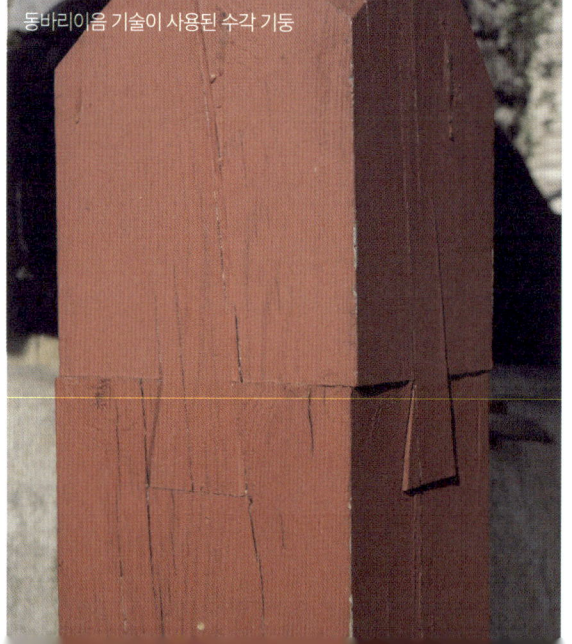

동바리이음 기술이 사용된 수각 기둥

네 개의 기둥을 세우고 그 위에 원형 지붕을 얹었다. 기둥 가운데 한 개는 일부러 잘라 동바리이음을 해서 세웠다. 동바리이음이란 기둥의 밑부분이 썩었을 때 그 부분을 잘라 낸 다음 그만큼 새 나무 부재를 사용하여 잘라내지 않은 부분과 잇는 기술로, 겉으로 보이는 이음새만 보면 도대체 어떻게 꽂았는지 알기 힘들다. 주로 문화재 보수에 쓰는 기술이지만 후손들이 이 기술을 잘 이어 나가길 바라는 차원에서 흔적을 남겨 둔 것이다.

석등과 통돌다리

보탑사 목탑의 앞쪽에는 전체 높이가 19척인 석등을 세웠다. 숫자 19는 심오한 의미를 담고 있다. 음력의 1년은 양력의 1년보다 11일 정도 짧아서 이를 조정하기 위해 윤달을 추가하는데, 정확히는 19년 동안 일곱 번의 윤달을 두게 된다('19년 7윤법'). 이렇게 하여 19년마다 음력과 양력의 날짜가 일치해 완전함에 이르게 된다. 참고로 경주 석불사 석굴암 금당 내부 본존상 둘레의 각도 19각이다. 석등은 아래에서부터 4각, 5각, 6각, 7각, 8각, 9각을 차례로 올리고 맨 위는 원으로 마무리했다. 석등 양쪽에는 통돌다리를 걸쳐 두었는데, 커다란 화강석 통돌을 다듬어 만들었다. 통돌다리 하부에는 구름 문양을 새겨 하늘로 오르는 미륵 상생경의 이상을 표현하였다.

또 하나의 보물, 진천 연곡리 석비

보탑사에는 보물 제404호로 지정된 진천 연곡리 석비가 있다. 비

커다란 화강석 통돌을 다듬어 만든 통돌다리. 하부에 구름 문양이 새겨져 있다.

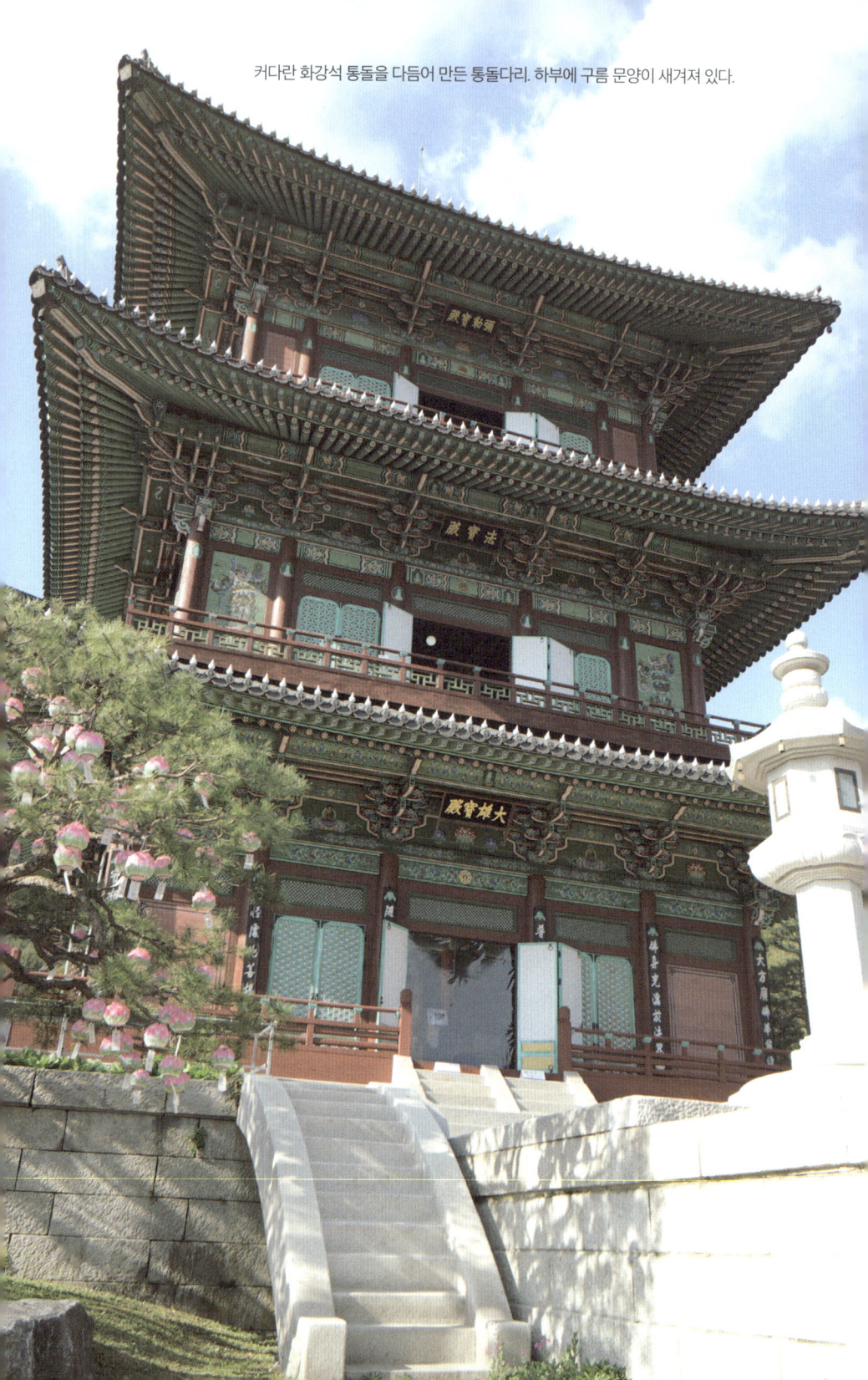

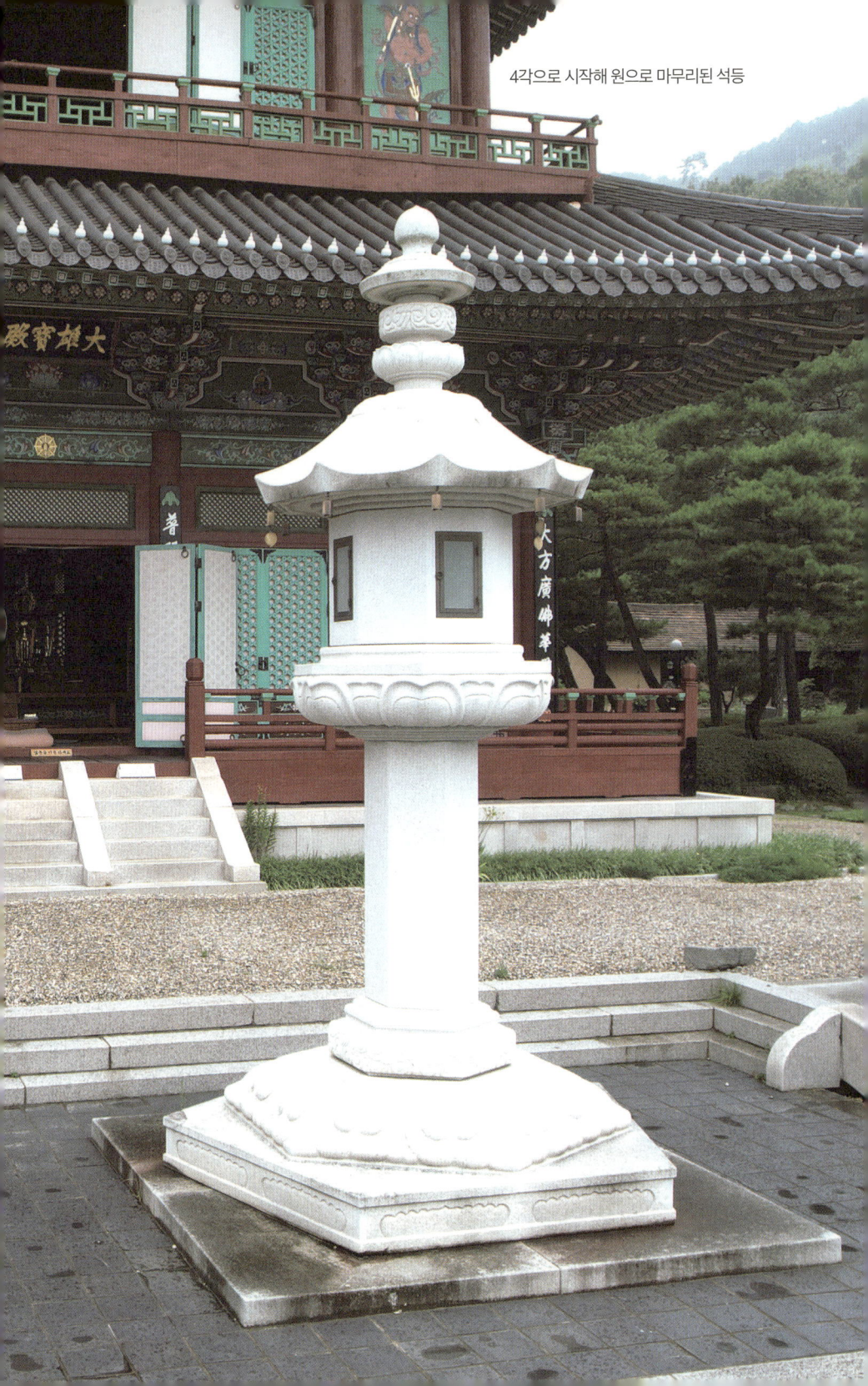

4각으로 시작해 원으로 마무리된 석등

문이 없는 무자비無字碑, 일명 백비白碑이다. 아무 글자도 없이 깨끗하다는 뜻이다. 석비를 세우면서 왜 비문을 기록하지 않았는지에 대한 정확한 문헌이 없다. 그래서 현재까지 이 석비를 세운 이가 누군지, 비의 주인이 누구인지 알려져 있지 않다.

거북 모양 받침돌 위에 비석의 몸체를 세웠는데, 이 받침돌의 깨진 부분이 신기하다. 돌 위에 거북등무늬를 조각해 놓았는데 돌이 깨져 나가도 거북등무늬가 그대로 드러난다. 돌이 깨지면 겉에 조각된 부분도 같이 깨져 없어져야 하는데 겉의 조각이 떨어져 나가도 그 안에서 똑같은 무늬가 다시 나온다니 어떻게 그럴 수 있는지 신기하기 그지없다. 그래서 보물이 아닐까?

보탑사 무자비. 석비 받침돌의 겉부분은 지금도 조금씩 깨지고 있다.

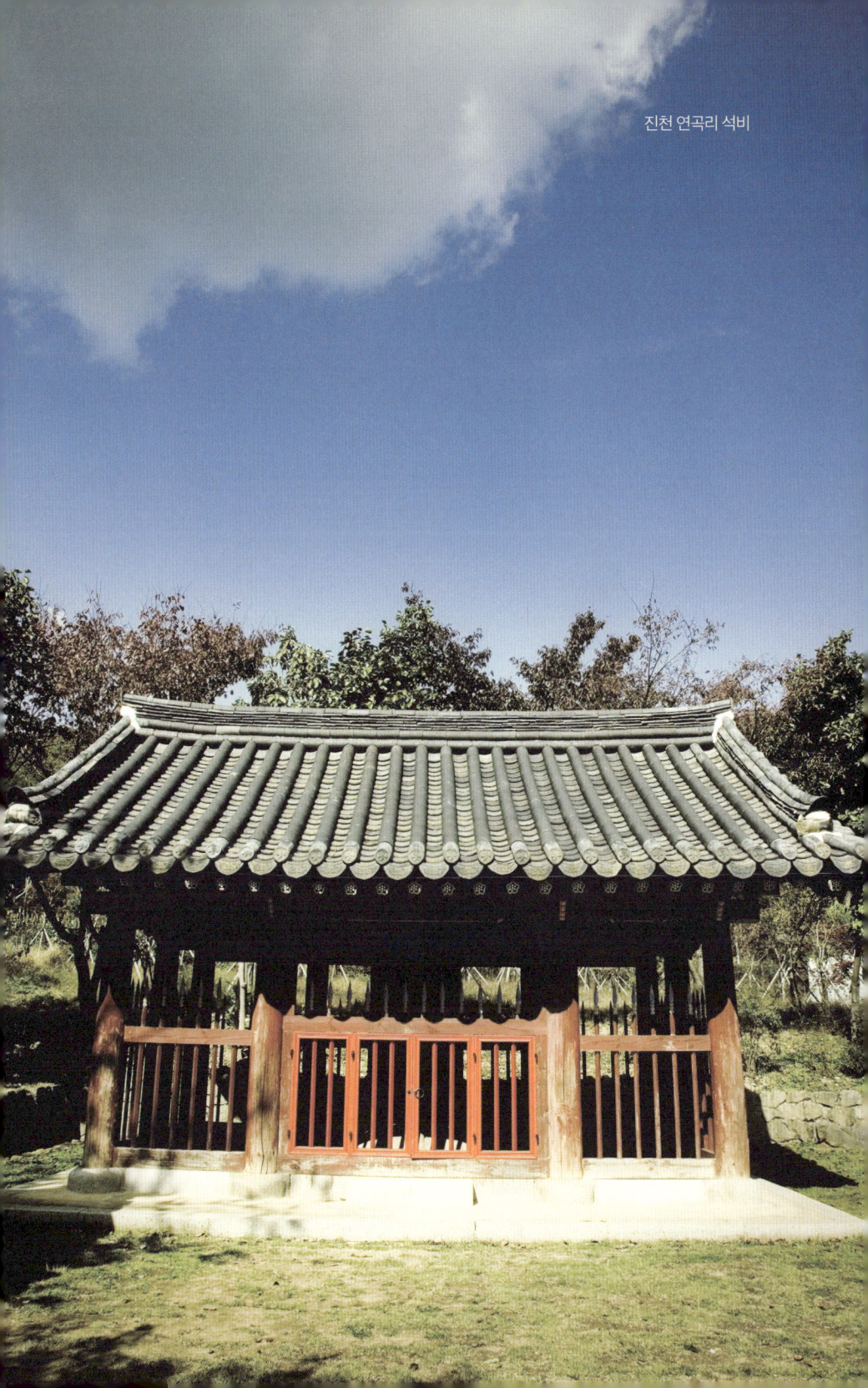

진천 연곡리 석비

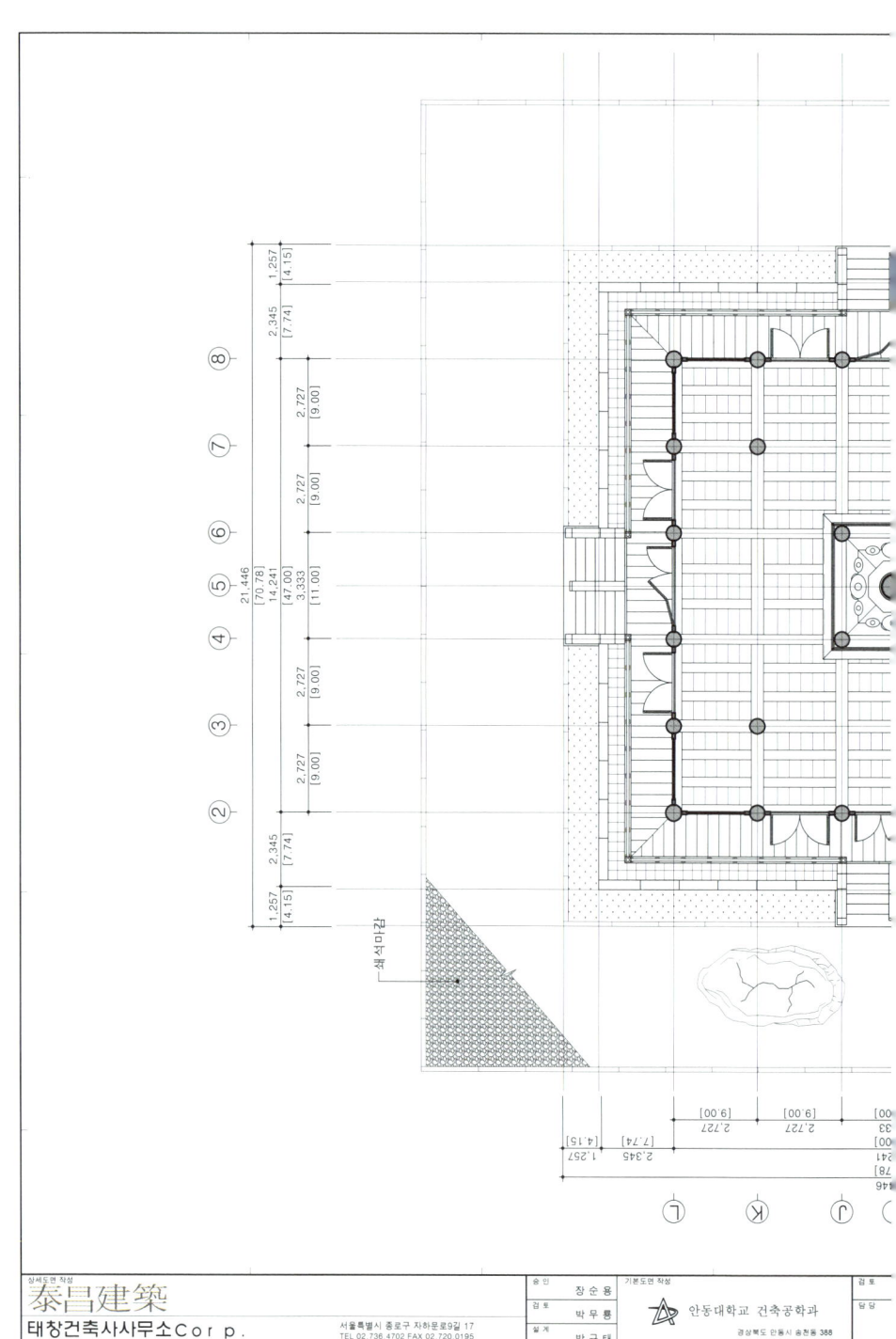

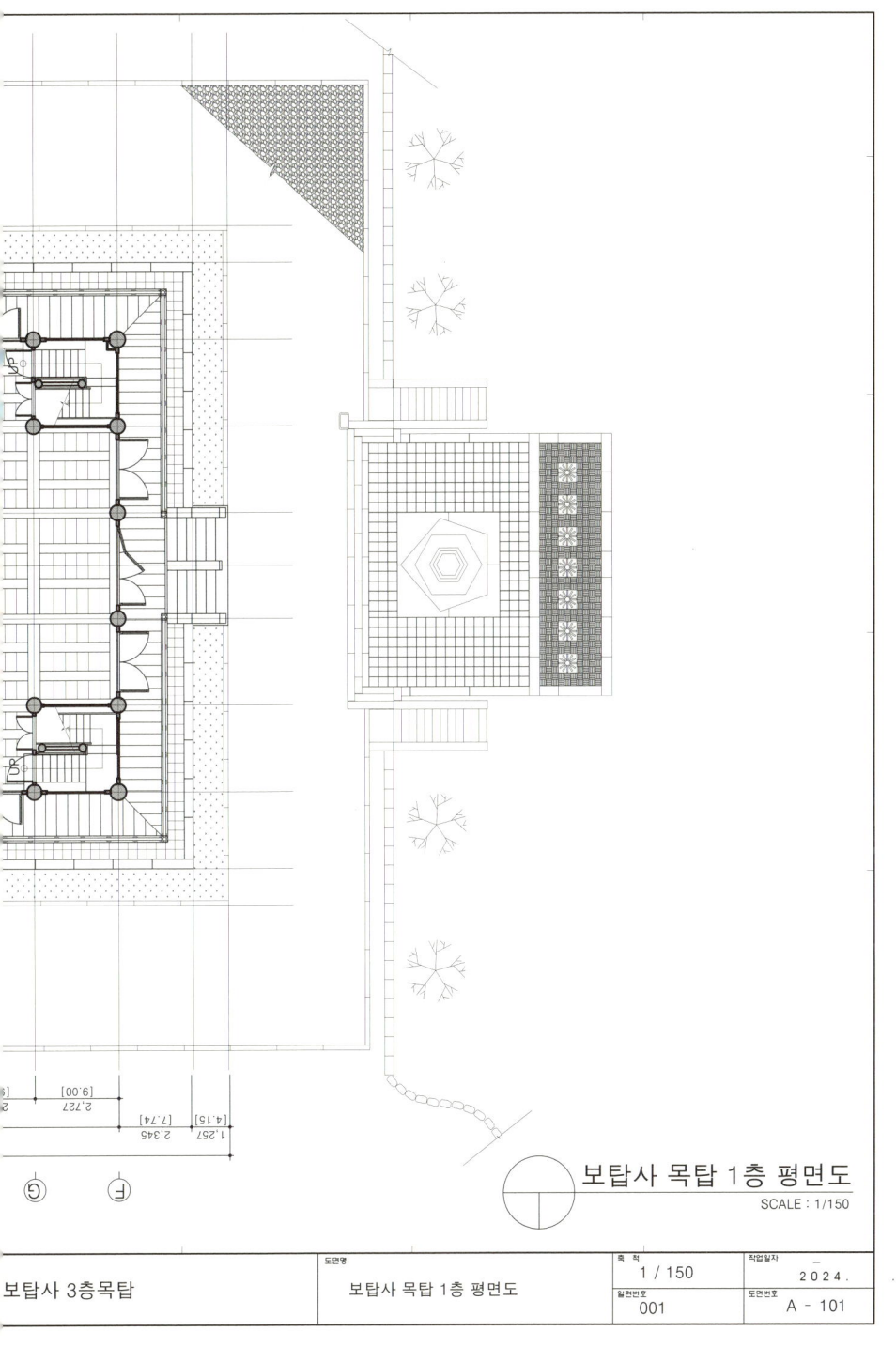

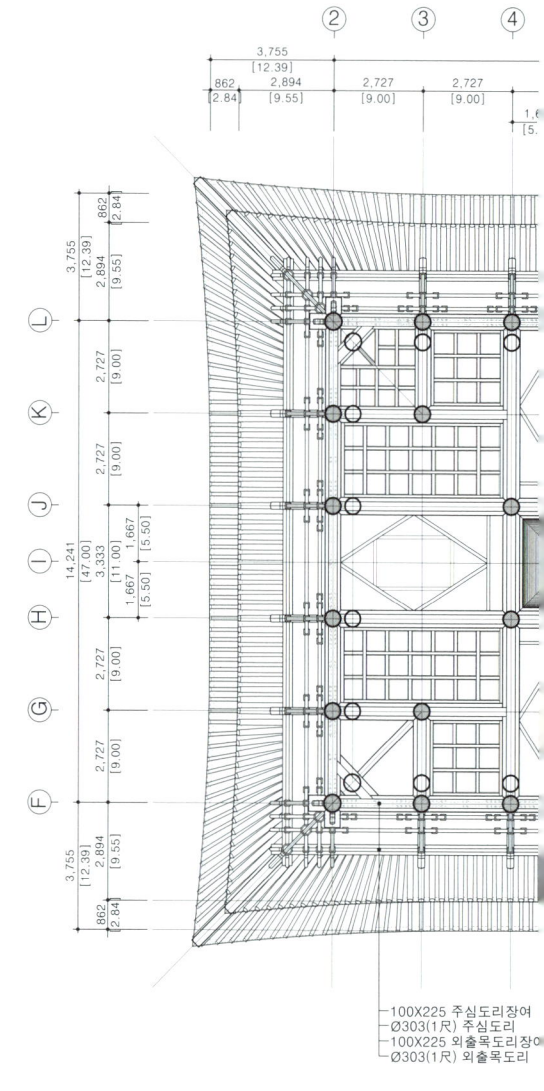

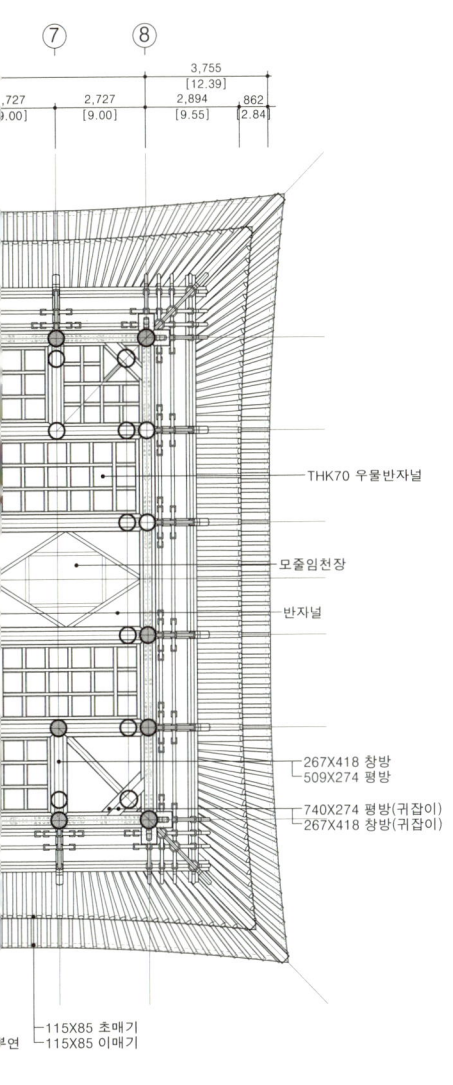

보탑사 목탑 1층 앙시도
SCALE : 1/150

	도면명	축척	작업일자
보탑사 3층목탑	보탑사 목탑 1층 앙시도	1 / 150	2024.
		일련번호 003	도면번호 A - 201

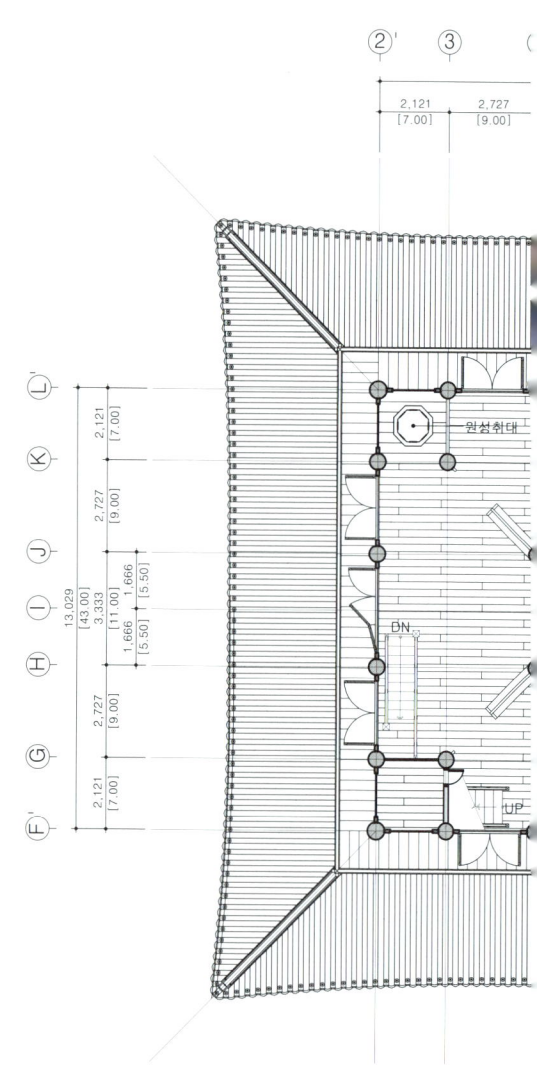

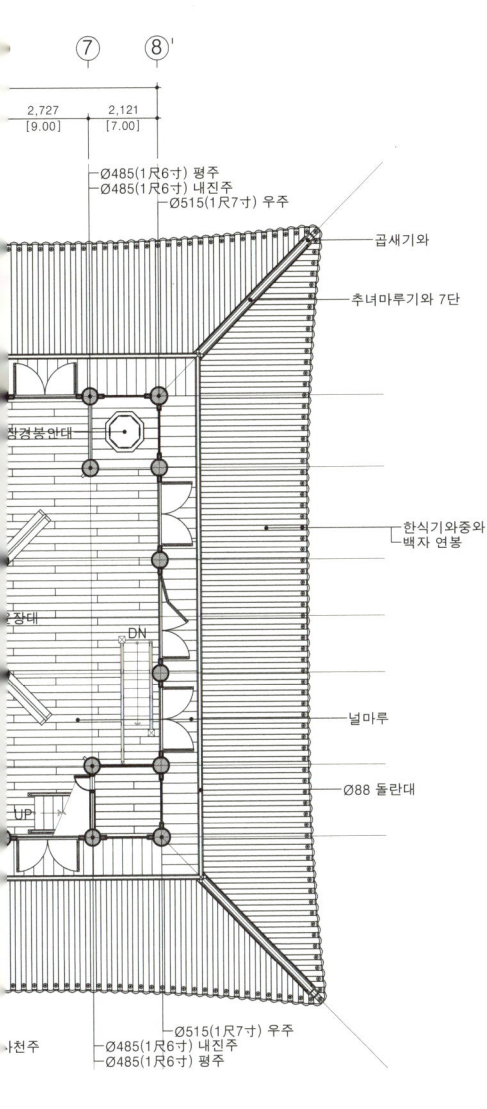

도면명	보탑사 목탑 2층 평면도
축척	1 / 150
작업일자	2024.
일련번호	005
도면번호	A - 103

보탑사 3층목탑

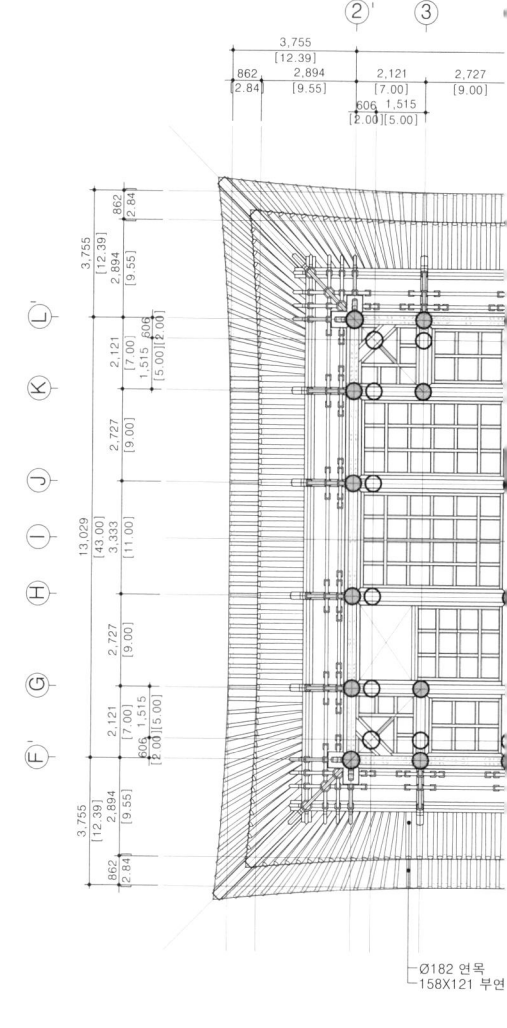

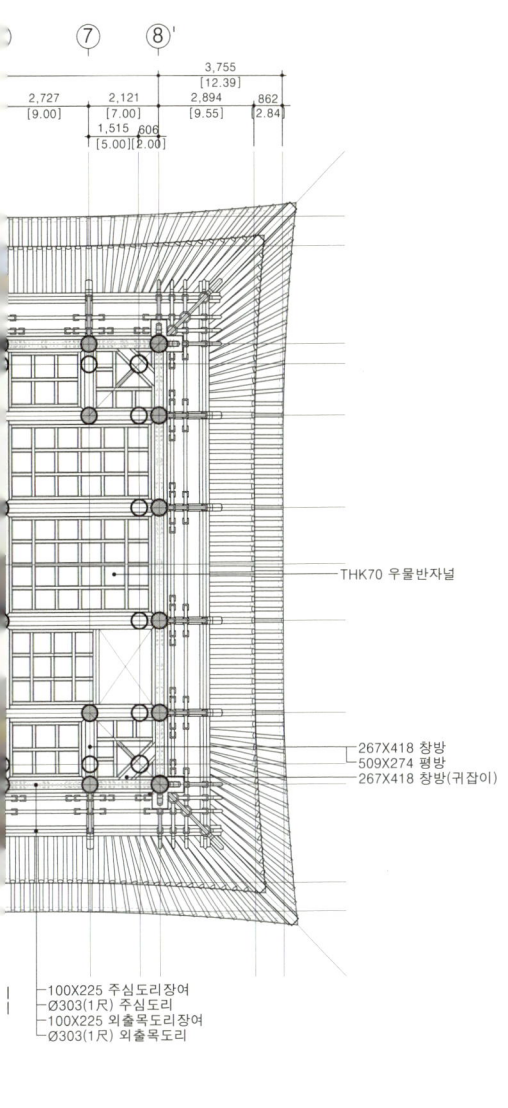

보탑사 목탑 2층 앙시도
SCALE : 1/150

도면명	축척	작업일자
보탑사 목탑 2층 앙시도	1 / 150	2024.
일련번호 006	도면번호	A - 202

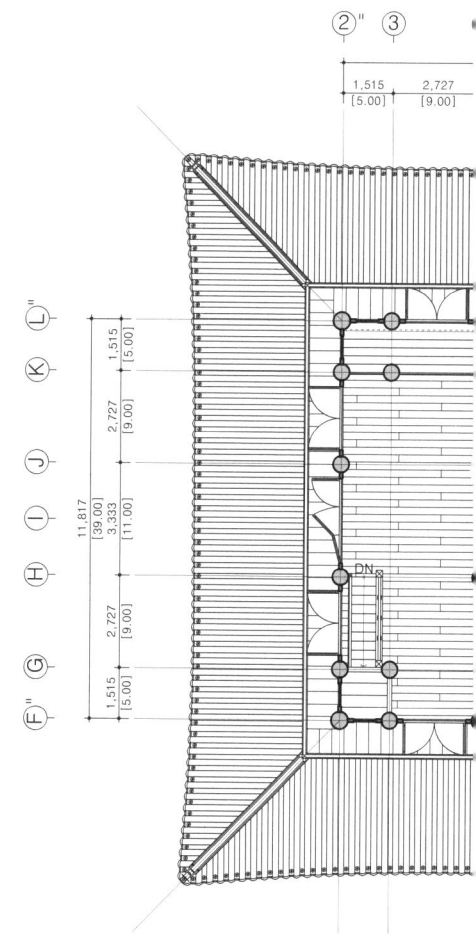

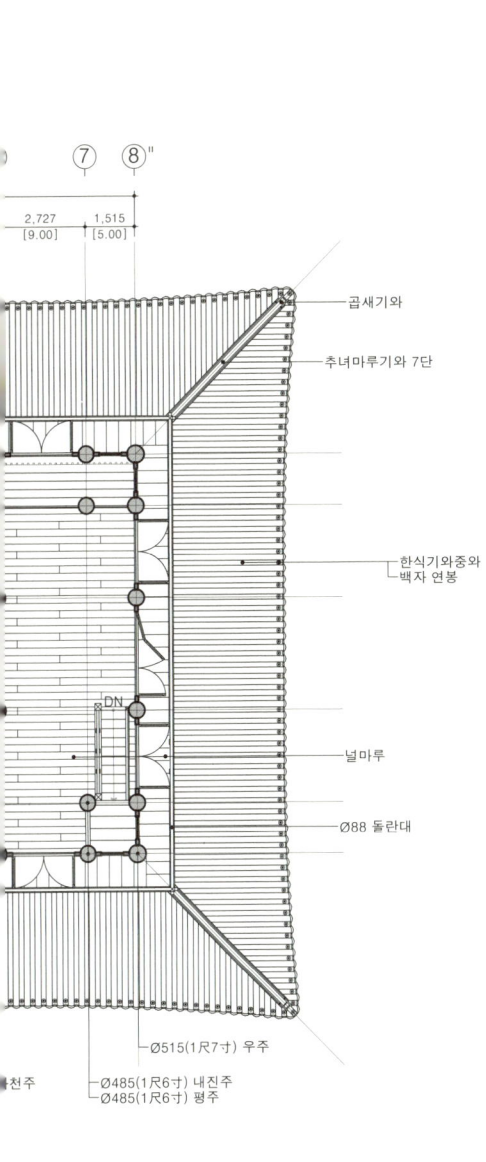

도면명	보탑사 목탑 3층 평면도
축척	1 / 150
작업일자	2024.
일련번호	008
도면번호	A - 105

보탑사 목탑 3층 평면도
SCALE : 1/150

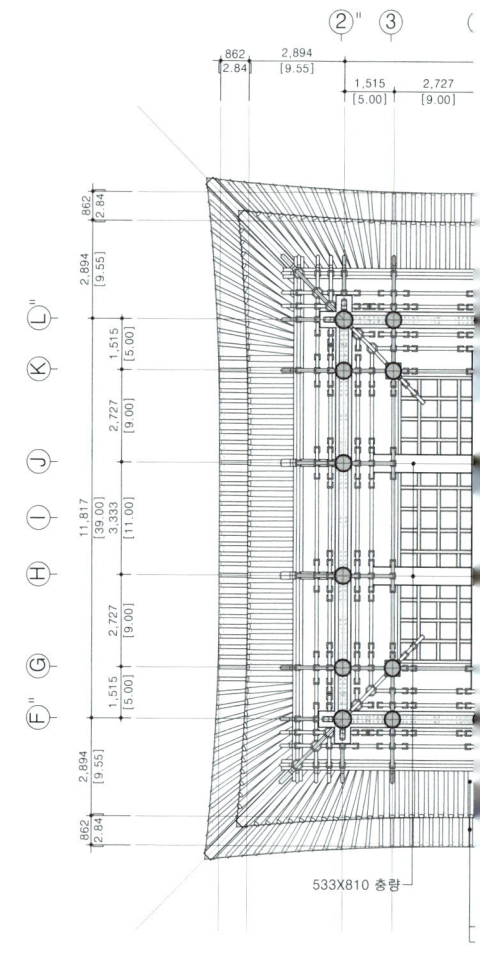

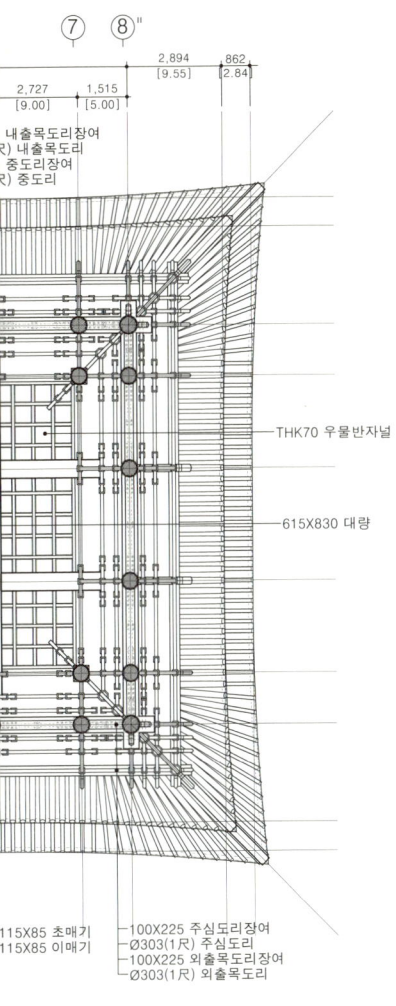

보탑사 목탑 3층 앙시도
SCALE : 1/150

도면명	축척	작업일자
보탑사 목탑 3 앙시도	1 / 150	2024.
일련번호 009	도면번호 A - 203	

보탑사 3층목탑

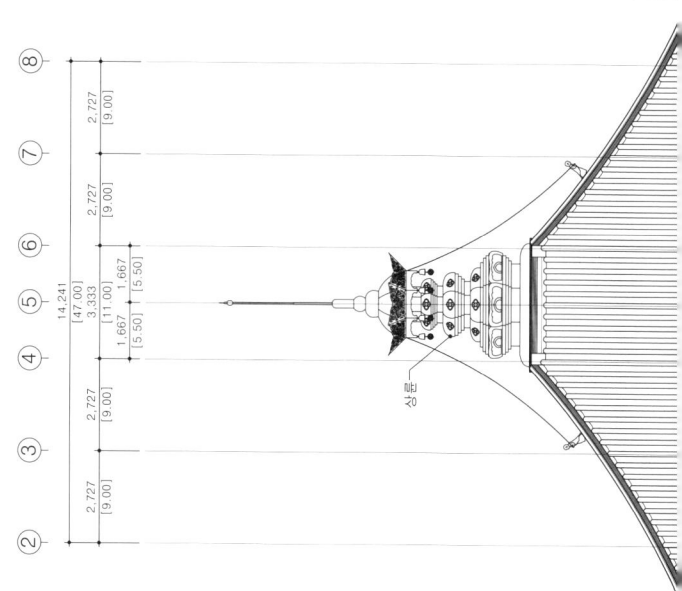

보탑사 목탑 정면도
SCALE : 1/150

2부
—
한옥을
짓다

터 잡기

하늘 아래 땅이 있고, 땅 위에 바람이 분다. 그리고 하늘과 땅과 바람 사이에 집이 들어선다. 집은 사람을 품고 산다. 그래서 사람은 결코 혼자 사는 것이 아니고, 자연과 더불어, 자연과 호흡하며, 자연이 되어 살아간다. 집은 그 사이를 잇는 매개체 역할을 한다. 사람을 자연과 가장 잘 어울리게 해 주는 집, 그런 집이 바로 한옥이다.

집을 지으려면 가장 먼저 집 지을 터를 잡고 좌향(앉은 방향)을 정해야 한다. 흔히 집이 바라보는 방향은 남쪽이나 동남쪽이 좋다고 이야기한다. 전통 건축을 하는 사람들 사이에서는 임좌병향壬坐丙向을 제일 좋은 좌향으로 보는데, 지금으로 말하면 남남동, 즉 남쪽과 동쪽 사이에서 남쪽으로 조금 치우친 방향이다.

이 방향이 좋은 이유는 집 안에 햇볕이 가장 오래 들어올 수 있기 때문이다. 하지만 요즘에는 집을 지을 땅의 여건상 이를 충실히 지키기는 어렵다. 이럴 때 가장 좋은 방법은 주변에 있는 산의 제일 높은 봉우리 방향을 향해 집을 짓는 것이다. 예부터 산 정상의 기운을 받고 태어난 아이는 커서 큰 인물이 될 것이라는 믿음과 기대가 있었기 때문이다.

또한 터를 잡을 때는 흙의 색깔을 주의 깊게 봐야 한다. 한번 팠던 땅인지 아닌지는 흙의 색깔과 강도를 보면 바로 알 수 있다. 그 다음으로 중요하게 봐야 할 것은 땅에 물기가 비치는지의 여부다. 특히 물이 흘러간 자국이 있으면 피해서 집을 지어야 한다. 땅속에 물이 흐르는 것을 수맥이라고 하는데, 자칫 집을 잘못 지어 이 수맥의 흐름을 끊어 버리면 물길이 다른 방향으로 나게 된다. 오랜 시간 한곳으로 흐르던 물길의 방향이 갑자기 바뀌면 지반이 약해져서 움푹 파이거나 무너지는 현상이 나타난다. 그래서 집을 지을 때는 물이 흐르는 상태를 그대로 두고 집을 짓도록 신경 써야 한다.

집을 지을 좌향을 정했으면 방, 마루, 부엌 등의 위치와 크기를 정한다. 위치와 크기를 정할 때는 바람과 햇빛, 눈, 비 등의 자연에 순응하고 화합하는 집이 되도록 해야 한다. 특히 집 안팎으로 바람이 지나다니는 길을 먼저 만들고, 거기에 맞추어 방의 위치와 크기를 정하는 것이 중요하다. 따라서 바람이 어디에서 들어와 어디로 빠져나가는지 잘 살펴봐야 한다.

석재 선택하기

한옥은 목재가 차지하는 비중이 높지만 기초가 되는 공사에는 돌을 빼놓을 수 없다. 돌은 기단을 놓거나 주초석의 재료로 쓰이며, 자연석(산돌, 강돌)과 화강석이 주로 사용된다.

자연석은 말 그대로 가공하지 않은 천연의 돌이다. 이런 자연석은 돌이 있던 곳을 기준으로 크게 산돌[山石]과 강돌[水石]로 나눌 수 있다. 이 중 집의 재료로 쓸 돌은 이끼가 묻어 살아 있는 산돌을 쓰는 것이 좋다. 반면 강돌은 물속에 있던 돌로, 오랜 시간 물에 다듬어져 형태가 각지지 않고 둥그스름하다. 강돌은 주로 돌아가신 분들이 계신 곳에 쓰는 경우가 많다. 그래서 고분을 수리해 보면 전부 강돌로 되어 있는 것을 자주 볼 수 있다.

강돌에 얽힌 일화가 있다. 내가 무령왕릉을 발견하게 된 것은 바로 작은 강돌 하나에서 시작되었다. 강돌은 죽은 자의 집을 짓는 데 사용하는 돌이라는, 전문가라면 당연히 알고 있는 이 사실 덕분에 무령왕릉을 발견할 수 있었다. 나는 1971년 7월 2일, 송산리 5호분과 6호분 내부에 습기가 차는 문제를 해결하기 위해 고분 뒤편으로 배수로 공사를 하던 중 우연히 흙속에서 작은 강돌 하나를 발견하였다.

'어째서 강돌이 이 산의 흙속에 있는 걸까?'

죽은 자의 집인 무덤에 사용하는 강돌이 발견되었다는 건, 근처에 아직 발굴되지 않은 고분이 있을 수도 있겠다는 느낌이 들었다. 이 단순한 의문이 그때까지 누구의 손도 타지 않은 역사적인 고분을 발견하게 했다.

간혹 집 안에 연못을 만들 때는 강돌을 쓰기도 하지만, 집을 지을 때는 사용하지 말아야 한다. 강돌이 겉으로 보기에는 반들반들하여 멋있어 보일지는 모르나, 강돌로 담장이나 벽을 쌓으면 속이 매끄러워 잘 빠지는 단점이 있다.

화강석은 장석, 석영, 규석 등을 주성분으로 하는 암석이다. 분홍색이나 밝은 회색을 띠는 경우가 대부분이며, 사용할 때는 용도에 맞게 다듬어 쓰면 된다. 같은 화강석이라도 그 빛깔에 따라 쓰임이 다르기 때문에 적합하게 사용하는 것이 좋다.

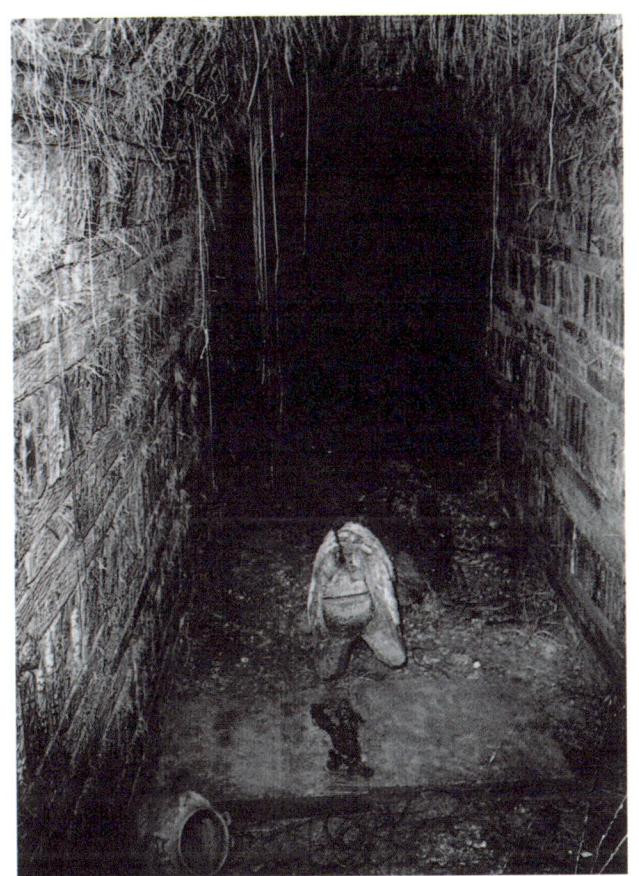

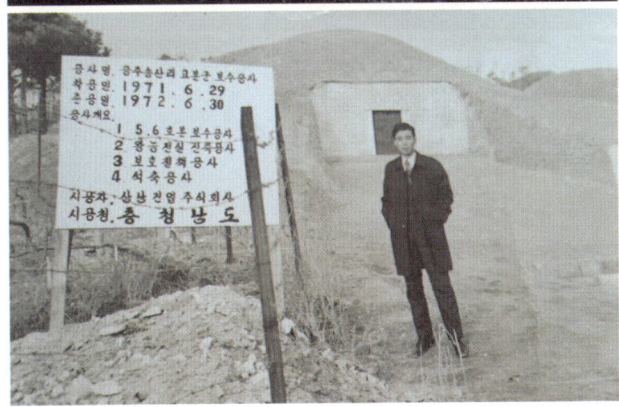

강돌 하나가 단초가 되어 발견된 당시의 무령왕릉(위), 발견자 김영일(아래)

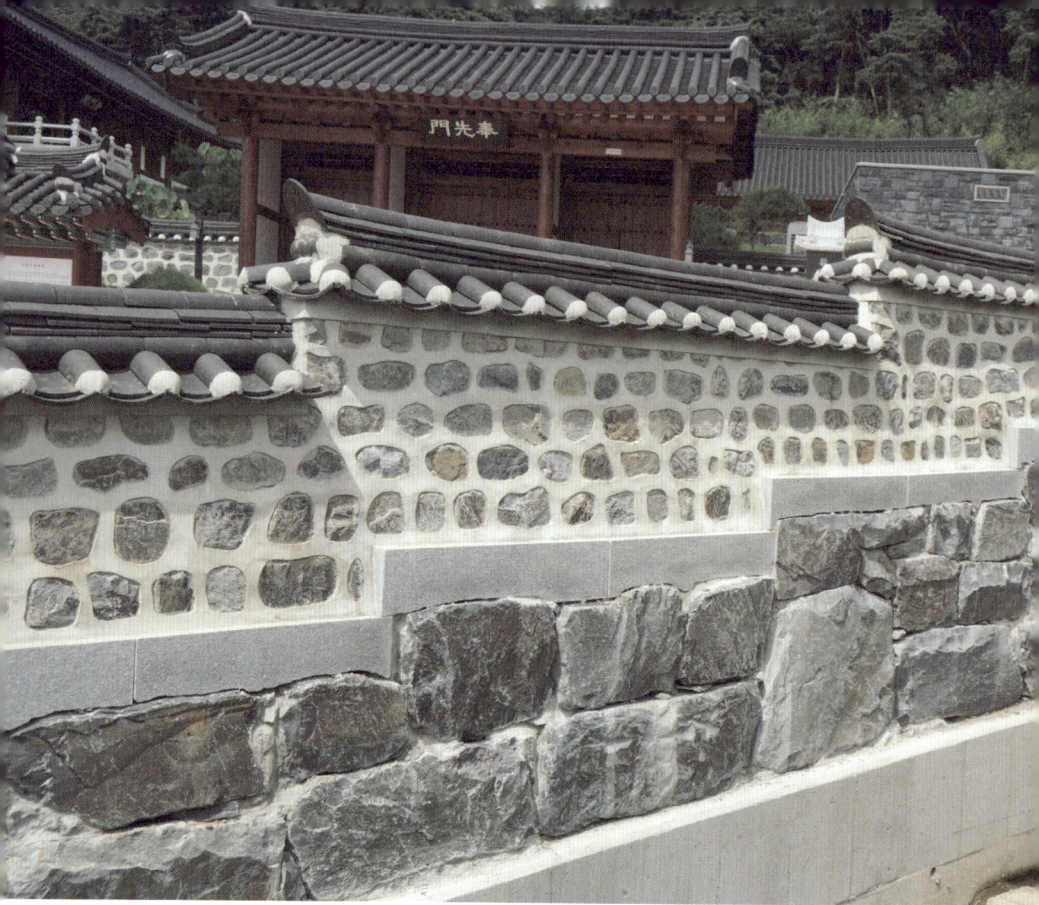

산돌로 쌓은 담장

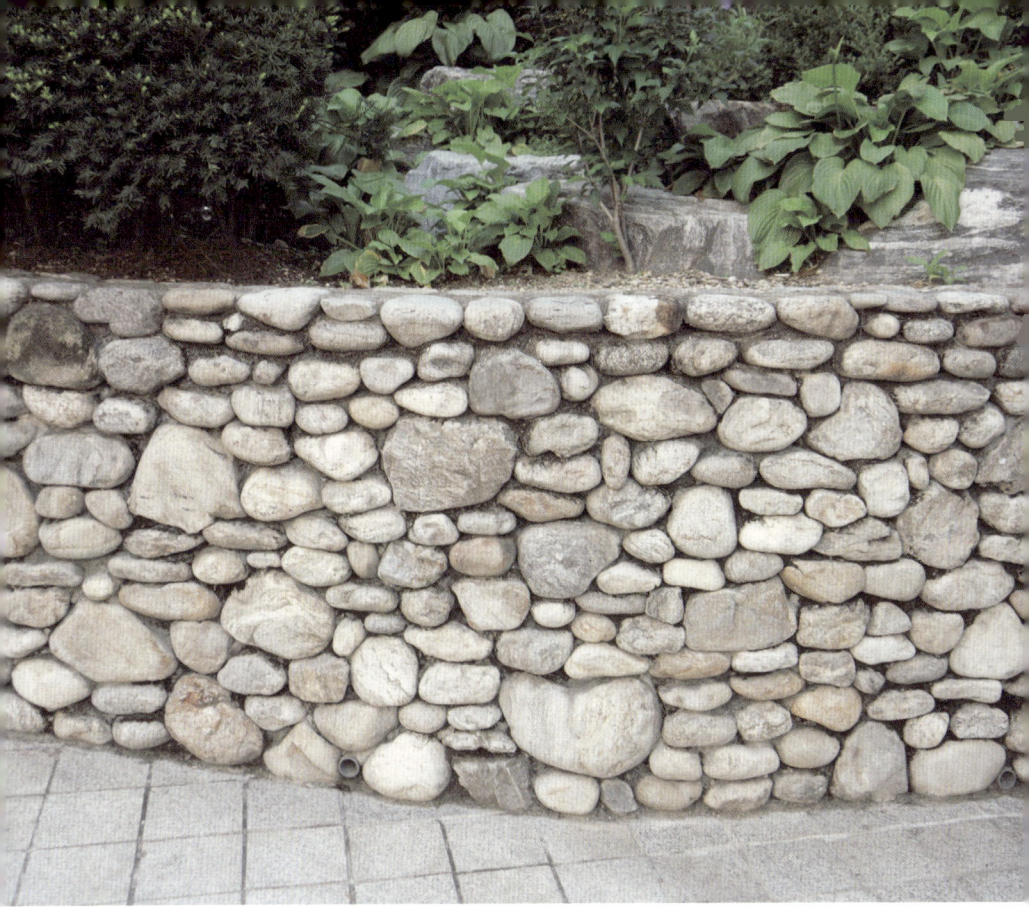

강돌로 쌓은 석축

약간 푸른빛이 나는 돌과 흰빛이 나는 고운 돌은 희소성 때문에 가격이 비싸다. 따라서 이런 돌은 대량으로 사용하기보다 돌아가신 분 묘소에 상석으로 사용하면 좋다. 돌에서 나오는 푸른빛이 으스스한 기운을 내보내 경건한 분위기를 조성하기 때문이다. 불그스레한 빛이 나거나 거무칙칙한 빛이 나면 그나마 값이 싸다. 한옥을 지을 때는 이런 돌을 선택해 사용한다.

집은 한번 지으면 최소 10년에서 20년은 살아야 한다. 그런데 세월이 흐르면 집도 나이를 먹는다. 특히 한옥의 주재료인 나무의 특성이 그렇다. 그렇게 집은 늙어 가지만, 돌은 세월이 지나도 나이를 잘 먹지 않는다. 그러면 마치 기단만 새로 하고 그 위로 헌 집을 뜯어다 옮겨 놓은 것 같은 부자연스러운 인상을 주게 된다. 비싼 돈을 주고 고급 돌을 써도 세월이 흐르면서 주는 인상은 마찬가지다. 그러니 굳이 너무 고급스럽게 지을 필요가 없다는 얘기다.

화강석을 다듬을 때 한 가지 주의할 점이 있다. 우리나라 화강석에는 1결, 2결, 3결 등 결이 있으니 그 결을 따라 잘라야 한다. 요즘에는 기계로 자르다 보니 그 결을 무시하는 경우가 많다. 아무리 기계로 자르더라도 결을 따라 잘라 사용하는 것이 바람직하다. 결을 따라 몇 군데에 쐐기를 박으면 자연스럽게 쪼개진다.

빛깔이 다른 4종류의 화강석

목재 제대로 고르기

　한옥에서 목재가 차지하는 비중은 절대적이다. 그러니 한옥을 지을 때 가장 신경 써야 하는 부분 중 하나가 좋은 목재를 구하는 것이다. 좋은 집을 지으려면 나무를 잘 알아야 하다 보니 나무에 대해 느끼는 감정이 남다르긴 하다.

　나무는 계절의 변화에 따라 상태가 달라진다. 봄에 비가 내리지 않으면 나무가 건강하게 자랄 수 없다. 하지만 가을이 되면 나무는 더 이상 비를 저장하지 않는다. 겨울 채비를 해야 하기 때문이다. 기온이 영하로 떨어졌는데도 속에 물이 남아 있다면 그대로 얼어 죽을지도 모른다. 그래서 영양소를 비축하고 겨울 채비를 하느라 광합성도 포기한다. 그 덕에 우리가 고운 단풍을 볼 수 있는 것이다.

한옥을 짓는 데 쓰이는 나무는 대부분 소나무다. 그중에서도 잎이 두 개인 소나무(이엽송)여야 한다. 그것이 우리나라 토종 소나무다. 토종 소나무를 써야 하는 이유는 송진이 많아서다. 송진이 있어야 집이 오래간다. 나무에서 송진이 흘러나와 굳게 되면 단단해져 방부제 역할을 하기 때문이다.

오엽송(잣나무)은 빨리 자라다 보니 단단하지 않고 약하다. 낙엽송은 마르면 못도 들어가지 않을 만큼 딱딱해진다. 그러다 보니 둘 다 집을 짓는 데는 적합하지 않다. 하지만 낙엽송의 가격이 소나무 가격의 3분의 1 정도밖에 되지 않기 때문에 집을 지을 때 사용하는 경우가 종종 있다. 낙엽송은 나무가 터질 때 엄청나게 큰 소리가 나는 것도 단점이다. 또 처마 부분이 금방 부러져 오래가지 못한다. 나무는 필연적으로 시간이 지나면 터지게 되어 있다. 그러니 가급적이면 덜 터지고, 터질 때 소리도 너무 크지 않은 나무가 더 낫지 않겠는가?

지금까지 오랜 세월 집을 지으면서 여러 목재를 써 본 결과, 잎이 두 개인 토종 소나무 중에서도 해발 600m 근처(500~700m 사이)에서 자란 것이 가장 쓰기가 좋았다. 그보다 높은 곳에서 자란 것은 너무 단단하거나 모양이 배배 꼬여서 한옥 목재로 적합하지 않았다. 또 전부 그런 것은 아니지만 그보다 낮은 곳에서 자란 것은 너무 빨리 자라서 강도가 약하다.

목재로 사용하는 나무는 베는 시기도 중요한데, 첫서리나 첫눈이

온 뒤에 벤 나무를 써야 한다. 첫서리나 첫눈이 올 때는 날씨가 추워지는 시기여서 나무를 베기는 힘들지만, 그 시기의 나무는 겨울을 나기 위해 영양분을 잔뜩 머금어 속이 꽉 차 있기 때문에 한옥의 부재로 쓰기에 가장 좋다.

산에 불이 나서 불기운을 먹은 나무는 필히 피해야 한다. 산에 불이 나면 나무는 스스로를 방어하기 위해 송진을 내보내 바깥을 둘러싼다. 밖으로 나온 송진은 불기운에 타서 굳어 버린다. 이런 나무는 안팎이 단절되어 겉으로 보기에는 멀쩡해도 안으로는 썩고 있어서 집을 지으면 낭패를 보게 된다. 어떤 경우에는 집을 지은 지 1~2년이 지난 후에 안에서 물이 줄줄 흘러나오기도 한다. 실제로 그런 경우를 보면 안타깝기 그지없다.

또한 내륙의 산속에서 자란 나무보다는 바닷가 근처 산에서 해풍을 맞으며 자란 나무가 더 좋다. 우리나라는 삼면이 바다로 둘러싸여 있으니 좋은 나무를 얻기에는 최상의 조건을 갖추었다고 할 수 있다.

나무는 땅의 성질에 따라 다르게 자란다. 우리나라 산은 대부분 화강석으로 이루어져 있다 보니 나무에도 그 성질이 옮아 있다. 화강석은 장석과 규석, 석영 등이 주성분으로, 인체에 가장 좋은 돌이다. 이런 화강석이 깨져서 만들어진 좋은 흙에서 자란 소나무로 한옥을 지었으니 그야말로 건강한 집이 된다.

옛 어른들은 집을 지을 때 쓰는 나무의 성질을 보면 각 나라의 민

중국 　　　　　한국 　　　　　일본

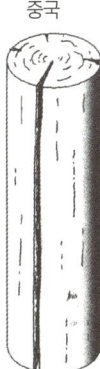
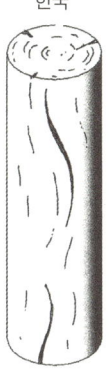
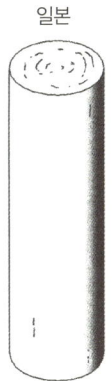

각국 목재의 터짐 비교

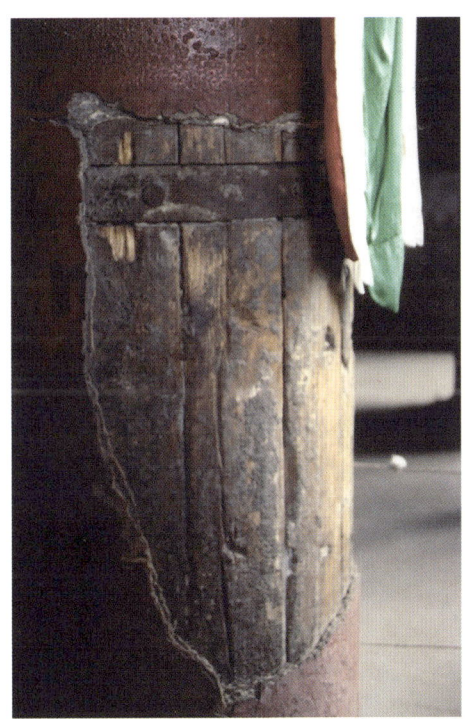

철 테를 두른 중국 자금성의 나무 기둥

족성을 엿볼 수 있다고 했다. 우리와 가까운 주변국인 일본의 토양은 대부분 현무암 성분으로 이루어져 있고, 중국의 토양은 석회암이 많은 부분을 차지한다. 토양이 다르다 보니 나무의 성질도 우리나라의 나무와는 다르다.

　나무로 지은 집은 시간이 지나면 필연적으로 터지고 갈라지는데, 일본 나무는 잘 갈라지지 않아서 속이 잘 보이지 않는다. 그것이 일본인이 가까운 사람에게도 속마음을 이야기하지 않는 것과 닮았다고들 한다. 한편 중국 나무는 수직으로 갈라지고, 심하면 기둥 속이 시꺼멓게 보인다. 그래서 두터운 판재를 여러 겹으로 합성하여 만든 기둥에 철 테를 두르고 그 위에 횟가루를 바른 후 천으로 감싼다. 이에 비해 한국 나무는 제멋대로 터진다. 하지만 나무가 질기고 끈기가 있어 무거운 흙과 기와를 얹어도 잘 버티고 오래간다.

　이런 나무의 특성 때문에 각 나라 전통 가옥의 형태도 조금씩 차이가 난다. 생긴 대로 산다는 말이 있는데, 나무도 사람도 그렇게 생긴 대로 사는 모양이다.

기와 구입하기

　기와는 목조 건물의 지붕을 덮는 데 쓰기 위하여 적당한 모래가 섞인 양질의 점토로 모양을 만들어 가마 속에서 1,000℃ 이상의 높은 온도로 구워 낸다. 우리나라에는 다양한 종류의 기와가 있으며, 대표적으로 수키와와 암키와, 암막새와 수막새 등으로 나뉜다.

　기와는 굽는 온도가 높을수록 더 단단해진다. 예전에는 기와를 700~800℃의 온도에서 구웠지만 요즘은 1,150℃에서 굽는다. 온도가 이 정도는 되어야 동파를 막을 수 있다. 가마의 온도가 1,250℃까지 올라가면 자기瓷器를 굽는 온도가 된다. 지금은 전기 가마를 사용한다지만, 그 옛날에는 이렇게 높은 온도를 어떻게 유지할 수 있었는지 신비롭기만 하다.

수키와　　　　암키와　　　　암막새　　　　수막새

　공주 무령왕릉에 쓰인 전돌(전통 벽돌)은 무려 1,350℃에서 구웠다고 한다. 현대의 기와 굽는 기술로도 상상하기 힘든 온도다. 많은 기술자가 무령왕릉의 백제 전돌을 재현해 보려 하였으나 잘 되지 않았다. 나 역시 기와 공장 사장과 함께 강도와 무늬를 똑같이 재현해 보려고 여러 차례 시도했으나 생각처럼 구워져 나오지 않았다. 낮은 온도에서는 무령왕릉 전돌과 같은 강도가 나오지 않았고, 억지로 불의 온도를 높이면 전돌에 새긴 연꽃무늬가 녹아 버리거나 구운 오징어처럼 일그러졌다.

　어떻게 백제 사람들은 그 높은 온도 속에서도 무늬가 살아 있는 높은 강도의 전돌을 구워 낼 수 있었을까? 아니 그보다 가스도, 석유도 없이 오로지 연료라곤 나무밖에 없었을 텐데 불의 온도를 1,350℃까지 올렸다는 것 자체가 말이 안 된다. 정말 불가사의한 일이 아닐 수 없다.

　기와를 굽는 온도만큼 중요한 것이 흙과 모래의 배합 비율, 흙의

성질이다. 흔히 기와는 자기가 집을 짓고 싶은 곳에서 가장 가까운 기와 공장에서 생산된 기와를 쓰는 것이 좋다고 한다. 그 이유는 집을 지으려는 곳과 가장 가까운 곳에서 나는 흙으로 만들어진 기와가 그곳의 기후와 잘 맞기 때문이다.

 '신토불이身土不二'라는 말이 있다. 말 그대로 몸과 땅은 둘이 아니고 하나라는 뜻이다. 즉, 내가 사는 땅에서 난 농산물이 내 체질에 제일 잘 맞는다는 의미다. 집도 마찬가지다. 집은 내 몸을 뉘어 쉬는 공간이다. 그러니 집을 지을 때 필요한 재료는 내 주변에서 구하는 것이 가장 현명하다. 집터와 잘 맞는 집을 지어야 그 안에 사는 사람들도 건강하고 행복하며, 집도 오래가는 법이다.

기단과 주초석 단단하게 놓기

기단은 집의 기초가 되는 부분으로, 지으려는 건축물 아랫부분에 흙이나 돌을 쌓아 지면보다 높여 주는 것을 말한다. 전통 가옥인 한옥에서 기단은 중요한 역할을 한다. 건물의 하중을 견디는 것은 물론이고, 지하수나 빗물 등이 건물로 올라오는 것을 막아 준다. 또 겨울철 한기가 건물에 직접 닿지 않게 보호하고, 지면과 건물 사이에 공기 흐름을 만들어 통풍이 되게 하고, 건물 내에 곰팡이나 습기가 쌓이지 않게 한다. 기단은 대개 돌로 만들어진다. 그렇기에 그 자체로도 견고하지만, 그 위에 세워지는 기둥과 함께 집의 전체 구조를 지탱하는 역할을 한다.

기단을 쌓을 때는 주변의 자연석을 많이 사용했는데, 요즘에는 거

의 화강석을 가공한 장대석으로 쌓는다. 장대석으로 기단을 쌓을 때는 특히 모서리 처리에 주의해야 한다. 원칙적으로 모서리는 커다란 돌을 'ㄱ' 자로 돌려 깎아 처리해야 한다. 그런데 직각으로 만나는 장대석의 귀퉁이를 사선으로 잘라서 맞붙이는 식으로 작업하는 경우가 많아졌다. 이렇게 작업하면 'ㄱ' 자로 돌려 깎는 것보다 재료비도 덜 들고 품도 덜 들기 때문이다. 하지만 시각적으로 보기 좋지 않을 뿐더러 뾰족한 모서리 부분이 잘 깨지는 치명적인 단점이 있다. 기초가 제대로 다져진 집을 짓고 싶다면 반드시 전통 방식으로 모서리 처리를 해야 한다. 우리나라 5대 궁을 가 보면 다 이런 식으로 기단 처리가 되어 있다.

기단 위에 세운 기둥과 지붕은 한옥의 미에 영향을 미치는 요소이다. 또한 기단의 높낮이나 형태에 따라 건물의 위풍과 안정감이 달라지기도 한다. 그래서 실제로 궁궐이나 사찰 같은 건물은 더 위엄 있게 보이는 효과를 주고자 기단을 더 높게 쌓기도 했다. 이처럼 선조들은 기단이 높으면 집이 번창한다고 믿었기에 기단 높이에도 중요한 의미를 부여했다.

주초석은 기둥을 지탱하기 위해 놓는 돌로, 기둥이 기단 위에 정확하게 세워지도록 돕는다. 따라서 주초석을 정확한 자리에 놓고 견고하게 고정시키는 일은 매우 중요하다. 주초석을 잘못 놓을 경우 자칫하면 건물이 기울어지거나 불안정해질 수 있다.

잘못된 기단의 예

잘된 기단의 예

주초석에는 자연석 주초도 있고 화강석을 다듬은 주초도 있다. 모양은 여러 가지가 있지만, 보통 사각 주초나 호박돌 주초를 사용해 기둥을 세운다. 사각 주초는 가장 일반적인 형태인데, 기둥의 바닥이 사각형인 경우에 사용된다. 호박돌 주초는 원기둥꼴로 다듬어 만든 주초로, 기둥이 원형인 경우에 주로 사용된다.

나무 기둥을 다룰 때 중요한 것

목재를 다룰 때 가장 중요한 것은 목재의 형태와 특징을 이해하는 것이다. 목재에는 아래-위, 앞-뒤, 음지에서 자란 부위-양지에서 자란 부위가 있다. 거기에 맞게 그때그때 각을 맞춰야 한다. 그런데 기계로 깎으면 깎지 말아야 할 부분을 깎고, 깎아야 할 부분을 깎지 않는 경우가 생긴다. 물론 어쩔 수 없이 기계를 써야 할 때도 있다. 하지만 기계를 썼다 하더라도 세심한 부분은 손으로 일일이 대패질해서 다듬어야 한다. 뭐든지 기계로 하는 것보다는 손으로 하는 것이 시간도 오래 걸리고, 비용도 더 든다. 그래도 좋은 한옥을 짓기 위해서 이 부분만은 양보하지 않았으면 한다.

기둥은 단면의 형태에 따라 크게 원주와 사각형, 육각형, 팔각형

6각 그리기

7각 그리기

189

모양으로 나눌 수 있다. 이 가운데 주로 사용되는 형태는 사각형과 원형이다. 사각형 기둥은 기둥의 단면이 정사각형 또는 직사각형으로, 기둥이 받는 하중을 고르게 분산할 수 있어 안정적이기 때문에 가장 일반적으로 쓰이는 형태이다. 원형 기둥은 기둥의 단면이 원형으로 부드러운 느낌을 주어 고급스러운 분위기를 연출할 때 사용한다. 주로 왕궁의 대문이나 사찰의 기둥 등에 사용되는데, 소나무 같은 내구성이 강한 목재로 만든다.

기둥의 전체 길이는 주초석 높이의 9~10배로 한다. 예를 들어 기둥의 길이 9자를 기준으로 원주를 치목할 때는 윗면의 너비(지름)를 아랫면의 너비보다 10분의 1만큼 줄인다. 그래야 기둥을 세웠을 때 건물이 벌어져 보이지 않고 안정감이 있다. 기둥의 윗면과 아랫면의 너비가 같으면 건물이 벌어져 보이는데, 이러한 현상을 시각적 착각이라고 한다. 이런 착시 현상을 없애기 위해 기둥 윗 부위의 너비를 줄여 치목해 만든 기둥이 민흘림기둥이다. 기둥의 가운데 부위보다 약간 아래의 배가 부르도록 하여 시각적으로 안정감을 주는 배흘림기둥도 있다. 부석사 무량수전은 배흘림기둥으로 유명하다.

배흘림기둥은 주로 고려 시대 건축물에서 그 예를 찾아볼 수 있으며, 민흘림기둥에 비해 공력이 많이 들어가는 고급 치목 방식이다. 옆의 그림에서처럼 배흘림기둥의 전체 길이를 3등분했을 때 ①번의 너비가 가장 작고, ②번과 ④번이 같고, ③번이 가장 크다. 이렇게 작업하는 예가 많다.

배흘림기둥 치목

사각형 모양 각주 치목

사각형 모양의 각주 역시 아랫면의 너비보다 윗면의 너비를 10분의 1만큼 줄인다. 예를 들어 아랫면의 각 변이 30㎝일 때 윗면의 각 변을 1.5㎝씩 줄여서 깎는다(앞의 그림 ㉠). 그런데 네 변을 다 깎는 것이 힘들기 때문에 현장에서는 작업의 편의를 위해 보통 두 변만 3㎝씩 줄여서 깎기도 한다(앞의 그림 ㉡). 그러나 두 변의 길이만 줄일 경우에는 중심이 옆으로 약간 기우는 단점이 있다. 그러면 아무래도 건물이 오래가지 못한다. 따라서 조금 더 힘이 들더라도 정석대로 각 변의 길이를 줄여 항상 중심축이 바로 서게 하는 것이 좋다.

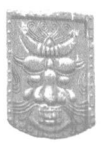

기둥에 벽선을 붙이는 세 가지 방법

　벽선壁線은 기둥에 붙여 세우는 직사각형의 각재를 말하는데, 기둥의 구조적 안정성과 강도를 증가시키기 위해 붙인다.

　벽선을 붙이는 방법에는 세 가지가 있다. 하나는 기둥과 벽선의 이음새가 맞물리도록 기둥 한쪽 면에 홈을 한 개 파서 붙이는 방법이고, 또 하나는 홈을 두 개 파서 붙이는 방법이고, 나머지는 그냥 기둥 면에 붙이는 방법이다. 완성된 겉모습만 보면 큰 차이가 없는 듯하지만 이 세 가지 방법은 여러 측면에서 많이 다르다.

　가장 먼저 시공비에서 큰 차이가 난다. 그냥 붙일 때보다 홈을 한 개 팠을 때, 홈을 한 개만 팠을 때보다 두 개 팠을 때 단가가 더 높아진다. 무엇보다 결정적으로 내구성에서 차이가 난다. 홈을 파서 벽선을 붙이면 이음새에 바람이 통하지 않고 나무도 덜 터진다. 콘크리트

벽선을 붙이는 세 가지 방법

포장 공사에 신축 줄눈을 설치하여 늘어나고 오므라지는 작용을 먼저 해 놓는 이치와 같다.

홈을 파서 기둥과 부자재를 이어 놓으면 기둥과 부자재가 서로 꼭 붙들고 있기 때문에 훨씬 튼튼하게 오래간다. 공사비를 아끼려고 벽선을 그냥 붙이면 겉으로는 똑같아 보여도 결국 부실한 집이 된다. 집을 지을 때 어느 부분에서 가격 차이가 나는지 집주인이 정확하게 알고 있어야 제대로 된 집이 완성된다.

벽선으로 붙이는 목재는 목재의 바깥 부분을 기둥에 붙이고 내부 심을 창호 쪽으로 해야 나무가 덜 휜다.

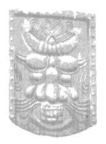

창방과 보 올리고 걸기

　창방과 보는 모두 수평으로 놓이는 구조 부재로, 한옥의 지붕을 받치고 건물 전체의 중심을 잡는 데 중요한 역할을 한다. 창방은 주로 기둥 위에 수평으로 놓여 지붕을 지지하고, 지붕의 하중을 기둥에 분배해 안정성을 유지하는 역할을 한다. 보는 건물의 앞쪽 기둥과 뒤쪽 기둥 위에 수평으로 걸치는 부재로, 역시 하중을 지탱한다.

　창방과 보를 놓을 때는 나무의 음지에서 자란 부위를 아래로, 양지에서 자란 부위를 위로 향하게 해야 한다. 이런 것을 무시하고 방향을 제대로 구분해 올리지 않으면 건물이 아래로 처지게 된다.

　보는 크기와 위치에 따라 대들보, 중보, 종보, 툇보(퇴칸의 평주와 고

주 사이에 없는 짧은 보), **충량**(건물 측면에 선 기둥의 머리에서 들보를 향해 걸친 보) 등으로 나뉜다.

대들보는 기둥 위에 걸리는 부재 중 가장 길고 굵다. 그러나 튼튼하게 한다고 무조건 굵은 나무를 쓸 수는 없다. 자칫 시각적으로 너무 무거워 보일 수 있기 때문이다. 중보는 건물의 중앙 부분에 놓이는 수평보이며, 종보는 세로 방향의 보로, 건물의 길이 방향으로 놓인다. 툇보는 보통 건물의 뒤쪽 공간이나 기둥 후방 부분에서 지붕을 지탱하는 역할을 한다. 마지막으로 충량은 원래 설계된 기존 보에 강도를 추가한 형식의 보이다.

부재들과의 전체적인 조화를 고려하여 최적의 굵기와 모양을 찾는 것은 유능한 전문가(설계자, 기술자, 목수)의 몫이다.

공간을 지탱하는 공포 짜기

　전통 목조 건축의 뼈대는 기둥, 보, 창방으로 이루어진다. 이러한 구조를 가구식架構式 구조라고 한다. 전통 건축에서 지붕의 하중은 서까래 - 도리 - 대공 - 보 - 공포를 거쳐 기둥으로 전달된다. 도리는 보와 직각 방향으로 위치하여 서까래를 받치는 수평 부재이며, 설치되는 위치에 따라 종도리宗道里, 중도리中道里, 주심도리柱心道里, 외목도리外目道里 등으로 불린다. 도리는 무엇보다도 지붕의 안정과 미적 균형을 유지하는 데 중요한 역할을 한다. 대공은 서까래 아래에 위치한 도리를 받치기 위해 보 위에 세운 키가 작은 받침재인데, 지붕의 하중을 보에 전달하는 역할을 한다.

　공포는 전통 건축에서 건물의 처마 부분을 지지하는 매우 중요한 구조 요소이다. 공포는 우리나라를 비롯해 중국, 일본 등지의 전통 목

조 건물에서 기둥머리 위나 평방 위에 위치하여 처마가 건물 밖으로 길게 내밀 수 있도록 하면서, 대들보와 그 상부의 하중을 기둥에 전달하기 위해 여러 작은 부재들로 짜맞추어 놓은 것을 말한다. 공포는 전통 건축물의 하중을 분산하고, 외부의 힘을 완충하는 구조적인 역할을 하는 동시에 건물 외관의 격식과 장식적인 조형미를 돋보이게 한다.

공포가 있는 건물은 공포를 건물에 설치한 위치와 공포의 결구법에 따라 주심포, 다포, 익공 등으로 나눌 수 있다.

주심포柱心包는 기둥머리 바로 위에 여러 개의 나무쪽을 짜맞추어 올린 구조이다. 특히 중심 기둥을 기준으로 대칭적인 방식으로 보강재와 구조적 요소를 배치하여 건물 중앙의 안정성과 균형성을 강화한다.

다포多包는 기둥 위쪽뿐만 아니라 기둥과 기둥 사이 평방 위에도 나무쪽을 짜맞추어 올린 공간포로, 여러 개의 보강재를 덧댄 방식이다. 다포 기법은 기둥이 많고 기둥 사이가 넓은 구조물에 사용된다.

익공翼工은 기둥 위에만 끼우는 장식 부재로, 기둥 간 연결을 통해 기둥 상단의 수평적 안정성을 강화한다. 익공의 단수에 따라 초익공, 이익공 등으로 부른다.

조선 시대에는 일반 가정집에서 주심포, 다포, 익공 양식으로 집을 짓는 것을 금했다. 공사비가 많이 들고 화려하기 때문이다. 그래서 궁궐, 사찰 건물에서 주로 사용되었다.

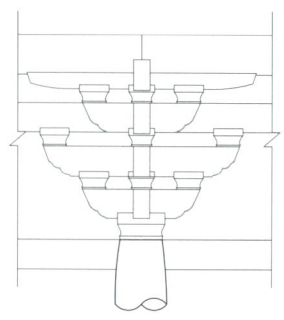

주심포 입면
(부석사 무량수전)

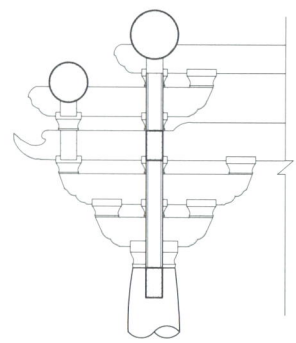

주심포 단면
(부석사 무량수전)

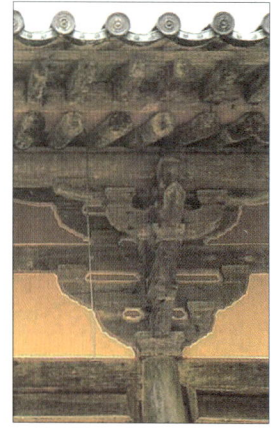

주심포
(부석사 무량수전)

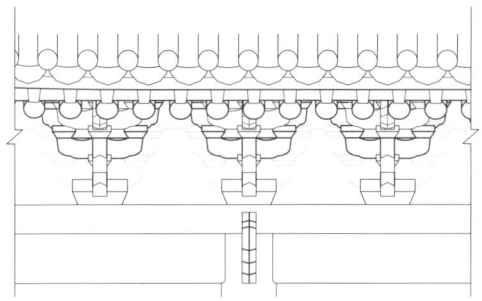

다포 입면
(창덕궁 인정문)

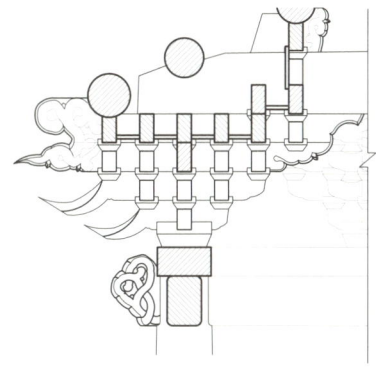

다포 단면
(창덕궁 인정문)

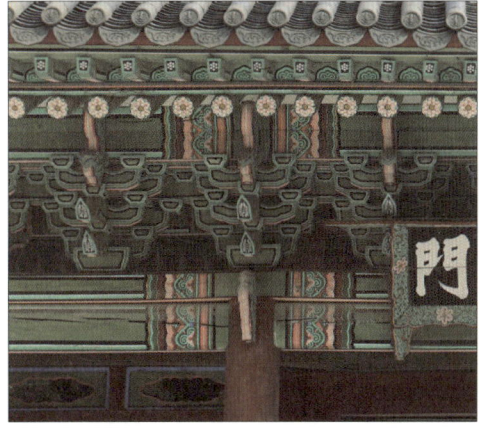

다포
(창덕궁 인정문)

초익공 입면
(소수서원 강학당)

초익공 단면
(소수서원 강학당)

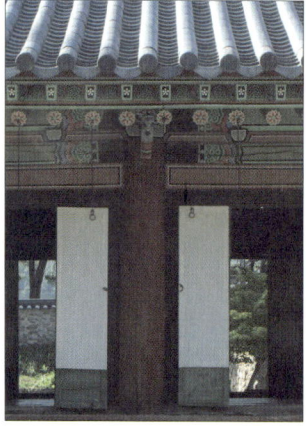

초익공
(소수서원 강학당)

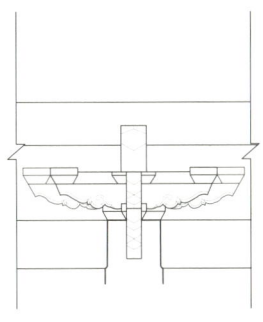

이익공 입면
(종묘 정전)

이익공 단면
(종묘 정전)

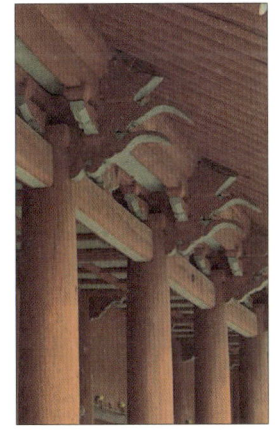

이익공
(종묘 정전)

공포 부재를 만들 때는 튼튼하면서도 유려한 곡선미를 제대로 살리는 것이 관건인데, 그러자면 곡선을 깊게 내려 파야 한다. 물론 나무도 그만큼 많이 들고 품도 더 든다. 그래서 요즘에는 얕게 내려 파는 공포 부재를 많이 보게 된다.

건축주의 동의하에 재료비를 아끼기 위해 얕게 내려 파는 것이라면 그나마 이해할 수 있지만, 시공자가 재료비는 재료비대로 다 받고는 얕게 파는 것이라면 문제다. 실제로 비교해 보고 어떤 것을 선택해야 아름다운 한옥의 전통미를 지키는 일인지 스스로 판단할 수 있어야 한다.

높이 쳐든 처마와 서까래

처마는 서까래가 건물의 외벽을 구성하는 기둥 밖으로 나온 부분 전체를 말한다. 서까래를 도리와 직각이 되도록 그 위에 경사지게 걸어 지붕을 완성하면 한옥 짓는 공정은 거의 마무리됐다고 할 수 있다.

한옥의 처마 각도는 수천 년 동안 지속된 우리나라의 기후에 맞게 만들어졌다. 그렇게 형성된 처마의 각도는 신기하게도 우리 눈썹의 각도와 같다. 외부로 노출된 신체 부위 중 가장 잘 보호해야 할 부분이 눈이다. 그래서 눈썹이 있는 것이다. 처마는 한옥에서 눈썹과 같은 역할을 한다. 즉, 처마는 집을 보호하기 위해 만들어졌다.

지붕 밖으로 처마를 빼는 이유는 단순히 멋 때문만이 아니다. 처마는 몇 가지 중요한 기능을 담당한다.

첫 번째로, 집 안으로 들어오는 햇빛을 조절해 준다. 햇빛이 집 안

으로 들어오는 각도는 계절마다 다르다. 여름에는 태양의 남중고도가 70도 정도로 꺾이고, 겨울에는 35도 정도밖에 꺾이지 않는다. 한옥의 처마 깊이로 인해 여름철 햇빛은 집 안으로 들어오지 않고, 겨울철 햇빛은 집 안으로 들어와 오래 머문다.

두 번째로, 비를 막아 준다. 아주 옛날에는 땅을 파서 바닥을 만들고 그 가운데에 화덕을 놓고 그 위에 지붕을 씌워 집을 만들었다. 이런 주거 양식을 수혈주거竪穴住居라고 부른다. 이때의 집은 처마가 거의 없는 형태였다. 그러다가 세월이 흐르면서 기둥을 세워 지붕을 들어 올린 형태로 집을 짓기 시작하면서 생긴 것이 처마이다. 처마 밑으로 그늘이 생기면서 곡식 같은 것을 보관하기도 했는데, 비가 들이치면 저장한 곡식이 젖으니 처마를 점점 더 길게 뺐다고 한다. 이와 함께 길어진 처마의 무게를 지탱하기 위해 기둥 위에 나무 부재를 덧대게 되었다. 처마의 기울기는 1년 강수량과도 관계가 있다. 비가 많이 오는 곳에서는 빗물이 빨리 빠지도록 처마의 기울기가 가파르게 했고, 비가 적게 오는 곳의 처마는 기울기가 덜 가파르다.

세 번째로, 온도 조절 기능을 한다. 처마로 들어온 바람이 빠져나가지 않고 처마 아래에서 맴돌며 공기 주머니를 만든다. 이 공기 주머니는 외부의 뜨거운 열기를 차단하는 효과가 있다. 그리고 차가운 실내 공기가 밖으로 나가는 것도 막아 준다. 그래서 한옥은 여름에는 시원하고 겨울에는 따뜻하다. 한옥의 이런 효과에 가장 큰 영향을 미치는 것이 처마의 각도이다. 처마의 길이를 늘이면서 옆으로만 길게 빼면 바람이 들어왔다가 바로 빠져나간다. 그러면 공기 주머니 효과

가 생길 수 없다. 여기에 지붕의 두께도 영향을 준다. 지붕에 흙을 두껍게 발라(보토) 더위나 추위를 막는다.

처마는 이러한 기후 조절이나 구조적 기능 외에 상징적 의미도 지닌다. 전통적으로 처마는 집의 기운을 모으고, 나쁜 기운은 차단하는 역할을 한다고 여겨졌다. 또한 아름다운 처마의 곡선은 한옥의 미를 완성시키는 특징으로 자리 잡았다.

한옥의 모든 요소는 건물의 안정성과 하중 분배에 중요한 역할을 한다. 서까래 역시 지붕을 지지하는 기본 부재이다. 주로 기둥 상단에서 지붕의 처마 끝까지 이어지는 형태로 설치되며, 지붕의 형태와 안정성을 결정짓는다. 서까래의 길이와 굵기는 지붕 모양에 따라 달라진다. 경사가 완만한 경우에는 긴 서까래를 사용하고, 경사가 급격할수록 짧고 두꺼운 서까래가 필요하다.

서까래를 치목할 때는 미리 계산된 처마 곡선에 맞춰 나무의 휜 부분을 살려 치목해야 서까래를 걸었을 때 들뜨는 부분이 없이 오래간다. 물론 하나하나 처마 곡선에 맞춰 휜 나무를 구해 치목하는 것은 쉬운 일이 아니다. 그러다 보니 그냥 일자 나무로 치목하여 걸고 들뜨는 부분에 나뭇조각을 괴어 못질을 해 놓는 경우가 있다. 그렇게 하면 아무래도 내구성이 떨어지고 오래가지 못한다.

제대로 치목하려면 도리 위에 8푼~1치(2.4~3㎝) 정도 두께의 각재를 대고, 그 위에 지붕 곡선에 맞춰 치목한 서까래를 설치한 후 각재를 빼내면 지붕 하중에 의해 도리와 서까래가 꽉 물리듯이 밀착된다. 이래야 좀 더 튼튼하고 시간이 흐른 뒤에도 변형이 적다.

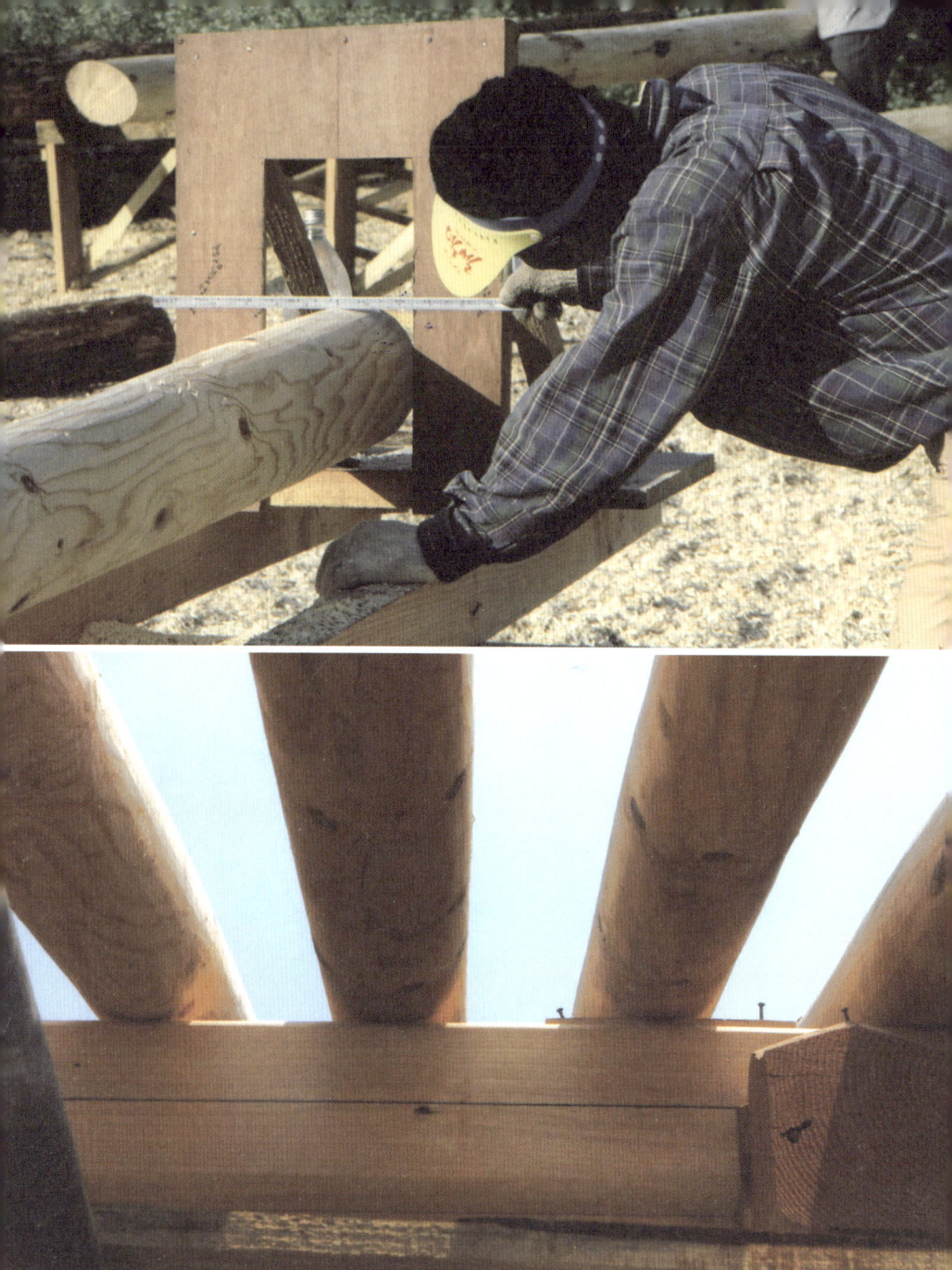

계산된 처마 곡선에 맞게 서까래 치목하기

꼼꼼하게 기와 잇기

기와 잇기는 지붕에 기와를 덮을 때 기와들을 겹치거나 연결하는 작업을 말한다. 기와를 잇는 주된 목적은 물이나 바람이 스며들지 않도록 하기 위해서이다. 이런 기와 잇기의 방식은 기와의 종류와 지붕의 형태에 따라 달라진다. 이때 기와는 가로 방향과 세로 방향이 모두 겹치도록 맞대어 이어서 물이 지붕을 따라 흐르게 해야 비가 새는 것을 막을 수 있다. 즉, 기와의 윗부분으로 아랫부분을 덮고, 좌우의 기와도 서로 걸쳐서 밀착시키는 것이다.

기와는 크기에 따라 소와, 중와, 대와, 특대와로 나뉜다. 소와는 주로 담장이나 협문, 조그만 건물을 지을 때 쓰고, 중와는 살림집이나 규모가 작은 건물을 지을 때 사용한다. 대와는 골이 길고 큰 집에 쓰

인다. 또 기와는 모양과 쓰임에 따라 암키와, 수키와, 막새, 망와 등으로 나뉜다. 특히 막새와 망와는 기능적인 역할뿐만 아니라 한옥의 개성과 예술성을 드러내는 역할을 한다.

망와는 지붕의 마루 끝에 세우는 기와이다. 망와 밑에 있는 머거불에는 그 건물의 역사 같은 것을 새겨 넣는다. 안성 해주 오씨 정무공파 종중 재실의 경우에는 '해주 오씨 정무공파 2010'이라고 썼다. 나중에 후손들이 이 기와를 보고 건물의 용도와 역사를 알 수 있도록 한 것이다.

기와는 앞서 이야기한 것처럼 집을 지으려는 곳과 가장 가까운 지역에서 구운 기와를 쓰는 게 좋다. 면역성이 같기 때문이다. 요즘에는 강도 때문에 재래식 수제 기와보다 기계식 기와를 많이 사용한다. 하지만 아무래도 기계식 기와는 재래식 기와보다 상대적으로 이끼나 곰팡이가 덜 피고 풀도 잘 자라지 않는다. 지붕 색이 자연스러우려면 이끼나 곰팡이가 피는 게 좋다. 너무 새것 같은 느낌보다는 조금 사용한 흔적이 있어야 집이 운치 있어 보이기 때문이다. 그래서 기계식 기와에도 이끼나 곰팡이가 빨리 피게 하려고 기와 표면에 차좁쌀로 풀을 쑤어 바르기도 한다.

바닥기와인 암키와를 이을 때는 대개 '3단 잇기'를 한다. 중와의 경우 길이가 36㎝, 폭이 30㎝이다. 이때 12㎝마다 한 단씩 3겹을 겹쳐 올리는 것을 3단 잇기라고 한다. 그런데 이런 기본을 무시하고

18㎝마다 한 단씩 2겹으로 올리는 경우가 종종 있다. 물론 이렇게 하면 기와가 3단 잇기를 할 때의 3분의 2밖에 들어가지 않는다. 예를 들어 전체 지붕을 3단 잇기로 올리는 데 기와 3천 장이 필요하다면, 2단 잇기로 하면 2천 장만 있으면 되는 것이다. 이런 식으로 지붕을 올리면 겉으로 보기에는 멀쩡하고 예산도 줄어든다. 하지만 기본을 제대로 지키지 않으면 얼마 지나지 않아 누수 등의 문제가 발생한다.

기와를 덜 쓰기 위해 팔작지붕의 합각머리를 낮게 하는 경우도 있다. 합각머리가 낮다는 것은 지붕 높이가 그만큼 낮다는 것이고, 기와도 그만큼 덜 들어간다. 하지만 한옥의 지붕 물매(경사도)는 수천 년 동안 내린 강우량에 맞게 형성된 것이고, 앞으로는 비가 더 많이 올 것으로 예상되므로 기와가 많이 들어가더라도 합각머리를 높게 하는 것이 좋다.

또한 합각머리를 높게 하면 시각적으로도 아름답고 다양한 무늬를 넣을 수 있어서 좋다. 나는 한옥을 지을 때 합각머리만큼은 꼭 집주인의 취향이 반영되도록 신경 쓰고, 될 수 있으면 집주인이 직접 문양을 그려 넣을 수 있도록 한다.

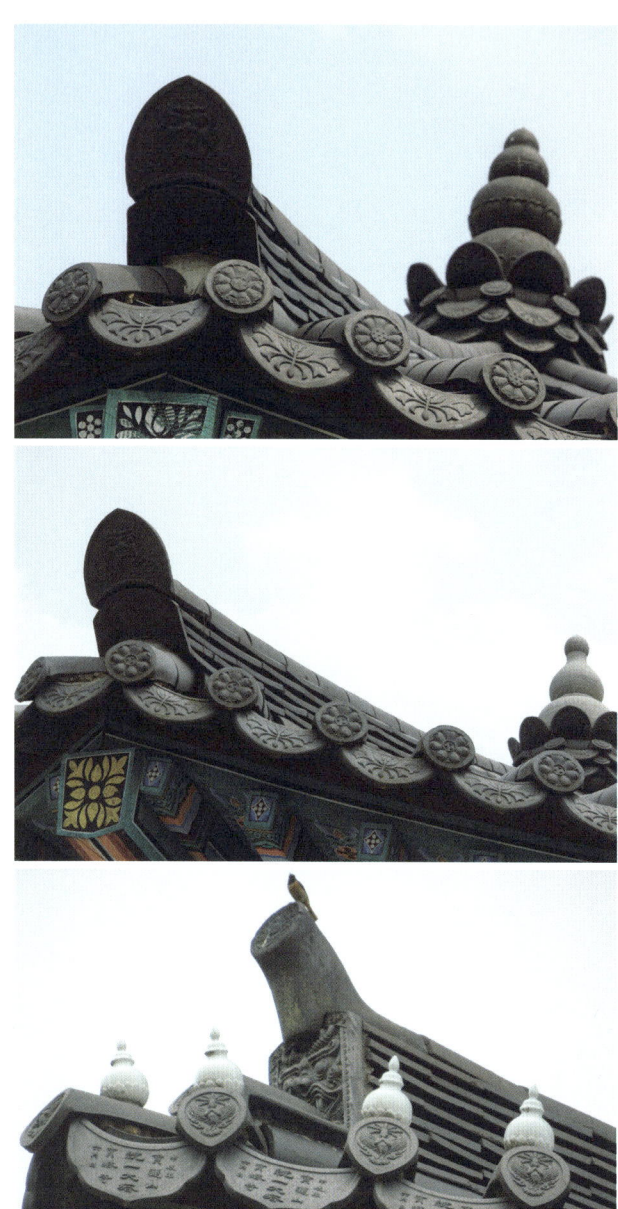

막새, 망와, 곱새기와, 귀면와

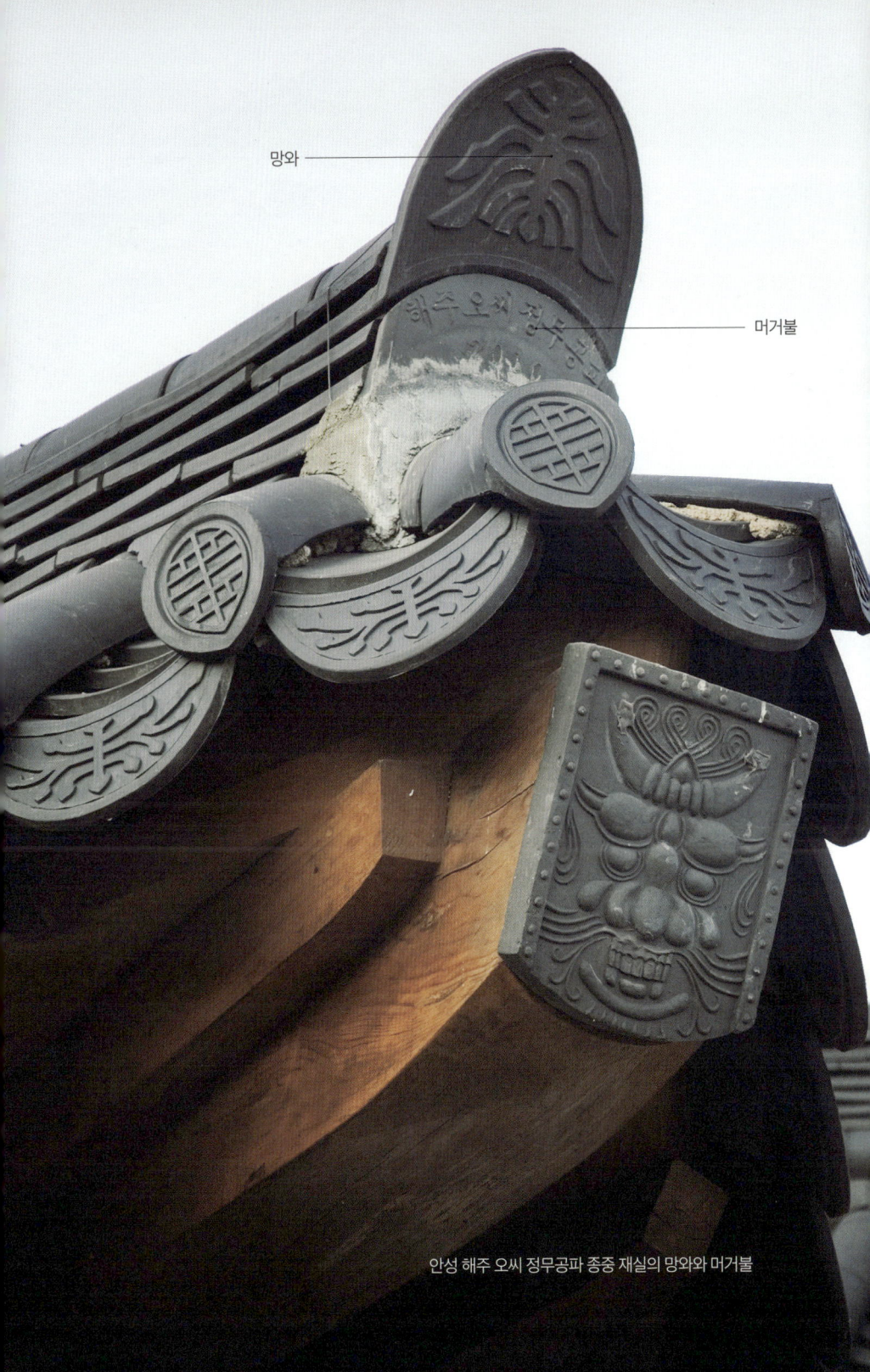

안성 해주 오씨 정무공파 종중 재실의 망와와 머거불

안성 해주 오씨 정무공파 종중 재실의 합각머리

다양한 문양의 합각머리

바닥이 따뜻한 구들 놓기

　구들은 우리나라의 전통 난방 방식으로, 고래(방의 구들장 밑으로 나 있는, 불길과 연기가 통하여 나가는 길)를 설치해 불기를 고래 사이로 통과시켜 구들장(고래 위에 깔아 방바닥을 만드는 얇고 넓은 돌)을 덥히는 구조물이다. 흔히 온돌이라고 표현되지만, 온돌이 바닥 난방을 뜻한다면 구들은 집 안의 전체적인 난방 구조라고 볼 수 있다.

　보일러로 난방을 하는 방은 아랫목과 윗목의 구분이 없이 방바닥 전체가 골고루 따뜻하지만, 아궁이에 불을 때는 전통 구들방은 아랫목과 윗목이 확실히 구분된다. 구들의 위치는 방향과 상관없이 아궁이 쪽이 항상 아랫목이고, 아궁이에서 먼 쪽이 윗목이 된다. 그래서 아궁이와 가까운 아랫목은 뜨겁고 윗목은 차다. 이런 방 안의 온도

차이에 의해 공기가 순환한다. 공기 순환이 잘되면 방 안이 건조해지는 것을 방지해 피부 건강은 물론이고, 호흡기 질환을 예방하는 데도 도움이 된다.

원래 사람의 몸은 배꼽 아래는 따뜻하고 그 위로는 차가워야 좋다. 그래야 잠도 푹 잘 수 있다. 옛날에는 구들방에서 자다가 갈증이 나면 마실 수 있도록 놋그릇에 물을 담아 머리맡에 두고 잤다. 윗목물, 목물로 불린 이 물이 꽝꽝 얼 정도로 윗목이 차가웠지만 아랫목은 절절 끓었다. 그런 곳에서 잠을 잔 뒤 아침에 기지개를 켜면 온몸이 개운하다. 많은 사람이 그걸 아니까 전통 구들을 찾는 것이다. 그런데 요새는 아무리 잠을 자도 바로 일어나지 못하고 "5분만 더"를 외친다. 그만큼 몸이 피곤함을 느끼는 것이다.

보일러가 보급되면서 이제는 한옥에도 대부분 보일러를 깔지만, 간혹 전통식 아궁이와 구들을 놓고 싶다는 사람들이 있다. 아무래도 전자파에 대한 걱정 때문인지 전기로 돌리는 보일러 대신 나무를 때는 아궁이에 관심을 갖는 것 같다. 확실히 우리 몸에는 전통 구들이 더 좋다.

그렇다 해도 도시 생활을 하면서 아궁이에 땔감을 때는 전통 구들 방식을 고수하기는 어렵다. 하지만 방법이 아주 없는 것은 아니다. 보일러를 깔 때 옛날 방식을 응용할 수 있다. 온수 배관이나 전기선을 아래에는 촘촘하게 깔고 위에는 넓게 깔아서 아랫목과 윗목의 효과

를 내는 것이다.

구들은 놓는 방법에 따라 쪽구들, 골구들, 막구들 등 대여섯 가지 종류로 구분할 수 있다. 또한 어느 방향으로 아궁이를 만드느냐에 따라 구들을 놓는 방법과 형태가 달라진다.

고구려 벽화에도 나오는 것처럼 북방 지역에서는 말을 타는 생활을 했기 때문에 구들을 방 전체에 놓지 않고 반만 놓았다. 방의 반은 구들이 있고, 나머지 반은 그냥 흙바닥인 것이다. 이를 고구려식 반구들인 쪽구들이라고 한다. 고구려식 쪽구들의 높이는 맨바닥에 의자를 놓고 앉았을 때의 높이와 같다. 말에서 내려 신발을 신은 채로 뜨뜻한 구들에 누워 잠을 자다가 유사시에 빨리 말을 타고 나가 적을 막기 위한 구조였다. 이러한 쪽구들은 고구려 시대에 많았고, 중국 여러 지역에서도 보인다.

골구들은 큰 돌이나 벽돌로 골의 둑을 만들고 그 위에 구들장을 덮는 방식으로, 지금도 재래식 건물에서는 주로 이 방식을 사용한다. 막구들은 골을 켜지 않고 잔돌로 괴어 놓는 방식으로, 골구들에 비해 상대적으로 간단하고 덜 복잡한 구조를 갖추었다. 연기 통로가 간단해 열전달이 약할 수 있지만 제작이 간단해 비용이 덜 드는 효과는 있다.

쪽구들의 굴뚝은 온돌 바닥에서 바깥으로 바로 빠지지 않고 벽을 많이 돌아서 빠진다. 두꺼운 벽 사이에 공간을 두고(이중벽) 그 길을 따라 연기가 빠지게 한다. 그렇게 벽을 데워서 보온 효과를 높였다.

추운 지방이니 벽도 차가워지지 않게 한 것이다.

현대식 한옥에서는 침대를 대신해 쪽구들을 만들어 봐도 좋을 것 같다. 좌식 생활이 불편하다면 쪽구들을 응용한 반입식 온돌로 변화를 줄 수 있을 것이다.

구들은 생각보다 굉장히 넓은 지역에 분포되어 있다. 중국 끝에 위치한 우루무치, 투루판, 카슈가르까지 구들이 퍼져 있다. 요즘에는 서양에서도 한국식 구들을 연구하는 건축가가 늘고 있다고 한다.

집의 중심, 마루 설치하기

마루는 목재로 만든 평평한 바닥 공간이다. 마루 가운데서도 대청마루는 집의 중심이며, 주로 가족이 모이는 공간으로 활용된다. 마루는 난방이 되지 않는다. 대신 방과 방을 구분하거나 집의 안쪽과 바깥쪽을 연결하는 중요한 요소로 작용한다.

마루는 '크고 높다'라는 뜻이다. 산마루라 하면 산등성이의 가장 높은 곳을 말하고, 용마루라 하면 한옥 지붕 중앙의 가장 높은 곳을 말한다. 마찬가지로 한옥의 마루도 집 안에서 가장 높은 곳이라는 뜻이다. 마루는 주로 방과 방 사이에 놓았는데, 마루의 바닥은 방보다 2~5치(6~15cm) 정도 높다.

마루를 놓을 때는 나무 두께에 신경 써야 한다. 옛날에는 통나무를 반으로 잘라 마루를 놓아서 상관없었지만, 요즘은 목재를 얇게 제재해서 만든 나무판을 쓰기 때문에 나무판의 두께가 너무 얇으면 걸어 다닐 때 쿵쿵 소리가 난다. 그래서 최소 2치(6cm)가 넘는 나무판으로 마루를 놓아야 한다.

마루는 주로 서서 다니는 공간이기 때문에 천장 높이도 방보다 높아야 한다. '자기의 선 키+자기의 선 키'가 마루방의 높이가 된다. 이는 전통 건축 현장에서 널리 통용되는 기준이다. 반면 온돌방은 주로 앉아서 생활하는 공간이기 때문에 마루보다 낮게 '자기의 앉은 키+자기의 선 키' 높이로 한다.

전통식 마루는 보통 우물마루라고 해서 우물 정井 자 모양으로 짜는데, 못을 쓰지 않는 것이 특징이다. 마루를 놓을 때 한 가지 빼놓지 말아야 할 과정이 있다. 마루를 놓기 전 그 밑에 소금을 가득 넣은 항아리를 뚜껑 없이 한두 개 묻고, 흙바닥에 숯가루를 3cm 이상의 두께로 까는 것이다. 그렇게 해 두면 소금 항아리에서 올라온 염분기와 숯의 정화 작용으로 인해 마루 밑으로 벌레가 다니지 못한다. 이런 과정이 있었기에 옛날에는 사람들이 마루에 앉아도 벌레를 걱정하지 않았다.

옛날 대가족이 모여 살던 한옥에는 중앙 기둥의 바로 앞(평소에는

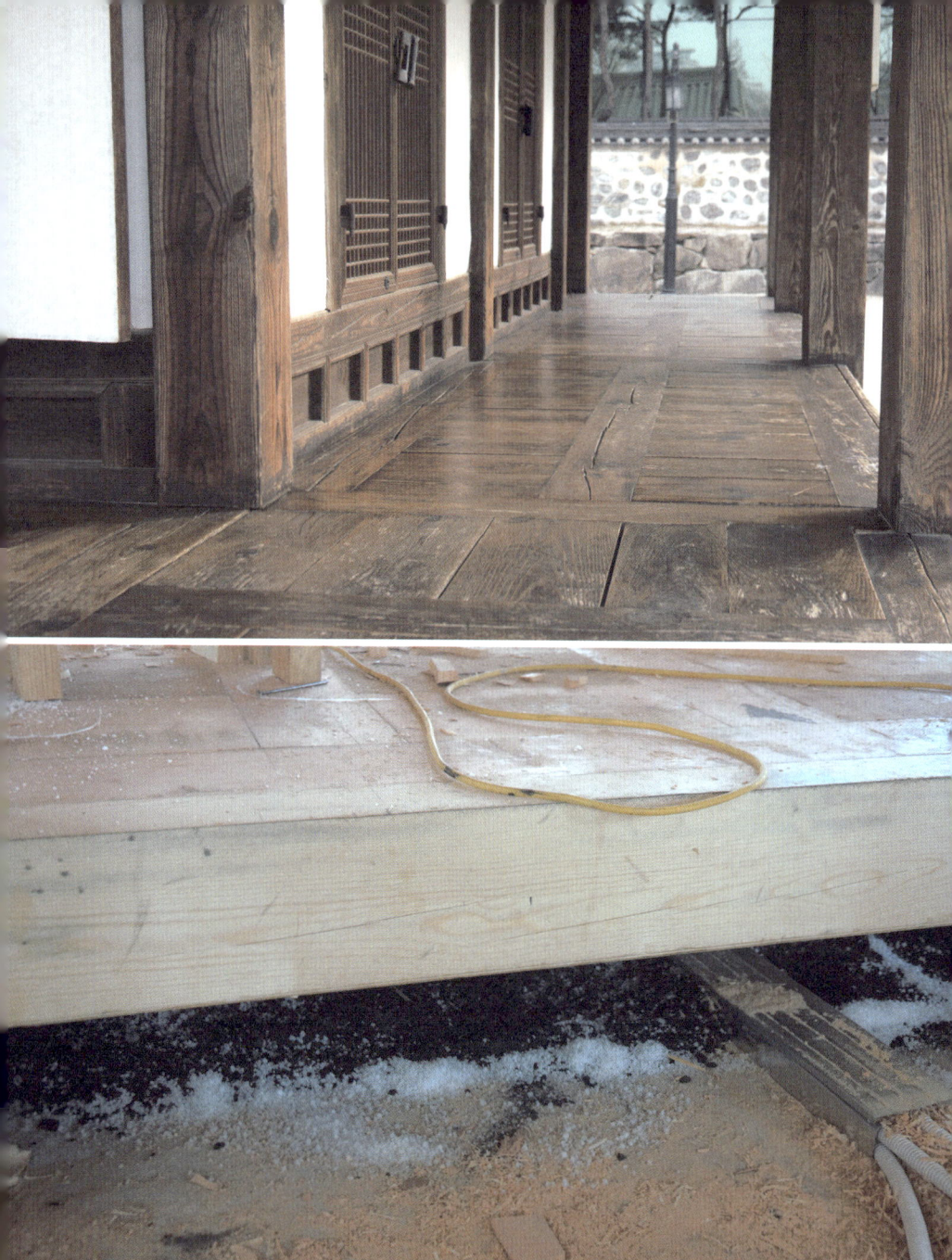
전통식 우물마루(위), 가정집 마루 밑에 숯과 소금을 뿌려 둔 모습(아래)

마루를 놓기 전 그 밑에 소금 항아리를 묻어 두면 벌레를 막을 수 있다.

잘 밟고 지나다니지 않는 곳, 불편하지 않은 위치)에 마루판 하나를 꽉 물리게 깔지 않고 일부러 놀게 만들어 놓기도 했다. 그 이유가 기발하면서도 재미있다. 마루 너머 건넌방에는 대개 며느리가 살았다. 그래서 시아버지가 들어올 때는 마당 또는 마루에서 헛기침을 했다. 방에 있는 며느리에게 시아버지가 들어왔다는 것을 알리는 일종의 신호였던 셈이다. 그런데 시어머니는 헛기침을 할 수 없으니 다른 방법이 필요했다. 그래서 노는 마루판을 밟아서 삐걱 소리가 나게 했다. 이 소리가 들리면 며느리는 시어머니가 들어왔다는 걸 알 수 있었다. 이런 작은 장치들은 한옥의 특별함이 아닐 수 없다.

　전통 방식으로 깐 마루는 한 가지 단점이 있다. 시간이 지날수록 나무가 뒤틀려서 틈이 생긴다는 것이다. 이러한 단점을 해결하기 위해 여러 방법이 시도되었다. 그 결과 요즘 시행되는 방법은 마루를 다 놓은 후 나무가 마르면 그 위에 니스 칠을 하는 것이다. 니스는 나무 표면을 고정시켜 팽창이나 수축을 막아 주기 때문에 뒤틀림 현상이 거의 생기지 않는다. 그렇게 니스를 2~3회 정도 칠해 놓고 2~3년쯤 지난 후에 싹 긁어낸다. 그리고 불린 콩을 갈아 무명천에 싸서 마루 표면을 문지르는 '콩땜'을 하면 깨끗하고 튼튼한 마루가 된다.
　이렇게 현대 방식을 활용해 전통 방식으로 깐 마루의 단점을 보완할 수 있다면 전통 방식의 여러 장점을 앞으로도 그대로 누릴 수 있다. 전통 방식과 현대 방식이 만나 한옥의 가치가 더욱 높아진 사례라 하겠다.

몸을 건강하게 해 주는 토벽 미장하기

 토벽은 우리나라 전통 가옥에서 가장 흔히 볼 수 있는 벽의 형태였다. 주로 흙을 기본 재료로 하고 모래, 석회, 짚 등을 혼합하여 만든 벽으로, 친환경적인 건축 방법이다. 친환경적이라는 장점 외에 토벽에는 여러 기능이 있다. 습기 조절에 효과적이고 통기성이 뛰어나며 환기도 잘되고 단열성이 높다. 그러다 보니 여름에는 시원하고 겨울에는 따뜻한 온도를 유지해 준다. 토벽은 시간이 지날수록 굳고 단단해져 수백 년이 지난 유적을 찾아볼 수도 있다. 하지만 물에 약해 미장을 해야 하는 단점이 있다.

 토벽을 설치할 때는 토종 흙으로 만들어야 한다. 내가 어렸을 때는 흙벽이 많았고, 어린아이들이 그 흙을 긁어 먹기도 했다. 그런데 요즘

에는 흙벽은 고사하고, 길바닥조차 흙으로 된 곳을 찾아보기 힘들다. 그만큼 생활 주변에서 흙을 보기가 귀해졌다. 이런 귀한 흙으로 벽을 만든 후 초배지를 발라 도배를 하면, 벽에서 우리 몸에 좋은 음이온이 나와 건강에 도움을 준다.

전통 흙벽을 만들 때는 나무(중깃대)를 세우고 가로대를 대는데, 대개 대나무를 쪼개서 대고 흙을 바른다. 간혹 제재소에서 쉽게 구할 수 있는 쪽대를 사용하기도 하는데, 그런 재료는 흙과 잘 접착되지 않으므로 쓰지 않는 것이 좋다. 플라스틱 같은 자연 재료가 아닌 합성 제품을 넣고 흙을 바르면 흙벽에 금방 금이 생기고 떨어져 무너진다. 안에 들어가는 재료를 자연 재료로 쓰면 벌어지고 무너지는 일이 없다. 대나무가 아니더라도 자연 소재라면 무엇이든 흙벽의 가로대로 쓸 수 있다. 산에서 나는 싸릿대, 심지어 옥수숫대를 엮어서 대는 것도 좋다. 그러면 흙벽이 오래간다. 또한 흙은 약간 회색빛이 나는 죽은 흙을 쓰는 게 좋다. 주로 논흙을 많이 쓴다.

요즘에는 황토가 살균 작용을 한다고 알려지면서 안쪽 벽에 황토를 바르는 경우가 많아졌다. 황토를 벽에 바를 때는 큰 그릇에 황토를 넣고 물을 부은 후 휘젓는다. 그러면 붉은 물이 되는데, 그 물을 가만히 놔두면 입자가 아주 고운 황토가 가라앉는다. 그것만 거둬서 차좁쌀 풀을 쑨 것과 섞어 벽에 바른다. 그러면 몸에 좋은 황토벽이 된다. 시간이 지나 황토 칠한 것이 떨어지면 그 위에 새로 바르면 된다.

그런데 벽에 황토를 바를 때 주의할 점이 있다. 아무리 사람 몸에 좋다고 해도 황토를 집 전체 벽에 바르는 것은 좋지 않다. 특히 사람이 오래 머무는 방의 벽에는 황토를 바르지 않아야 한다. 이유는 의외로 단순하다. 황토가 우리 몸에서 살균 작용을 하다가 더 이상 균이 없는 상태가 됐을 때 알아서 작용을 멈추면 좋겠지만, 그러지 못하기 때문이다. 그만해야 하는데, 황토는 계속해서 살균 작용을 한다. 무엇이든 과유불급이다. 지나치면 안 하니만 못할 수 있다는 의미다. 그래서 벽에 황토를 바른 방에서 매일 생활하면 오히려 피로를 더 빨리 느끼게 된다. 무엇보다도 몸이 좋지 않아 방에 며칠씩 누워 있는 환자에게는 황토의 지나친 살균 작용이 몸 상태를 더 안 좋게 만들 수도 있다. 물론 찜질방에서 황토 찜질을 하는 것은 며칠씩 오래 하는 것이 아니니 전혀 문제될 것이 없다.

황토를 방에 바르고 싶다면 바닥에만 바르는 게 좋다. 방바닥에 발라 놓은 황토는 그 위에 요를 깔고 베개를 베고 자니까 괜찮다. 황토를 방이 아닌 마루의 벽에 바르는 것도 좋다. 마루는 왔다 갔다 하면서 잠깐 쉬는 곳이다. 오래 머무르지 않고 잠을 자더라도 잠시만 자는 곳이기 때문이다.

최근에는 전통 흙벽 대신 전통 흙벽의 느낌이 나도록 현대식으로 벽을 미장하는 방법을 쓰는 경우가 많다. 보통은 기둥에 붙이는 벽선의 두께가 벽의 두께가 된다. 그런데 벽선 밖으로 나뭇조각을 덧대어 벽의 두께를 더 두껍게 해서 내부를 채운 후 마감하면 흙을 쓰지 않

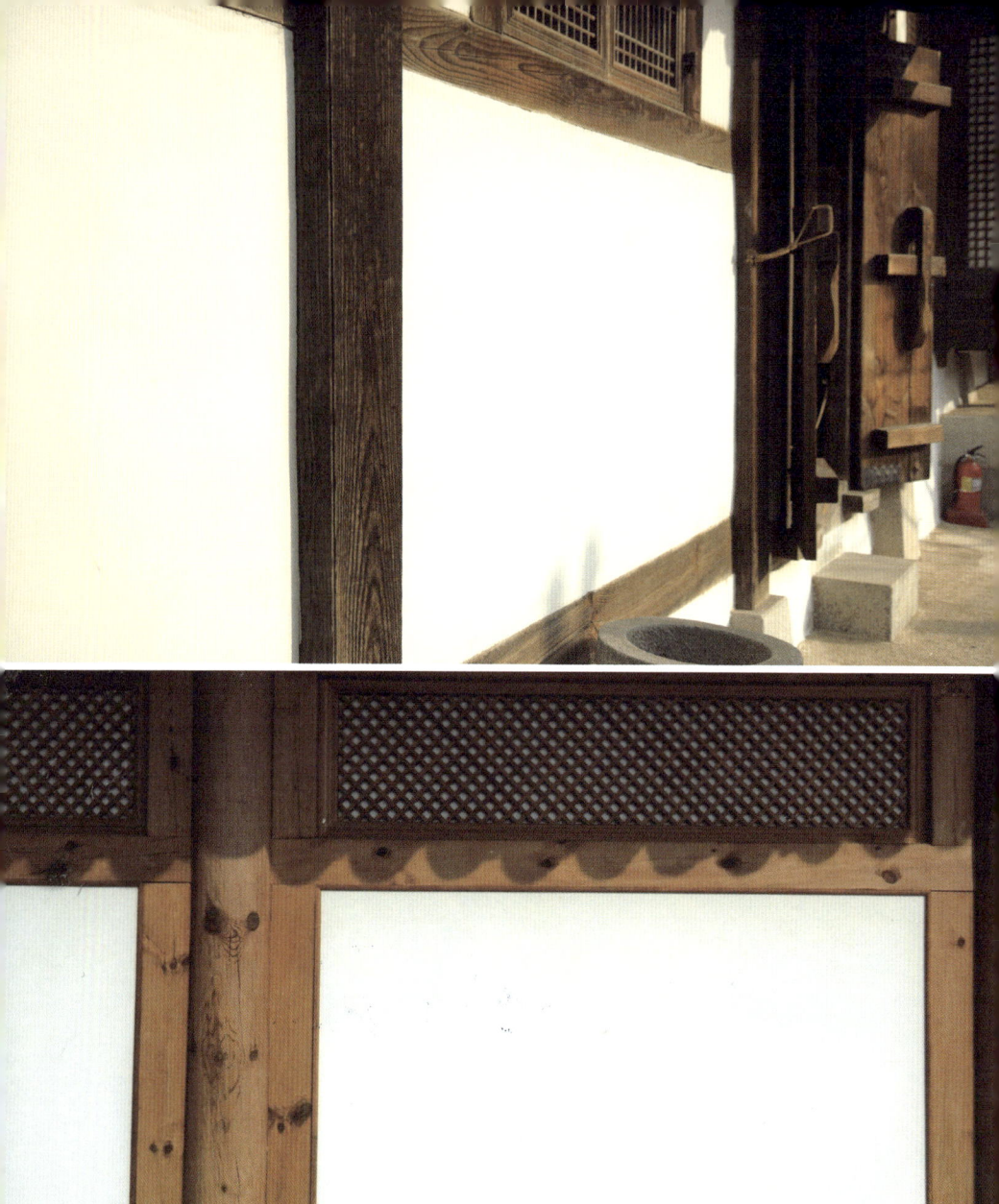

전통식 벽 미장(위)과 현대식 벽 미장(아래). 겉으로 보기에는 비슷하지만 내부 구조에 차이가 있다.

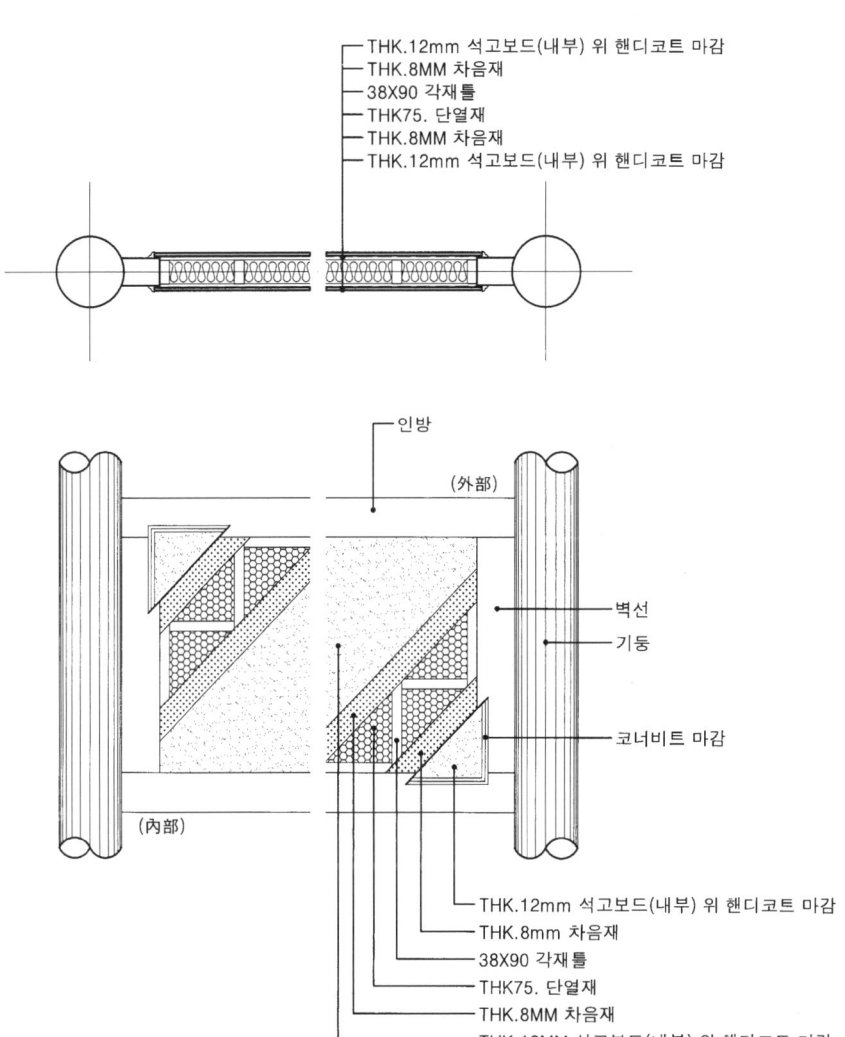

현대식 벽 미장

고도 흙벽의 멋스러움은 그대로 살릴 수 있다. 더구나 단열과 방음 효과가 있으며, 떨어지거나 금이 가는 것도 막을 수 있어 나쁘지 않은 방법이라 생각한다. 전통 방식의 한옥 짓기가 현대의 생활 방식에 맞지 않거나 불편한 점이 느껴진다면, 이렇게 새로운 공법을 응용하여 한옥의 현대화를 꾀할 수 있다.

내부와 외부를 잇는 창호 달기

창호窓戶는 밖을 내다볼 수 있도록 벽이나 지붕에 낸 문을 뜻하는 창窓과 마루와 방 사이를 드나들도록 낸 문을 뜻하는 호戶가 결합한 말이다. 이런 창호의 가장 주된 목적은 통풍과 채광이다. 여기에 덧붙여진 중요한 요소 하나가 자연과의 조화이다. 창호는 내부와 외부를 이어 주는 연결 지점으로, 끊임없는 자연과의 교감을 가능하게 한다.

창을 통해서는 외부의 풍경을 내부로 끌어들일 수 있다. 봄, 여름, 가을, 겨울이라는 계절의 변화가 창을 통해 자연스럽게 실내로 들어오고, 그런 자연의 변화에 따라 집 안의 분위기도 달라진다. 특히 얇고 반투명한 성질을 가진 창호지를 사용하는 한옥의 창호는 빛을 잘 통과시키면서도 외부에서 안이 보이지 않도록 한다. 전통 한지의 특성을 가진 창호지는 내구성이 뛰어나며 자연 친화적이다.

한옥의 창호는 나무로 틀을 짜고 문종이(창호지)를 바른다. 문은 원래 외문, 내문, 방충망 이렇게 3겹 문으로 만들어야 한다. 외문은 밖으로 여는 여닫이문이고, 내문은 옆으로 여는 미닫이문이다. 외문, 내문 모두 이중으로 문종이를 바른다. 그렇게 하면 단열이 굉장히 잘되어서 요즘처럼 유리로 하는 것보다 보온 효과가 더 크다.

문종이를 바를 때, 우리나라는 주로 난방이 온돌이기 때문에 더운 공기가 바깥으로 나가지 말라는 뜻에서 안쪽에 바른다. 반면 다다미를 사용하는 일본은 밖에서 불어오는 염분과 습기가 있는 공기가 안으로 들어오지 말라고 문종이를 바깥쪽에 바른다. 환경에 따라 나타난 흥미로운 차이다.

문은 뒤틀림이 생기는 것이 가장 문제다. 뒤틀림이 생기면 문과 문설주 사이가 벌어지는데, 이때는 문풍지(문에 종이를 바를 때 문보다 더 넓게 잘라서 문 옆에 붙여 놓는 종이로, 벌어진 틈을 막아 준다)를 발라서 해결한다. 문풍지를 바를 때도 전체를 다 바르는 게 아니라 귀퉁이 한 부분을 잘라서 말아 올린다. 이런 문풍지의 구멍은 일반 가정에서는 방 안의 공기를 순환시키는 통풍 구멍 역할을 한다. 사당이나 재실에서는 문풍지의 구멍을 일명 '귀신 구멍'이라고 하는데, 조상의 혼령이 그 구멍을 통해 드나드시라는 의미로 뚫어 놓았다. 단순히 미신이라고 치부할 것이 아니라 문 하나에도 조상을 모시는 정성을 담았던 것이다.

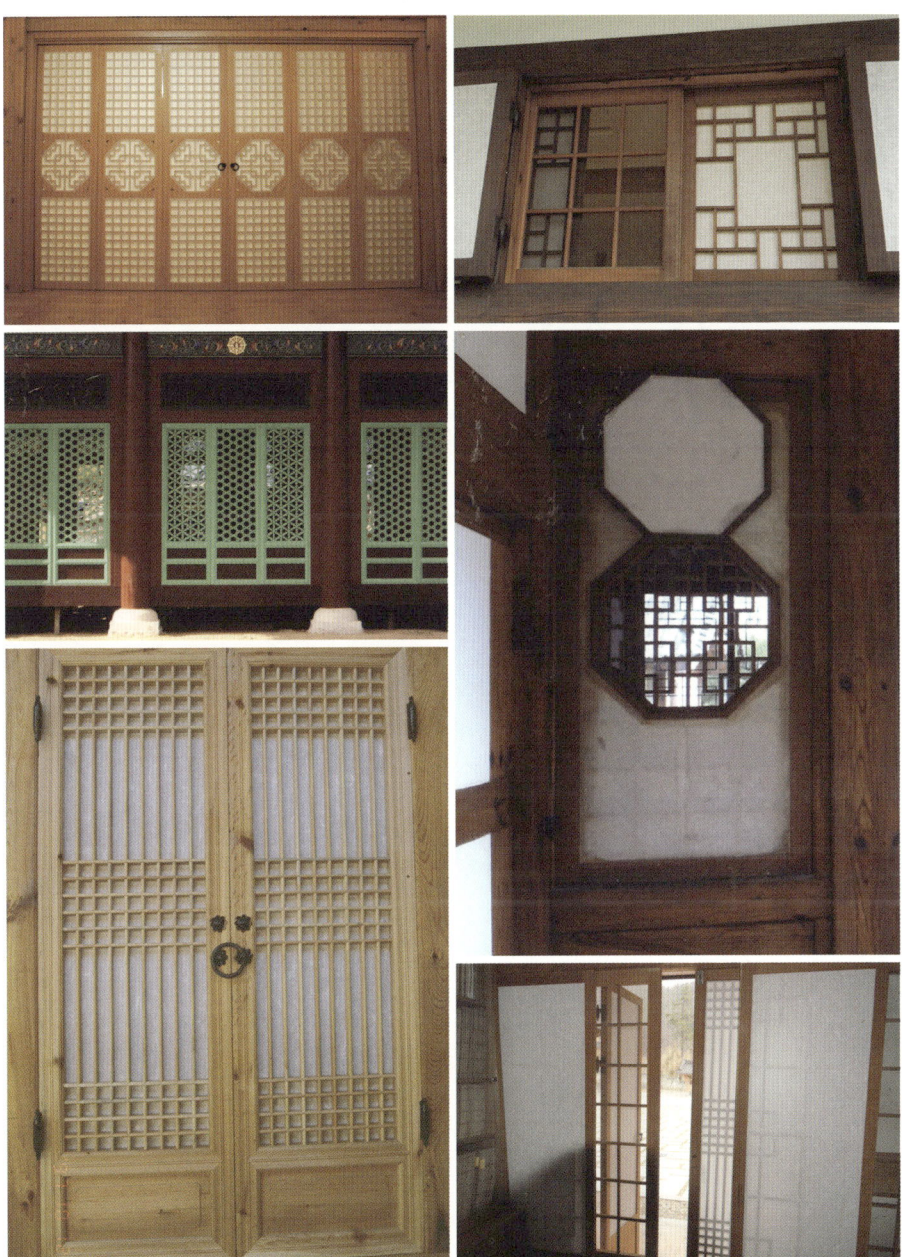

한옥의 다양한 살문

우리 한옥의 전통 문은 '살문'이라고 한다. 살문은 살을 가로세로로 넣어서 짠 문이다. 전통 살문은 가로 살대를 위와 아래에는 3~4칸씩 넣고 가운데 부분에는 4~5칸을 넣는다. 이것이 조형미가 가장 뛰어난 살문의 형태로, 보는 사람의 마음을 편안하게 해 준다. 그런데 요즘 만들어진 살문들을 보면 가운데에 4개를 넣고 위아래에 5개씩 넣은 형태가 많다. 이것은 전통 방식의 살문이 아니다.

살문은 바깥문(외문)에 쓰고, 내문은 살대가 '완卍' 자 모양으로 된 완자문으로 하거나 좀 더 화려한 문양을 넣는다.

문을 만들 때도 사용하는 재료와 만드는 방법이 다양하다. 그런데 요즘 현대식으로 한옥을 싸게 짓는다는 명분으로 문틀을 값싼 알루미늄으로 하는 경우가 많다. 그렇게 하면 비용은 낮출 수 있지만, 전통 문의 장점은 제대로 살릴 수가 없다.

완성된 집에 색 입히기

집이 다 지어지면 마지막으로 목재에 색을 입히는 작업을 한다. 옛날에는 칠을 할 때 황토로 흙칠을 하거나 불로 지져서 색깔을 냈다. 불로 지져 놓으면 곰팡이가 생기지 않고 벌레도 들어가지 않는다. 또 들기름을 칠하기도 했다. 들기름을 칠할 때는 볶지 않은 깨로 짠 생들기름을 사용했는데, 이는 기름을 만들 때 가열하지 않았기 때문에 들깨의 영양소가 그대로 들어 있고, 기름 색이 맑아 목재 본연의 색을 더 잘 드러내 주기 때문이다.

생들기름을 칠하면 불그스레한 빛이 나고, 볶은 들기름을 바르면 색이 검어진다. 제일 좋지 않은 것은 들기름에 석유와 같은 다른 물질을 섞어서 바르는 것이다. 석유를 넣으면 기름의 양이 많아지고 잘 발리기 때문에 종종 섞는 경우가 있다.

들기름을 바르면 먼지가 앉아서 보기 싫다는 사람들도 있는데, 그것은 생각의 차이인 것 같다. 옛날에는 너무 새 집 티가 나는 것보다는 고색창연한 느낌을 주려고 일부러 먹물을 타서 바르기도 했다.

사람들이 흔히 떠올리는 한옥은 단청으로 곱고 화려하게 장식된 모습일 것이다. 단청은 벽, 기둥, 천장, 기와 등에 한국의 전통 색상인 오방색五方色, 즉 황黃, 청靑, 백白, 적赤, 흑黑의 5가지 색을 기본으로 하여 그림이나 무늬를 그려 넣은 것을 말한다. 단청의 기원은 삼국 시대까지 거슬러 올라간다. 주로 불교의 전파와 함께 사찰 건축에서 시작되었으며, 궁궐이나 사당과 같은 다양한 건축 공간으로 확장되었다. 하지만 단청에 사용하는 화려하고 다양한 색을 만드는 데는 예나 지금이나 품과 비용이 많이 들었다. 그러다 보니 궁궐이나 대규모 사찰 같은 곳에서나 단청 장식을 할 수 있었다.

단청 안료에는 살균 효과가 있어서 나무가 더 오래 보존된다. 그리고 단청 위에 생들기름을 바르면 기름 막을 형성해 습기를 막아 준다. 최근에는 생들기름 대신 오일스테인을 많이 바른다. 오일스테인을 바르면 방충 효과도 있고, 색깔을 마음대로 낼 수 있다는 장점이 있으며, 나무의 수명도 굉장히 오래간다.

단청은 한국 전통 건축에서 단순한 장식의 의미를 넘어, 상징적이고 철학적인 의미를 지니는 중요한 요소이다.

한옥, 마무리 작업하기

집 짓기가 마무리되면 담장을 세우는 일이 남는다. 담장을 세우는 가장 큰 이유는 나의 공간과 남의 공간이 차지하는 영역을 구분하기 위해서이다. 흔히 담장을 쌓는다고 하면 무조건 수평으로 쌓아야 한다고 생각하기 쉬운데, 그렇게 쌓으면 안 된다. 요즘 설계 도면을 보면 담장은 무조건 수평으로 설계한다. 하지만 도면에 나온 대로 쌓는 것이 아니라 지형에 따라서 시각적인 부분을 고려하여 쌓아야 한다.

우리나라처럼 산이 많은 나라는 어딜 가나 언덕배기가 있다. 그래서 집과 면한 길이 수평이 아닌 경우가 많다. 이럴 때 담장만 수평으로 맞춰 쌓으면 앞쪽이 위로 쳐들려 보인다. 그러니 항상 길의 높낮이에 맞추어 담장의 높낮이를 조정해야 한다.

담장뿐만이 아니다. 집도 무조건 수평으로 짓는 것이 아니라 집 뒤

를 받쳐 주는 배경을 보고 지어야 한다. 집은 삐딱하게 지어야 바로 보인다는 말도 있다. 수평이 맞지 않아야 수평처럼 편안하게 보일 수 있다는 말이다. 그래서 집 지을 곳의 자연환경, 즉 바람이나 비, 주변 산천의 경계 등을 모두 고려해야 한다.

집을 다 짓고 주위를 아름답게 정리하기 위해 석축石築을 쌓고, 집 뒤에 꽃을 심기 위한 화계花階를 만들기도 한다. 석축과 화계 역시 제대로 잘 쌓아야 집 안에 바람이 잘 통한다. 기껏 집을 잘 지어 놓고 석축을 잘못 쌓아 바람이 다니는 길을 막는 일은 없어야겠다.

석축을 쌓을 때는 전체 높이 4m를 기준으로 3단으로 쌓는데, 전체 높이의 3분의 1에 해당하는 길이(1.3m)가 가운데 단의 높이가 되고, 남은 2.7m의 3분의 1에 해당하는 길이(0.9m)가 맨 윗단의 높이가 된다. 그리고 나머지 1.8m가 맨 밑단의 높이가 된다(240쪽 그림 참조). 이런 식으로 쌓아야 사람들 눈에 가장 편안하게 보이며, 바람도 잘 통한다. 이렇게 석축을 쌓고 화계를 조성해 놓으면 가서 보고 싶은 마음이 저절로 생긴다. 안성 해주 오씨 정무공파 종중 재실의 화계가 이렇게 쌓은 대표적인 사례에 속하는 석축이다.

화단이나 화계는 주로 집 뒤편에 만들었다. 앞마당은 판판하게 정리하여 햇빛이 잘 들게 하고, 집 뒤쪽에 화단이나 화계를 만든 이유는 그곳을 여자들이 주로 사용하는 공간으로 여겼기 때문이다. 옛날

위의 사진은 지형의 기울기에 맞춰 쌓은 담장이고, 아래 사진은 지형과 상관없이 수평으로 맞춰 쌓은 담장으로 앞이 높아 보인다.

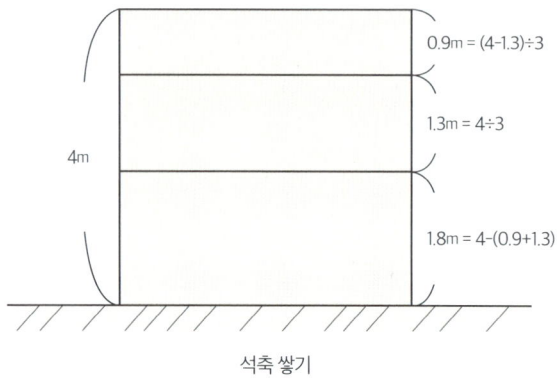

석축 쌓기

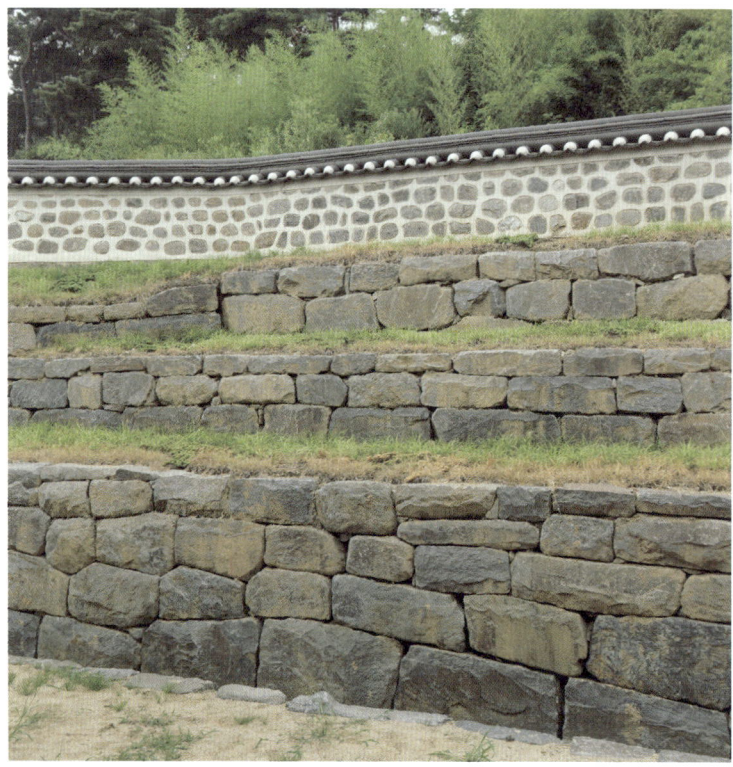

안성 해주 오씨 정무공파 종중 재실의 화계 석축

에는 여자들이 지금처럼 자유롭게 외출하지 못했고, 집 안에 머무는 시간이 많았다. 그래서 아름다운 공간을 마련해 준 배려가 담겨 있다.

화단이나 화계를 만들 때는 하나쯤 부족하게 만들어야 한다. 그 집의 주인이 들어왔을 때 비로소 완성된 느낌이 들도록 말이다. 사람과 조화롭게 어우러져야 좋은 집이다.

이제 마지막으로 마당을 정리한다. 마당에는 백토를 깐다. 백토는 화강석이 마모된 곱고 희고 불그스레한 빛깔의 흙이다. 백토를 마당에 깔면 물도 잘 빠지고, 무엇보다 빛을 반사시켜 집 안으로 햇볕이 들어가게 해서 좋다. 마당에 백토를 깔기 위해서는 그 전에 물이 흘러가는 길을 잘 내서 비가 왔을 때 빗물이 천천히 빠지도록 해야 한다. 빗물이 한꺼번에 빨리 빠지면 마당이 파이기 때문이다.

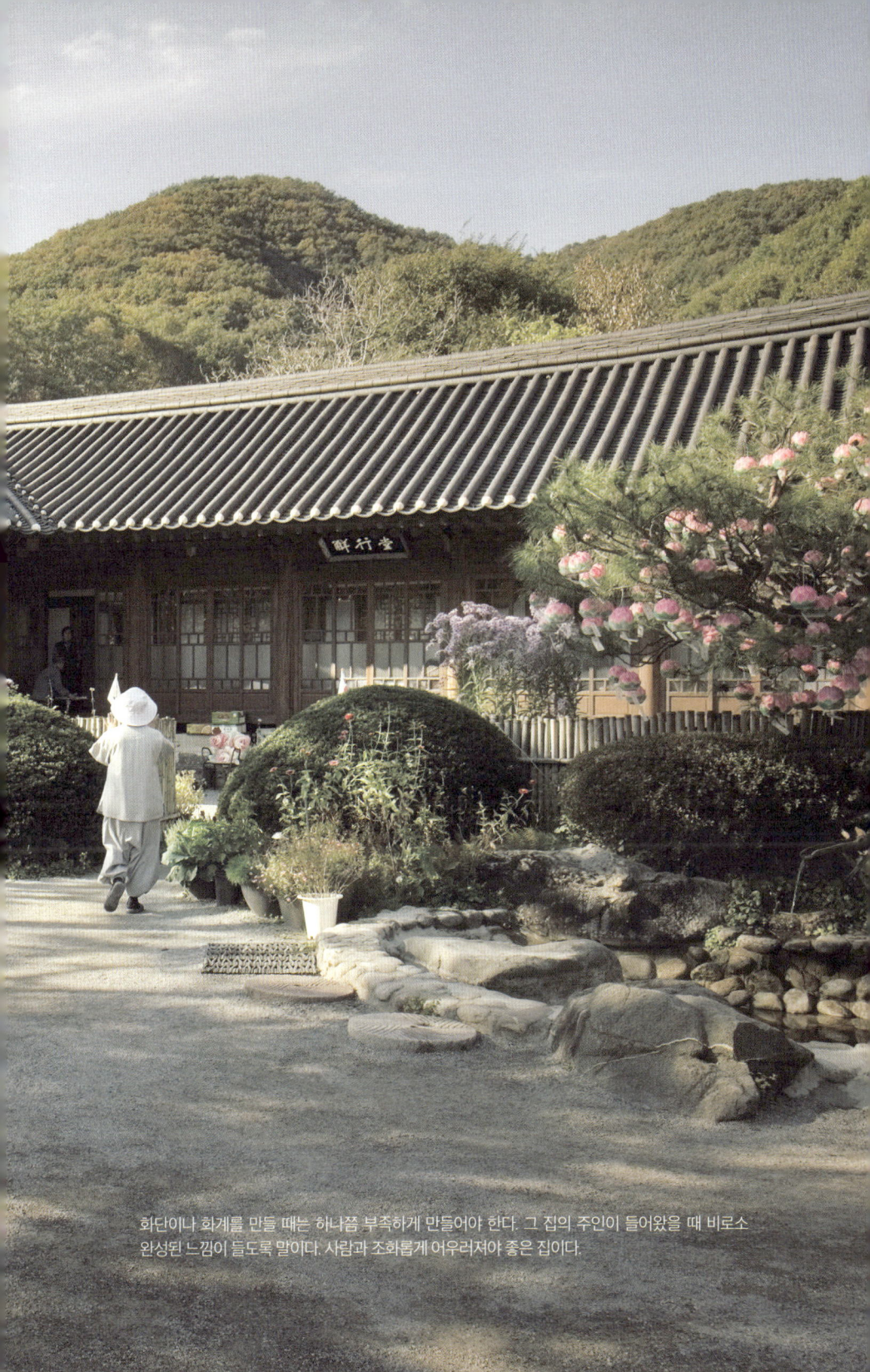

화단이나 화계를 만들 때는 하나쯤 부족하게 만들어야 한다. 그 집의 주인이 들어왔을 때 비로소 완성된 느낌이 들도록 말이다. 사람과 조화롭게 어우러져야 좋은 집이다.

글을
마무리하며

1966년에 전통 건축과 처음 인연을 맺었으니, 햇수로 벌써 60년에 가까운 세월을 한옥과 함께 살아왔다. 문화재를 수리해야 하는 현장이 나오면 어디든지 다녔고, 1974년 후반부터는 본격적으로 한옥 공사를 맡아 왔다. 지금까지 여러 한옥 작품을 남겼고, 내게는 작품 하나하나가 모두 소중하다. 하지만 그 가운데 나에게 전통 건축가로서 긍지를 갖게 하는 작품을 딱 하나만 꼽으라고 한다면, 주저 없이 보탑사라고 이야기할 것이다.
보탑사는 어느 한 사람의 힘으로 완성된 걸작이 아니다. 여러 전문가와 지지자들이 역사적으로 길이 남을 3층 목탑을 세워 보자는 뜻에서 하나로 뭉쳤기에 가능했던 일이다. 그 결과로 완성된 보탑사는 전통 한옥 건축의 진수를 담았다고 자부할 수 있다.

그동안 한옥 전문가로 살아오면서 수많은 일을 겪었지만, 그중에서 가장 손꼽는 사건은 무령왕릉 발견과 대영박물관 내부에 한옥 전시장을 지은 일이다.
내가 1971년 7월 2일에 처음 발견한 백제 고분 무령왕릉을 두고 사람들은 광복 이후 우리나라 고고학 사상 '최고의 발견'이라고 말한다.

영국박물관 사랑방 창건기

한국실에 사랑채를 지었다.
한옥 특성에 따라 구들 말루와
여러가지 아름다운 문짝과
선자서까래와 처마곡선까지
정성을 다하여 민족문화를
널리 알리려 하였다.

지유 신영훈
설계 박태수
도감 강병식
행수 김영일
편수 조희환
목수 이재혁
구자완
이정철

목수 이광복
설수 강갈흥
도배 양영송
와공 시국선
기록 김일석
통역 최문정

단기 4333년 7월 5일
입주하고 상량하였다.

백제 왕릉 중 유일하게 주인이 명확히 밝혀진 무덤을 발견한 나에게는 무척 영광된 말이다. 무령왕릉 발견은 고고학사에 한 획을 그은 일이었다.

영국 런던 대영박물관에 세운 한옥 전시장은 2000년 영국 정부의 공식 요청으로 만든 자랑스러운 결과물이다. 실내에 전시될 공간이라 규모는 작았지만, '사랑방'이라는 이름을 단 소박한 사랑채 한 채가 당당하게 전시되어 있다는 사실만으로도 뿌듯한 마음을 금할 길이 없다. 한옥을 짓는 내내 쇠못 하나 쓰지 않고 제법 육중해 보이는 나무 부재들을 차곡차곡 쌓아 올리는 모습을 보면서 대영박물관 관계자들이 감탄사를 연발했던 기억이 새롭다.

우리 전통 한옥의 우수함을 알리고 한국 전통문화의 자긍심을 고취시킨 사랑방은 이후 '한영실韓英室'로 이름이 바뀌었다. 얼마 전 손녀들과 대영박물관을 방문해 그 앞에서 할아버지가 이룩한 뿌듯한 성과를 보일 수 있어 더없이 기뻤다. '한영실'은 지금까지도 가장 사랑받는 전시실 중 하나로 남아 있다.

많은 사람이 전통문화는 어렵고 고루하다고 생각한다. 하지만 우리

가 살아가는 이곳에서 우리와 함께, 우리에게 가장 알맞은 형태로 발전한 것이 바로 전통문화이다. 전통문화를 지키지 못한다면 우리의 고유한 기질마저 잃게 된다는 사실을 늘 염두에 두어야 한다. 우리의 전통문화는 세계 어느 나라의 문화유산과 비교해도 결코 뒤떨어지지 않는다. 그러니 자부심을 갖고 지켜 나가자고 말하고 싶다.

한옥을 짓고 문화재를 수리하며 살아온 모든 순간에 후회는 없다. 언젠가부터 전통 건축 기술자들 사이에서 내가 제일 연장자 축에 들게 되었다. 이제는 그동안 내가 지켜왔던 것들을 후대에 알려 줘야 한다는 생각이 든다. 좋은 집을 지을 것인지, 나쁜 집을 지을 것인지는 마음먹기에 달려 있다. 집이란 그저 땅을 고르고 재료만 쌓아 올린다고 만들어지는 것이 아니다. 그 위에 집 짓는 사람들의 마음이 차곡차곡 쌓여야 비로소 완성된다.

한옥을 지으며 외길 인생을 걸어온 내가 지키고자 했던 제대로 된 한옥에 대한 열정과 마음을 담은 이 책이 한옥을 짓고 싶은 모든 분께 조금이라도 보탬이 되었으면 하는 바람이다.

목탑과 한옥
자연을 품은 사찰 보탑사와 한옥 건축 이야기

초 판 1쇄 인쇄 · 2025. 3. 3.
초 판 1쇄 발행 · 2025. 3. 18.

지은이　김영일
발행인　이상용 이성훈
발행처　청아출판사
출판등록　1979. 11. 13. 제9-84호
주소　경기도 파주시 회동길 363-15
대표전화　031-955-6031　팩스 031-955-6036
전자우편　chungabook@naver.com

ⓒ 김영일, 2025
ISBN 978-89-368-1250-8　03600

값은 뒤표지에 있습니다.
잘못된 책은 구입한 서점에서 바꾸어 드립니다.
본 도서에 대한 문의사항은 이메일을 통해 주십시오.